INFECTIOUS
RHYTHM

For J.M., Good Mother

CONTENTS

ACKNOWLEDGMENTS

This book grew, in large part, out of lectures for a course at Princeton University on postmodern culture. The course had been instituted by Andrew Ross, and after his departure was taught by me and Thomas Keenan. My thanks are due to Andrew for opening up the space for this kind of teaching, and to Tom for educating me about the real effects of virtual violence.

The book took shape, however, in the Department of Performance Studies at N.Y.U., and it has benefited greatly from the astute comments of my colleagues May Joseph, Barbara Kirshenblatt-Gimblett, José Muñoz, Ngũgĩ wa Thiong'o, Peggy Phelan, and Richard Schechner. It was only in retrospect that I realized how much my writing now owes to this department's historical commitment to engaging with anthropological knowledge not merely in the analysis but in the production of culture.

A number of other colleagues, students, and friends have offered information, advice, encouragement, and caveats. They include David Brown, Una Chaudhuri, Laurent DuBois, Diana Fuss, Mandy Harris, Don Kulick, André Lepecki, Fábio Lima, Luiz Mott, Chris McGahan, June Reich, João Reis, Robert Stam, Andy Young, and all members of my feminist ethnography workshops.

Though it's been tacit, my admiration of S.K. runs deep—ôdo iyá-ê.

Brian Austin has struggled with me through the issues of secrecy and disclosure.

Finally, thanks to my son Leo. Graceful little Oankali-Human construct, your fluent movement between two worlds gives me hope for this one.

I completed a first draft of this book's manuscript in the fall of 1996, and began revising. In the intervening months (I write these last words in the summer of 1997), media representations of AIDS have changed dramatically. New drug therapies (or "regimens"—an interesting militaristic figure) appear to offer hope of, if not a cure, a manner of controlling viral levels in certain individuals. This may sound like the long-promised era of AIDS as a "chronic, treatable illness"—not a fatal one. But of course it isn't. In fact, the new therapies, welcome as they are, only serve to make more obvious, at the national and global levels, the social inequities that have facilitated the spread of HIV.

The *New York Times*, November 28, 1996, Lawrence K. Altman, "U.N. Reports 3 Million New H.I.V. Cases Worldwide for '96":

> The H.I.V. epidemic is "strengthening its grip on the world's most vulnerable populations," Dr. [Peter] Piot [head of the UN's global AIDS program] said. . . . The effectiveness of new combination drug therapies requires monitoring of the amount of virus in the blood. But most countries cannot afford the costs of such tests or to pay for the costly drugs. A great fear is that misuse of the new drugs will create large numbers of cases of drug-resistant H.I.V. (p. A10)

This fear is not exclusive to the "Third World." The *New York Times*, March 2, 1997, Deborah Sontag and Lynda Richardson, "Doctors Withhold H.I.V. Pill Regimen From Some":

> With the early successes of drug cocktails built on a new class of drugs called protease inhibitors, national concern has focused on whether their high cost puts them out of the reach of many AIDS patients. But in New York State, which has the most comprehensive drug assistance program in the nation, everyone is covered for the new AIDS drugs.
>
> But not everyone can get them. And cost is not the deciding factor; doctors are. Since the exacting regimen for taking the new drugs

taxes even the most stable patients, many doctors do not want to prescribe them to those . . . with chaotic lives and a poor record of taking care of themselves. . . .

The doctors maintain that poor compliance with the drug-taking regimen could not only spell disaster for an individual patient, but also create a potential health risk through the spread of a virus resistant to many drugs. (p. A1)[1]

Those who are considered "resistant" to regimen-compliance are read as the threat of a drug-resistant virus. And of course their "chaotic" lives cannot be abstracted from their race, class, and gender. The article cited here opens with a depiction of Tyeisha Ross, an HIV-positive, pregnant, 18-year-old, African American woman from the Bronx, raised in foster care, who "concurs" with her doctor's classification of her as "irresponsible."

But this is not the only kind of drug-resistance occurring among African Americans. The *New York Times*, April 28, 1997, Lynda Richardson, "Experiment Leaves Legacy of Distrust of New AIDS Drugs":

Walter Williams, a 49-year-old Vietnam veteran in Harlem, tested positive for the AIDS virus eight years ago, but he has rejected his doctor's urging that he try the new drugs that have shown such promise in reversing the progress of the deadly disease.

After a short, nauseating stint taking AZT when it was the only drug approved to fight AIDS, he now tries to stave off ailments with a potpourri of natural remedies like dandelion, gingko and herbal pills derived from cat's claw, a rain forest plant.

And although he works at the Harlem United Community AIDS Center, passing out condoms and fliers promoting its counseling and support services, he often cannot contain his suspicions about mainstream medicine. He has heckled doctors at public forums when they talk of recruiting Harlem residents for AIDS research and clinical trials, accusing them of looking for human guinea pigs. What they call treatment, he calls poison. (pp. A1, B4)

The article calls Williams' "outbursts" the "rhetorical extreme" of a pervasive line of thought among many African Americans: they see conventional medical responses to AIDS in light of the infamous "Tuskegee Study of Untreated Syphilis in the Negro Male." The study, which ran from

1932–1972, tracked poor black men in Macon County, Alabama—observed them without offering treatment, even as the purported purpose of the study was to justify treatment programs for blacks. None of the participants was even informed of his condition. Many went blind, some insane, as they were followed to the study's logical conclusion: their autopsies. While Tuskegee operated through a withholding of treatment and current clinical trials generally offer it, Walter Williams expresses a common position with little rhetorical excess: "People have been dishonest before, and it gives me reason to question what they are doing and what they are saying." One should also question what is *not* being said. Tyeisha Ross's doctor, by her own account, "did not tell Ms. Ross much about the new drugs."

In this country, HIV-positive people who stand the least chance of getting any possible benefit from the new therapies are women of color. The *New York Times*, July 20, 1997, Sheryl Gay Stolberg, "The Better Half Got the Worse End":

> The headlines last week trumpeted the good news: Deaths from AIDS had dropped 19 percent in the United States, continuing a decline first reported in May. . . .
>
> Yet in the fine print of the Government's statistics was a less cheerful tale. Between 1995 and 1996, deaths of women decreased by just 7 percent, as against 22 percent in men. And while the number of deaths dropped 28 percent for whites, the drop was 10 percent for blacks and 16 percent for Hispanic victims.
>
> The turnaround, in other words, has primarily benefited white men. (Section 4, pp. 1, 4)

The rest of this article follows a bold-face sub-heading, lest the point be lost on some readers: "**The Problem Is Not Biology**." Stolberg quotes Dr. Janet Mitchell, a Brooklyn-based Ob/Gyn: "Women, especially women of color, don't have the time or money or the energy to be surfing the Internet to know what the new and improved latest treatment is. They tend overwhelmingly to be mothers. They don't have that leisure to make AIDS the only focus in their life."

Reading about the many successes of the new therapies overwhelms me with both hope and sorrow. Not just in this country but throughout the world, *all* people living with HIV deserve information about and access to

the most effective treatments. But this is not to take Walter Williams's reason from him. While I mourn the fact that friends who have already died missed the opportunity of protease inhibitors, the one I loved best died a meaningful death, eschewing all Western pharmaceuticals, accepting only the very "natural" treatments Walter Williams takes. Until the Western medical establishment acknowledges the importance of healing in accord with the demands of one's life, cosmology, and politics, there will be no communication with the "drug-resistant."

"Haiti Is Here/
Haiti Is Not Here"

Sticks beating, hands beating, the rumble of bass drums so bass they sound for all the world like thunder, the rapid-fire crackling of a stick so sharp on a skin so tight it sounds for all the world like gunfire. You could be anywhere: This is a war zone, this is a party. Sticks beating, hands beating, there's a body underfoot in the middle of the crowd, that's the military police beating a man like a drum, that's blood on the stones.

The beat could be rhumba, hip hop, juju, reggae, samba. Or it could be a combination of all of these, layered one over the other, gaining intensity and significance with every rhythmic line. It's Salvador, Bahia, Brazil, and it's the Afrocentric carnival organization Olodum rehearsing in Pelourinho (Pelô), the old square in which slaves were pilloried, now a preserved "historic district" and tourist center. The state government has refurbished the square, including a picturesque local museum named after Jorge Amado,

the romantic literary chronicler of Salvador as the heart of African culture in Brazil.[1]

Olodum's public rehearsals are gorgeous percussive spectacles, attracting enormous numbers of Brazilian and foreign tourists, particularly in recent years when their trademark rhythm, samba-reggae, began to sweep the Brazilian pop charts.[2] They reached an international audience when they played on one track of Paul Simon's 1990 CD, "The Rhythm of the Saints," and subsequently appeared in a music video. Some members went on concert tour with Simon as well. A number of invitations from other U.S. artists followed. In February 1996, the group appeared in a Michael Jackson video, filmed by Spike Lee.[3] Olodum has changed considerably from its earliest incarnation.[4] It started out in 1979 as one of a small number of carnival organizations committed to the celebration of the cultural heritage of Bahia's black underclass, and, while it continues to do outreach work among poor communities, it also enjoys a high profile in the profitable music industry. In addition to its CDs, records, and tapes, Olodum has a product line (Afrocentric fashions and accessories) for sale in its upscale Pelô boutique, and it sponsors a Visa card. Still, despite the grass roots educational activities of the group,[5] the lives of some of the kids on the front line beating the drums remain dangerous.

Kids living on the street lead a particularly precarious existence in Brazil. While there has been a loosening of political strictures such as official censorship since the end of the military regime in 1985, the military police have maintained, and, in fact, expanded their role as exterminators of urban undesirables.[6] There is no death penalty in Brazil, but military police death squads are often supported by a public mortified by urban violent crime precipitated by the rapidly increasing class stratification.

Thousands die each year, but word only reaches the U.S. when they die en masse, as occurred in the 1993 massacre of 111 prisoners in São Paulo's House of Detention—most of them non-violent, first-time, young offenders. Prison officials explained the killing as a necessary response to an uncontrollable uprising, although there was evidence of a number of men having been shot with their hands tied behind their backs. What makes life so expendable? Dark skin and poverty—this is not new—but increasingly, something else. A *New York Times* report on the incident concluded:

In the attack, several policemen wore surgical gloves, an increasingly common practice in prisoner control operations at the jail. An esti-

mated one-third of the House of Detention inmates are believed to be infected with the HIV virus, which causes AIDS. One newspaper reported today that inmates had threatened to attack the police with blowguns loaded with darts dipped in HIV-infected blood.[7]

The rumor of the prisoners' threat, of course, is suspect—as is the estimate of the rate of HIV infection among prisoners.[8] But the public understanding of a link between an "uncontrollable" and an "infected" population is significant.[9]

How have we moved so quickly from the ecstatic crackling of drums, an irresistible, celebratory rhythm that marks itself as simultaneously Afrocentric and diasporic, to the bloody scene at the House of Detention? I've followed here the trajectory marked by the Brazilian lyricist Caetano Veloso in his 1995 song, "Haiti." Veloso collaborated with Gilberto Gil on the music, which is itself a complex overlay of rap on a computer-programmed "drum corps" playing an eerily subdued samba-reggae:

When you're invited up onto the terrace
Of the House of Jorge Amado Foundation
To watch from up above the line of soldiers, almost all black,
Beating on the necks of the black riff-raff,
Of mulatto thieves and other almost white men
Treated like black men
(And they are almost all black),
How is it that blacks, poor men and mulattos,
And almost white men, so poor they're almost black, are treated?
And it doesn't matter if the eyes of the whole world
Might be turned for a moment toward the square
Where the slaves were punished.
And today a drumbeat a drumbeat
With all the innocence of boys in secondary school uniforms on a parade
 day
And all the epic grandeur of an orderly people
Attracts, stuns and excites us.
Nothing matters: not the architectural detail of the second story,
Not the camera lens from the TV show "Fantástico," not Paul Simon's
 record—
No one, no one is a citizen.

If you go to the party there at Pelô, and if you don't go,
Think about Haiti, pray for Haiti.
Haiti is here—Haiti is not here.
And on TV, if you see a congressman barely able to conceal his panic
When faced with any, but really any, any
Plan for education that might seem easy,
That might seem fast and easy
And might represent a threat to democratize
Primary school education,
And if this same congressman should defend the adoption of capital
 punishment,
And if the venerable Cardinal should say that he recognizes the spirit of a
 fetus
And not that of a petty thief,
And if, when you run a red light, that old red light,
Your habitual red light,
You should notice a man pissing on a corner
Onto a shiny bag of garbage from Leblon,
And when you hear the smiling silence of São Paulo
In response to the massacre,
One hundred and eleven defenseless prisoners, but then prisoners are
 almost all black men,
Or almost black men, or almost white men so poor they're almost black,
And poor men are rotten, and every one knows how blacks are treated . . .
And when you go on a little trip to the Caribbean,
And when you screw without a rubber,
And participate knowingly in the blockade of Cuba,
Think about Haiti, pray for Haiti.
Haiti is here—Haiti is not here.[10]

Veloso's compressed lyricism spins together economic, sexual and political exploitation, AIDS, and the pounding of drums, all through the politically charged musical idiom of rap, which is then layered over the already syncretic and markedly diasporic rhythm of samba-reggae. In other words, Haiti is here—you could be in Port-au-Prince—but so could you be in L.A., in Kingston, in Havana, in Lagos.

The currency of rap as a musical idiom in the global popular music market is a complex phenomenon, related to the global popularization of reggae which led to syncretic forms such as samba-reggae.[11] In fact, as Paul Gilroy and others have pointed out, hip hop is itself a hybrid form emerging from the cross-fertilization of African American and Caribbean cultures.[12] Rap is perceived as a musical language of protest, and of course it is associated in particular with black resistance—although certainly there is plenty of rap, both in the U.S. and elsewhere, which has no explicit message of race politics. One could argue, though, that there is always an implicit racial political message in the rhythm itself. The argument would seem to be confounded by artists whose overt lyric messages are in opposition to race consciousness, who cite the mass appeal of the form to argue that it is no longer "merely" a "black" idiom. A song, though, can mean more than one thing at one time. And mass appeal across race, class, and nation, which might superficially deflate even a politically explicit address to a specific, politicized listenership, may not be the last word.

The meanings of such music are multiple, and we need to attend to all of them. As Gilroy writes:

> black music cannot be reduced to a fixed dialogue between a thinking racial self and a stable racial community. Apart from anything else, the globalisation of vernacular forms means that our understanding of antiphony will have to change. The calls and responses no longer converge in the tidy patterns of secret, ethnically encoded dialogue. The original call is becoming harder to locate. If we privilege it over the subsequent sounds that compete with one another to make the most appropriate reply, we will have to remember that these communicative gestures are not expressive of an essence that exists outside of the acts which perform them and thereby transmit the structures of racial feeling to wider, as yet uncharted, worlds.[13]

My argument here is the flip side of the same coin (or, more appropriately, the same disk): while a drumbeat is not *simply* the "black heart beating back to Africa on a steady pulse of dub,"[14] the resonance of this image still matters.

Hip hop is one moment in the history of the dispersion and populariza-

tion of black musical idioms, a process of cultural exchange which was concomitant with the first processes of global economic exploitation—that is, colonization. Reggae represents another such moment. Funk. Soul. Mambo. All "infectious" rhythms—all spread quickly, transnationally, accompanied by equally "contagious" dances, often characterized as dangerous, usually as overly sexually explicit, by white critics. Music historian Susan McClary has noted a seventeenth-century style of Peruvian dance music, probably of mixed African and indigenous origin, which prompted a public reaction similar to the outcry, 350 years later, over Wilson Pickett's funky "jungle rhythms":

> When the *ciaccona's* infectious rhythms hit Europe, it sparked a dance craze that inspired a familiar set of reactions: on the one hand, it was celebrated as liberating bodies that had been stifled by the constraints of Western civilization; on the other, it was condemned as obscene, as a threat to Christian mores. But most sources concurred that its rhythms–once experienced–were irresistible; it was banned temporarily in 1615 on grounds of its "irredeemably infectious lasciviousness."[15]

Despite the ban, McClary recounts that the *ciaccona's* "energies" contributed to seventeenth-century developments in European music, including tonality, such that any subsequent discussion of "Western" musical style neglects a significant African and Native American influence.

There is no fixed historical point prior to which one can speak of cultural purity. The colonial period, of course, represented a moment of greatly accelerated exchange—as does the present moment. Rapidly developing communications technologies are facilitating transnational economic relationships, as well as global cultural exchanges. These changes are leading to a proliferation of theoretical models for configuring the "spread" or dispersal of national performative and representational practices. The aim of this book is to consider a model with a lengthy and complex history: the Western account of African diasporic culture that relies on the figure of disease and contagion. The metaphor is invoked—often in the guise of a "literal" threat—at moments of anxiety over diasporic flows, whether migrational or cultural. At this juncture, the figure has accrued new significance, and new virulence.

This is not to say that the figure of "infectious rhythm" is always nega-

tive. Artists and performers in the diaspora sometimes invert, ironically, the metaphor, such that "Western influence" is itself shown as a pathogen. Or, more typically, they recuperate the notion of African "infection" by suggesting that diasporic culture *is* contagious, irresistible—vital, life-giving, and productive. The life-giving plague redeems the very qualities Western stereotypes have scorned, especially sensuality. Marvin Gaye's "Sexual Healing" is not so much a negation of "infectious rhythm" as a celebration of its own curative powers. My own analysis of the metaphor is not an argument for its eradication, as it can be powerfully life-affirming. In fact, I invoke it myself at strategic moments, always in the hope of activating its healing potential.

The following essays examine both vital and violent ways in which recent associations have been made between the AIDS pandemic and African diasporic cultural practices. While the primary figure for African "contagion" is "infectious rhythm," the entire spectrum of diasporic performative and representational practices is implicated: not only polyrhythmic percussive music and accompanying secular dances, but also religious dances of divine animation (so-called "spirit possession"), oral narrative, and sculpture. In fact, African and diasporic expressions through "Western" media, including the novel and film, are part of the story.

The metaphor of contagion, even when invoked by Europeans, often takes seemingly benign forms ("infectious rhythm" as a dispersal of joy), but it can also often lead to hostile, even violent, reactions to cultural expressions. It is the conflation of economic, spiritual, and sexual exchange that has allowed for the characterization of diasporic culture as a chaotic or uncontrolled force which can only be countered by military or police violence. Olodum's public rehearsals are merely one example. The ever more sophisticated multinational exploitation of a diasporic labor force means that "protecting" "our" interests has become even more complex. While the Western depiction of Africans as virulent and dangerous is certainly not new, the recent acceleration of economic and cultural exchange has apparently raised the stakes. HIV emerged as a pathogen simultaneously with new anxieties over the risks of these other "contagions." And while it may seem clear that one pandemic is painfully literal, the others figurative, they were quickly associated with one another. In fact, economic exploitation, cultural exchange, and disease *are* interrelated—but Africanness is hardly the deadly pathogen.

I have chosen not to divide my analyses here hermetically between

"Western" and "African" perspectives on the notion of cultural contagion, or on AIDS. As McClary's example demonstrates, cultural genealogy is never so clear-cut. Though some of the European forms of cultural representation and control I analyze here are clearly racist and xenophobic, they often betray, ironically, a deeply embedded African cultural influence. Likewise, I have tried to resist an account of African diasporic representations of epidemia that might imagine an original, "authentic" African philosophy of disease. Even divine embodiments of epidemia have been inflected by European responses to them. Western medical technologies have been absorbed into "ritual" healing systems in ways that the World Health Organization would be hard-pressed to explain. And it was in large part the Western medical establishment's early inability to offer effective treatment for HIV-related illness that prompted a somewhat increased openness among Western practitioners to non-Western therapies in recent years. These exchanges are fluid, moving both ways.

EFFLUVIA

One of the most compelling theoretical models proffered in response to the fluidity and multidirectionality of cultural exchange is that of Arjun Appadurai. He suggests fractal cartography, not epidemiology, might give us a way to configure global relations, acknowledging the "disjuncture" of the often oppositional flows of populations, media, technologies, capital, and ideology. While Appadurai's terminology evokes a highly abstract geometric projection of these flows ("ethnoscapes, mediascapes, technoscapes, finanscapes, and ideoscapes"), he notes that cultural "fluid" exchanges are also played out in the literal fluid exchanges of sexual bodies. Citing the Western-influenced Hindi film industry's impact on the Indian sex trade, which he marks as increasingly exploitative of "deterritorialized" women, he writes:

> These tragedies of displacement could certainly be replayed in a more detailed analysis of the relations between the Japanese and German sex tours to Thailand and the tragedies of the sex trade in Bangkok, and in other similar loops which tie together fantasies about the Other, the conveniences and seductions of travel, the economics of global trade and the brutal mobility fantasies that dominate gender politics in many parts of Asia and the world at large.[16]

Critics of the epidemiological AIDS narrative of a vulnerable U.S. penetrated by an infected foreign population (Haitian, African, or both) have countered the accusation with the observation that Western sex tourism—in particular North American gay men's sexual adventuring in the Caribbean (as well as Asia)—preceded the epidemic there.[17] If viewed *merely* as a counteraccusation, the response seems limited, both epidemiologically and politically. Actually thinking through the complications of tourism, however, doesn't mean pointing to circulating U.S. gay men as "polluting persons." (*This* accusation is hardly unfamiliar in the domestic context.) Rather, as Appadurai argues, economic imbalances, in *conjunction* with the flow of media images, necessarily destabilize sexual exchanges, creating intimacies precisely at the points most strenuously marked as Other.

Everyone is implicated—not merely through sexual intimacy, but through economic and cultural intimacy through Othering as well. ("And when you go on a little trip to the Caribbean, / And when you screw without a rubber, / And participate knowingly in the blockade of Cuba, / Think about Haiti. . . .") Because of the radical imbalances of economic and military force, the U.S. holds and exercises the power to police the hemisphere. The most recent military intervention in Haiti was just the last chapter in a long, long story. This country's capacity for political control creates an illusion of difference, and distance. But of course, Haiti, too, is here—Haiti is not here.

SILENCE AND DEATH

The demographics of AIDS are changing, both within the U.S. and across the globe. The outset of the epidemic was marked in this country by a rapid and voluble response from artists, scholars, and activists. The collaboration between these groups—which itself dissolved the distinctions between art, analysis, and activism—was effective. Through a strategy of maximum volume and maximum visibility, ACT-UP succeeded in affecting not only public awareness, but also the seemingly intractable medical establishment, including the pharmaceutical industry.[18] The proliferation of images, slogans, and active bodies was accompanied by cutting analyses of AIDS discourse in the media.[19] In the 1980s, AIDS effectively taught us to read and to engage in activism in new ways.

But the strategy of volubility (Silence=Death) was predicated on a fact of early AIDS demography in the U.S.: the impacted community had a considerable economic, and so political, base. That doesn't mean there weren't tremendous risks for white gay men to stand and announce their seropositivity, and it isn't to denigrate the heroic accomplishments of AIDS activists in the 1980s. But in truth, little of the progress made by them will carry over to the next decade's infected population, at least in a global context.[20] In nations where the annual per capita expenditure on health care is less than the cost of a single HIV blood test, questions of faster access to ever more advanced therapies become insignificant. How much sense does acting up make in such a context? Of course, one can't rest on the false and temporary security of silence. There are creative responses in some of the cultural productions I examine in this book, responses which use figural deflection or irony to express truths often as trenchant as any bared by direct address. Often what these works achieve is a way of speaking *within* a community, while refusing to make themselves immediately discernible to an exploitative Western audience.

In this country, too, AIDS statistics are changing, and new discursive strategies may be in order. Statistics are figures, complicated images to be read deeply, not flatly. That is, all epidemiological hypotheses are based on a series of questionable assumptions of categoric identities and behaviors. And yet it seems a misguided response to deny that HIV in this country is increasingly affecting people of color. And while critics have reason to question the WHO's estimates of HIV infection in sub-Saharan Africa,[21] it also seems counterproductive to argue that AIDS isn't a significant health problem there. Still, a disinclination on the part of African and diasporic populations to follow the tactics of primarily white male activists in the United States rests, again, on the question of a power differential.

I do not mean to suggest that silence is the only response. This book owes a tremendous amount to two medical anthropologists who have taught us about the dangers of the medical establishment's failure to listen. Paul Farmer's work on AIDS in Haiti[22] has persistently shown that Haitians' own understandings and articulations of the significance of the pandemic are more politically astute—and more accurate—than those of Western epidemiologists. And Emily Martin[23] has shown the complicity of economic, cultural, and medical discourses in our own society by listening carefully to the voices of people usually discounted by scientists. Paul Farmer cites Paula Treichler on the "quiet" response of women in this

country to AIDS. Epidemiologists have suggested that women "at risk" were underclass women, women of color, women in the Third World . . . precisely those women "silenced categorically so far as public biomedical discourse was concerned."[24] Farmer clarifies that these women have not actually been silent: "They have been, rather, unheard."

Ethnography that takes seriously patients' own explanatory models[25] of their illness teaches us the catastrophic effects of medicine which silences, and the salutary effects of listening. Certainly, opening public biomedical discourse to those who have been categorically disregarded is a necessary part of understanding more fully the meaning of illness. But my project here is somewhat different. I am trying to attend to meaningful silences. To my mind this is not a contradictory but a complementary project to that of giving voice.

Globally oriented AIDS activism—as well as culturally sensitive AIDS activism and education in this country—needs to take into account the complicated motivations behind discretion. Certainly, individuals have understandable personal motivations. But one of the questions I have had to ask myself repeatedly in writing this book is: what is *cultural* discretion? It often coincides with the personal. While most of the analyses that follow examine public acts and documents, they were provoked by my desire to deal sensitively with the lives of real people, many of whom were not prepared to publicize their illness. I had envisioned a homecoming in the final chapter, a return to the site of my own education of diasporic epidemiology. This was to be the one chapter based on a more intimate, embodied knowledge—on personal experience, and the experience of people I love. But I found myself deferring to friends' desires for their stories to remain not merely anonymous, but *unwritten*. Finally, I had to consider the *significance* of silence, including cosmological, ethnographic, and even autobiographical silence.[26] Sometimes, silence doesn't equal death.

Despite the necessary differences between the political strategies of the first U.S. AIDS activists and those of diasporic artists and thinkers, it strikes me that there is room for a productive exchange. As I said, AIDS has taught us to read and to engage in activism in new ways. One thing that it has taught us is the speciousness of categories, including those of "risk." Despite their mutual resonances, recent critiques of gender, sexual, racial, and national identity often seem to fail to speak to one another, and yet they are confluent. The global pandemic, precisely, demonstrates what post-structural critiques of restrictive political identities argue: that

apparent oppositions (racial, colonial, sexual) are all too intimately interconnected, as are these categories themselves.

The trajectory of the analyses that follow may at first appear chaotic, yet they follow a trail which is itself epidemiological. That is, these chapters trace, from one to the next, the way in which certain figures circulate between the seemingly most disparate of contexts. The central figure is always the virus, and yet it moves through what epidemiologists refer to as "vectors": paths of contagion.

"Babaluaiyé: Diaspora as Pandemic" examines a text that pre-dates the AIDS pandemic, and yet seems in every way to speak to the racist narratives it has provoked. Ishmael Reed's *Mumbo Jumbo* is a novel in which a lively African "anti-plague" of rhythm and movement "infects" the U.S. via Haitian infiltration. The epidemic of the novel is accompanied by a number of African diasporic divinities who make themselves manifest in characters' bodies. One divinity, however, seems to be manifested in the plot itself, though his name is never mentioned. The diasporic divine principle of epidemia must be addressed with discretion. In a book attempting a textualization of this principle, I begin with a consideration of the significance of a-textuality, and of silence.

The following chapter attempts to specify some of the technological developments that have accelerated the global spread of "infectious rhythm." "Compact World" considers the phenomenon of "World Music" and the relationship of multinational recording companies to non-Western musical forms. The CD, and subsequently the CD-ROM, have been marketed on the principle of an increasingly compact world, in which culture travels with greater speed. The argument rests on a notion of global marketing articulated by its cultural pioneer, Walt Disney: "It's a Small World After All." This marketing maneuver is related to the identity politics of global charity projects initiated by the music industry, including AIDS charities.

"*Lutte contre les moustiques*: The Question of Irony" tries to refine a question I have raised in this introduction: how does irony function in the work of African and diasporic artists who take on the figure of cultural contamination? I focus on the work of the most globally successful African painter today, the Congo (formerly Zairian) national Cheri Samba.

Samba's work sells because of its combination of two qualities termed by his critics "cosmopolitanism" and "authenticity." An Africanist take on Samba distinguishes him from artists "infected" by a European style of irony and political commentary, and is itself ironic, as such artists are often explicitly anti-European in their politics. While Samba's work is distinctive, it is not without its own cutting irony—but that irony is often difficult to read. He frequently makes paintings about AIDS, French-African sexual liaisons, technological development, and a Western disregard for diseases such as malaria that kill many more Africans than AIDS.

"African Medicine Men," African public health, and the complicity of the West in epidemia there are figured in two recent African fictional works on AIDS: *Nice People* by the Kenyan pop novelist Wamugunda Geteria, and the Togolese/French co-production "Ashakara" by filmmaker Gérard Louvin. *Nice People* careens between incisive observations about the global context of sexual stereotypes and the politics of pharmaceuticals, and surreal, frenzied replications of a *Heart of Darkness* surrounding a sinking clinic. "Ashakara" depicts a traditional "fetishist" in a remote village in Togo who discovers a cure for an unnamed plague bearing every obvious resemblance to AIDS. Both of these works evidence an ambivalent irony in relation to the Western representational vocabularies they invoke, even as they point to the West as a source of cultural, and perhaps viral, contagion.

I follow a depiction of West African "fetishism" with an analysis of U.S. depictions of Haitian "voodoo." "Voodoo Economics" examines the historical context of both voodoo and infection as metaphors for the political threat of the world's first black republic, and the only case of a successful slave revolt leading to an independent state. This history has had obvious implications for the attitude of the United States toward Haiti. Black politicization, of course, was the *real* scary "disease" that the U.S. has always feared. I extend the discussion of the prior chapter on ethnographic film technique, montage, and fetishism in a consideration of filmic representations of Haiti (including media representations of the most recent U.S. military occupation there). I also attempt to give a historical frame to epidemiological accusations.

The segue from Haiti to L.A. is the notion of the riot—the flood, seemingly chaotic, known in Haitian creole as *dechoukaj*—(uprooting). "Mixing Bloods: The L.A. Riots" argues that the significance of the L.A. riots swings on one's understanding of the event as a chaotic moment of exploded, inarticulate frustration, or as a political expression. It also depends, of

course, on what you hear in the eerily silent image of police beating a man like a drum. Blood—as racial identity, and as the meaningful sign of violence—spreads. I consider some of the techniques of urban social control which would appear to maintain a "hygienic" separation of cultural flows in Los Angeles, but which in fact provoked their bloody mixing. Subsequent to the riots, the truce between the rival Bloods and the Crips presented a model of civility in a society that had figured gang members as social virulence embodied. I also consider the ritual healing proposed by Anna Deavere Smith in her attempts to embody theatrically racial and cultural tolerance.

If earlier chapters indicate that multiculturalism and electronic technologies have led to a notion of a dangerously intimate world, "Cyberspace, Voodoo Sex, and Retroviral Identity" looks at the conjunction of these cultural trends. Cyberspace is rife with the following figures: the virus, sex, and "voodoo" spirit possession. William Gibson's cyberpunk novel, *Count Zero*, was an early fictional account of the conflation of African diasporic religion and computer science. In the book, characters are vulnerable to potentially mortal penetration by electronic information which simulates the possession techniques of the Haitian *lwa*. Similarly, in an infamous *Village Voice* article a few years ago, Julian Dibbell reported one danger of electronic socializing: the possibility of the voodoo-like manipulation of one's on-screen persona, which could even lead to "rape"—particularly of "women," regardless of their cyber-gender. I push this question through a reading of Neal Stephenson's *Snow Crash*, another cyberpunk fiction, in which caracters literally risk HIV infection through sexual contact; but the virus also serves as the model for a bigger problem: the infection of the natural with the technological, the male with the female, and the European with the African and Asian. After Donna Haraway and others' early enthusiasm for the liberatory aspects of cyberculture, the novel seems to concur, while adding the warning that cyborgs, however liberated, are susceptible to AIDS. And yet the retroviral model of deconstructed identity may, ironically, be what protects us all from the virulence of racism, sexism, and homophobia. This is a similar argument to that of Octavia Butler, an African American science fiction writer whose novels struggle to *embody* hybridity, through the unsafest (and yet saving) of sexual exchanges.

While *Snow Crash* celebrates deconstructed identity, it also suggests that it can be exploited in dangerous ways—particularly through the processes

of global marketing. "Benetton: BLOOD IS BIG BUSINESS" examines a real-world case. Much has been made of the Benetton Corporation's place as the exemplary post-fordist clothing manufacturer. This chapter focuses on the other "exemplary" aspect of Benetton, which is the company's advertising campaign. A 1994 issue of the Benetton magazine, *Colors*, was devoted to the topic of AIDS. AIDS, in fact, is used here to exploit the notion of deconstructed identity as fashion statement. Benetton's campaign has rested on the appearance of social responsibility, and on the invocation of the image of multiculturalism, multiracialism, and, in effect, of difference. But it relies on the fixity of difference in order to maintain its appeal: difference, like AIDS, is safe when contained by the brand name.

Fashion is re-appropriated, however, by self-fashioning. "Penetrable Selves ('Paris Is Burning')" considers Jennie Livingston's much discussed film documentary of Harlem gay balls in a different light. Commentary on the film has focused on drag as the exemplary site of the construction of gender. But the balls are also the site of another ambivalent mimicry—that of racial identity. I consider the film in the context of African diasporic community-defining practices to which the "houses" of the balls bear a remarkable similarity. Houses of religious worship in the diaspora are home to sons and daughters who redefine themselves according to their spiritual, aesthetic, and political beliefs. They also often cross genders. Champions of a politics of constructed identity may be loathe to compare drag to spirit possession by a divine principle—which might appear an even more essentialist notion than "real" gender. But the chapter draws on other ethnographic film representations to argue that syncretic African religion is hardly essentialist. The chapter ends with a meditation on the significance of Livingston's film's discretion on the topics of AIDS and police violence.

Finally, "The Closed Body" returns to a figure that has preoccupied me elsewhere: "of bodies open (wounded, sexualized, politically or psychically vulnerable) and closed (protected by enclosure in the community)."[27] To "close the body" in the African religious houses of Brazil is to be initiated in a process which includes scarification. The body is literally opened, cut, in order that it may be figurally healed into the house. (Such ritual incisions and the risks of viral transmission through them are being taken up by AIDS education projects within these communities.) I also return in this chapter to the figure of Babaluaiyé, this time almost unrecognizably transformed into a bouncing blonde sex kitten on a recent Brazilian telenovela.

"Babalú," as she's called, becomes a national obsession, not only on account of her embodiment of U.S. feminine sexual ideals, but also because of her peculiar raunchy slang. She speaks—and popularizes—the slang of Brazilian transvestites, which also just happens to be the lingua franca of African religious communities there: Yoruba. These apparently disjunctive elements—blonde hair, tits and ass, Yoruba, spirit possession, scarification—and police violence converge in the alleyways of Pelourinho, where transvestite sex workers try to create a family, and stay alive.

This book begins—and ends—in Pelourinho, because I know this scene so well. I've walked through this square hundreds of times—partied there, danced, sweated, kissed, came to understand the subtle and not so subtle complications of intimacy across national, racial, ethnic, and class lines, tried desperately to get beyond them, thought I would die of love, took "risks," watched my beloved dying, took tests, answered demographic questionnaires, tried desperately to make sense of this, finally saw a male god *dance* the sense of it through a woman's body, and understood my own intensely intimate connection to the African principle which animated that dance. May it animate this.[28]

Babaluaiyé

Diaspora As Pandemic

As I have already said, the statistics—figures—regarding HIV infection are fraught with complications, not merely because they are changing so rapidly, but because they have an uncanny way of slipping into figuration. This means two things: on the one hand, these numbers seem to lift off the page and signify to us something other than literal, living, dying men and women. On the other hand, they are often read *too* literally—as representing the "reality" of a situation that is in fact much more complex, and implicates many more people. But here they are—the figures provided us by the WHO and the CDC: in 1995, all twenty of the countries worldwide with provisional HIV infection rates topping 3% of the population were in Africa and the Caribbean.[1] Currently in the United States, more than 50% of reported AIDS cases are among blacks and hispanics. Among women, it is more than 75%.[2] Here in New York City, 67% of men, 87% of women and 92% of children diagnosed with AIDS through March, 1997

are or were black or hispanic. Fifty thousand and thirty-one black or hispanic men, 17,327 black or hispanic women, 1,634 black or hispanic children—in this city alone.[3] These are AIDS cases, not numbers of HIV-positives. These numbers, of course, are much, much higher, and by all estimates even more racially disproportionate. Whatever one's position on the reliability of these numbers, it is difficult not to acknowledge two things: too many people are dying; many too many people are dying in the diaspora.

THE EPIDEMIC AND THE MISSING TEXT

So Jes Grew is seeking its words.
Its text. For what good is a liturgy
without a text?[4]

Figures textualize the pandemic in a way that freezes its significance. In truth, it can't be fixed, as it is in constant motion. While of course literary expressions constitute an important part of African diasporic cultural expression, a principle thematic of this body of writing is the tension between textual fixity and more mobile, mutable forms, such as oral narrative, music, and dance.[5] The difficulties of inscribing diasporic performance practices and the pandemic are similar, and perhaps related. What follows is not actually a reading of a text about AIDS. In fact, it is a reading, one might say, of an absence of a text. But I want to begin in a literal text that seems to me all the more present, and meaningful, if this reading can recontextualize it in the midst of the AIDS crisis. Ishmael Reed's *Mumbo Jumbo* was published in 1972, several years before a Human Immunodeficiency Virus was identified or even hypothesized.[6] My desire here is not to read *Mumbo Jumbo* as a parodic prophecy of the AIDS pandemic, but rather as a possible clue to the absence of a text I mentioned above.

Mumbo Jumbo is not an easy book to summarize. Its plot resists reduction, as it itself subverts the idea of a time-line, either historical or narrative. The novel recounts an outbreak in the 1920s of an epidemic called Jes Grew. The origin of the epidemic is not exactly given, but its spread is particularly virulent in an area of profound Haitian cultural influence: New Orleans. Epidemiologists trace its course and suggest it will "settle" in New York, and then progress to a pandemic. *Mumbo Jumbo* does not give an explicit explanation of the significance, past, or, as I said, origin of the

epidemic, but it suggests that a text does, or did, exist which contained these secrets. Various groups attempt to secure the ancient text of Jes Grew, but finally it is destroyed by Abdul Sufi Hamid, who was translating it into the language of "the Brother on the Street" until he determined that "black people could never have been involved in such a lewd, nasty, decadent thing as is depicted" in the book.[7]

The text is destroyed and so a number of questions go unanswered. In a sense, *Mumbo Jumbo* is a mystery novel without a conclusion. Henry Louis Gates, Jr. has described the novel as having two "basic mysteries. . . [that] remain unsolved."[8] These are the mysteries of the epidemic itself, and of the absence of its text. What is Jes Grew? Not AIDS: "Actually, Jes Grew was an anti-plague. Some plagues caused the body to waste away; Jes Grew enlivened the host."[9] The epidemic of *Mumbo Jumbo* is an inversion of the notion of disease. It breeds life, and animates those that it attacks. A simplified reading might say that Jes Grew represents African diasporic culture.[10] It bears some resemblance in particular to animist or "possessional" diasporic religious practices. It is gorgeous and pleasurable and it is not life-threatening.

There is another sense in which Jes Grew clearly opposes itself to AIDS, which is its age. While *Mumbo Jumbo* seems to depict an "outbreak" at a certain historical moment, there is every indication that Jes Grew is a traditional, in fact ancient, condition. While certain hypotheses exist surrounding the historical existence of HIV, none of them seem particularly convincing. AIDS is considered to be an essentially new phenomenon.[11]

The place of tradition, and specifically diasporic cultural tradition, in *Mumbo Jumbo* is extremely complex. Reed seems to be ironizing a notion of a-textual, non-literate African cultural tradition by suggesting that it has always been textual, and yet that the text of the tradition has been suppressed, and ultimately destroyed. African diasporic textuality however might be recuperated by the book itself. Reed's insistence on demonstrating to the reader his or her own insufficiencies in reading the diasporic text—*Mumbo Jumbo*—is perhaps part of the point. But rigorous study of the novel does bear fruit. The reader who looks at the book in the context of the cultures it represents may actually make a step toward solving its mysteries.

In a more restricted sense, *Mumbo Jumbo* critiques another tradition, the specifically African American literary tradition. Gates has argued convincingly that the book creates a postmodern discourse ironizing the

African American textual modes of the preceding decades. But again, I find the question of irony here a delicate one. It strikes me that there may in fact be an unironized, quite serious cry for diasporic textual identification, for a coalition of writers of color addressing the specific experiences of their communities in crisis. I don't want so much to attribute the plaintiveness of that cry to Reed in 1972. Rather, it seems to be a voice I hear emerging from *Mumbo Jumbo* as I read it today, in the midst of a literal pandemic.

I should note a final difference between Jes Grew and AIDS, in relation to notions of textuality I have just discussed. Jes Grew, we are told, would be spread through its own inscription. It would be too simple to suggest here a direct inversion of the theory, to say that establishing a literal text of AIDS in the African diasporic community would halt its spread. Certain silences are themselves meaningful, and need to be read.

If I have been marking the differences between Jes Grew and AIDS, I should pause to mention their similarities. I said it was a simplification to call Jes Grew the diasporic cultural tradition. The meaning of Jes Grew must remain somewhat suspended, since the only explanation of it is an absence in the book. Our understanding of HIV is similarly confounded. The logic of the retrovirus seems strangely backwards. It marks its presence, symptomatically, through the effects of the absence it causes, i.e., through the diminution of T-4 fighter cells. Although it is possible to culture the virus itself, our primary mode of identifying its presence in human beings continues to be through the antibodies produced in a futile effort to eradicate it. That is, we read it through its negative image.

Another similarity is the sense of uncontrollability of the two epidemics. In *Mumbo Jumbo*, the lack of control over Jes Grew is underscored by an apparent lack of narrative control. The book slops out of its own boundaries, spills into alternative genres; the very title warns us of impending confusion. "Mumbo jumbo" means, in North American usage, impenetrable language—meaningless. Specifically, it relates to a perception of the impenetrability of African diasporic cultural difference, although one might want to rephrase that as a racist disinclination to attempt to understand that difference. Reed gives the *American Heritage* etymology within the text:

Mandingo *ma-ma-gyo-mbo*, "magician who makes the troubled spirits of ancestors go away": *ma-ma*, grandmother + *gyo*, trouble + *mbo*, to leave.[12]

The mambo, a related term, refers not only to an Afro-Latin musical style, but also to the high priestess in the African religious system of Haiti, Vodou. The mambo is hardly a figure of meaninglessness. In fact, she is an arbiter of meaning, a maker and interpreter of signs.[13] The logic exerted by the mambo is not causal, not linear, but operates on a figural level. This is why it is so ironic that she should be construed as lacking linguistic control. She is always reading for deeper meaning.

The interpretive structures within diasporic cultural systems have been consistently perceived by white cultures as unintelligible, spooky, even dangerous. Various animist religions in West Africa, Vodou in Haiti, Santería in Cuba, Candomblé in Brazil, and Hoodoo in the black United States[14] have been not only dismissed but persecuted by colonial powers. The reader who would recuperate their wisdom in trying to understand the meaning of AIDS in these communities must understand that interpretive systems cannot be extracted from their political histories.

BABALUAIYÉ: THE MEANING OF EPIDEMIA

You see, its not 1 of those germs that break bleed suck gnaw or devour. It's nothing we can bring into focus or categorize; once we call it 1 thing it forms into something else. No man. This is a psychic epidemic, not a lesser germ like typhoid yellow fever or syphilis. We can handle those. This belongs under some ancient Demonic Theory of Disease.[15]

Mumbo Jumbo incorporates figures from the constellation of belief systems mentioned above, which might be loosely termed Yoruba-Dahomean-derived religions.[16] The deities vary in certain respects from one diasporic site to another, and in all have undergone some syncretism with Catholic or Christian belief. But whether called the *lwa* of Haiti or the *orishás* of Cuba, they are fundamentally principles of nature. These principles exist whether you worship them or not: Yemoja (salt waters, productivity, maternity, generosity); Ṣango (thunder, divine justice, reason); Oṣoosi (verdure, the hunt, dexterity); Oya (wind storms, menstruation, female strength). These are some of the most revered gods, here called by their Yoruba names. But there is a deity who gets less press, one who is not in fact named in *Mumbo Jumbo* but who might be the clue to its mysteries: Babaluaiyé.

Babaluaiyé is the Yoruba god of epidemics. Reed is not alone in not articulating his name. Pronouncing the god's name is extremely dangerous.

Babaluaiyé, in fact, is not his "true" name, but rather a praise name (Father, Lord of the World) meant to appease him. His first name, Sopona, meant smallpox. But it would be a misreading to suggest that the avoidance of his name is based on a naive belief that saying the word provokes the thing. The logic of Yoruba-Dahomean belief is not, as I said before, simplistically causal. It does, however, acknowledge the power of signs, and specifically of language.

Words are dangerous. And this is painfully clear in the present epidemic. To articulate one's HIV status is a profoundly dangerous thing, which may result in loss of medical coverage, housing, employment, and acceptance in one's community. Articulating the prevalence of HIV infection in a given community can result in widespread social discrimination of that group. This is an obvious point to all members of so-called risk groups, regardless of their individual HIV status.[17]

What does it mean to worship a god of epidemics? These principles exist whether you worship them or not. Worship is an acknowledgment of power, and of meaning. The colonial authorities in Nigeria completely misunderstood: in 1917, they legally banned the worship of Babaluaiyé, charging that his devotees were attempting to spread smallpox by pricking victims and exposing them to infected bodily fluids. The charge was unfounded, but subsequent to the ban, Babaluaiyé's worshippers were understandably disinclined to speak of their real practices.[18] William Bascom suggests that the Yoruba can exhort the god to provoke disease by a figural act (involving naming an enemy while presenting an offensive article on Babaluaiyé's altar). But,

> [t]hey regard this practice as evil, however, and contrary to the very
> purposes of their cult, which are to prevent the spread of smallpox
> and to aid in the recovery of those who are suffering from it.[19]

I would add just one more clause to this description of the purposes of worshipping the god of epidemics: to try to understand the significance of the spread of disease in the community. Babaluaiyé is powerful, but not because he is an evil spirit, nor a divine executioner. He is the principle by which we understand what is healthy and what is diseased not only in an individual, but in a society.

My insistence that an epidemic can be read as meaningful is clearly a

complicated position. Susan Sontag has urged us not to over-read illness.[20] A reading of AIDS might seem abhorrent, particularly the literal-minded kind of reading which would see the physical illness as causally related to a moral or sexual "illness." That is the kind of literal-minded reading offered by colonial authorities who saw Babaluaiyé as both evil spirit and divine executioner. But if we bring Babaluaiyé's principle back into political and historical perspective, we might be able to find a deeper meaning.

Disease might be read as a literalizing or making manifest of the social atrocities practiced against those afflicted—in the case of AIDS here, gays, the urban poor, women of color, and pandemically, the African diaspora. Rather than as a punishment, I am suggesting, we might read AIDS as the superficial lesion, the sore on global society that evidences deeper sicknesses. In the United States, it makes manifest that we do not concentrate our medical energies on the marginalized, that the realities of urban poverty lead to substance abuse, that people of color in particular are denied adequate health care, education, and access to barrier-method birth control. In the world, it manifests patterns of economic exploitation. Babaluaiyé is not the arbiter of these violences. He merely makes evident, readable, the violences that are unarticulated in a society. If I call this line of thinking a form of worship of him, it is a manner of expressing a commitment to understanding the sense of a disease, both at home and in the world. And the desire is that understanding might literally help to relieve illness and prevent its spread.

HAITI: THE SITE OF AN OUTBREAK OF SIGNIFICANCE

. . . Holy Wars have been launched against Haiti under the cover of "bringing stability to the Caribbean." 1 such war lasted longer than Vietnam. But you don't hear much about it because it was against niggers. From 1914 to 1934 Southern Marines "because they knew how to handle niggers" destroyed the government and ruined the economy in their attempt to kill Jes Grew's effluvia by fumigating its miasmatic source.[21]

Babaluaiyé resides in *Mumbo Jumbo* unnamed. But he is evoked throughout the book by the incorporation of other Yoruba-Dahomean divine figures. They are drawn from across the diaspora, but if a particular diasporic site can be located as a source for the novel's figures,

and their meanings, it is probably Haiti. Within all Yoruba-Dahomean-derived belief systems, divine principles are not merely represented, but make themselves present in the bodies of their worshippers.[22] But despite the literal presence of divinity in the body possessed, these religions redouble that presence in an extraordinarily elaborate system of representations, mirrorings between the human and the divine. The phenomenon of spirit possession has been misapprehended by white cultures for hundreds of years. In this country, gross misreading of its significance has resulted in especially horrific media representations of Haiti in particular as a land rampant with evil spirits and superstitions, both dangerous and naive. *Mumbo Jumbo* reappropriates Haiti and recomplicates its relation to representation. Haiti in the novel seems to be the terrain in which textuality is opened out from a causal logic to a figural logic. That, of course, is the logic of the book itself, although in both Haiti and in *Mumbo Jumbo* historical, political causality does not drop out. It is what gives the figures their deeper significance.

Political history is of course also what gives significance to the gruesome American representations of "voodoo." Haiti was the first independent black republic—in fact it was the only such republic for nearly a century. Its defeat of French colonial forces in 1804 was the culmination of the only successful slave revolt ever. It was an improbable war that lasted twelve years, pitting barely armed peasants against some of the most sophisticated military forces of Europe. This history of resistance has inscribed itself into the Haitian belief system.[23] Vodou's modification of Dahomean belief is the doubling of divine figures, such that each has not only a "cool" aspect, but also a hot, violent one. African divine principles were called upon in formulating a successful revolutionary strategy. The *lwa* were invoked constantly by revolutionary leaders (and they continue to play a role in political rhetoric—sometimes, unfortunately in an all too manipulative way). The violent doubling of the gods was an outcome of political oppression.[24] It acknowledges that belief can be used not only to unify and protect a community, but also to resist an oppressive one.

Haiti, in 1804, was a North American nightmare—and an embarrassment, as the Haitians also tended to invoke American revolutionary rhetoric in their struggle. But a black revolution was never what the United States had in mind. This country has, ever since, held a threatening posture toward Haiti, and from 1915 to 1934 maintained a military occupation. It

was during this occupation that the sensational literature on Haitian rites and "superstitions" began to appear, later spawning even more fantastic cinematic representations.

If the United States has failed to comprehend Haitian belief, Haiti has understood clearly the political consequences of racism and cultural imperialism. That understanding has become inscribed in the hot, resistant aspect of the *lwa*, known as the *Petwo* side. But Vodou also has a conciliatory, nurturing, cool side, *Rada*, which is invoked to bring health and cohesiveness to the community itself. If Vodou can accommodate political violence, how does it accommodate the ravaging of disease? Most practitioners of Vodou, in Haiti as well as the United States, do not discount Western explanations of disease. But Vodou accepts that not only germs or viruses cause illness.

In a fairly pulpy account of his investigations of the Haitian phenomenon of zombification, *The Serpent and the Rainbow*, Wade Davis does make some redeeming observations on the political context of certain Vodou beliefs, and on the complexity of the Haitian understanding of disease. Zombification is a psychomedical procedure involving death-like symptoms, live interment and disinterment—a trick called "the Human Seed" in *Mumbo Jumbo*. After doubting the authenticity of the practice, Wade Davis comes to concede: "A society can generate physical ailments and conditions that have meaning only in the minds of the people."[25] But that doesn't mean that zombification doesn't happen—it does. The social psyche can have physical effect, but the physical manifestation will only have meaning within that society. What I suggested above regarding the meaning of AIDS in this country, as well as in the world, is in a sense an inversion, or perhaps just a different articulation of the same formulation. Physical manifestations of social ills such as racism and cultural repression need to be read as meaningful. My reading of AIDS as manifesting racism, sexism, classism, and xeno- and homophobia is not just figural. It is given its significance by political causality. If a poor black adolescent woman does not have access to condoms or information regarding their use, she will likely risk infection.[26]

But the white medical establishment must recognize that it is not simply its place to educate other cultural communities. It also has much to learn. Davis's book began, ostensibly, as an ethnobotanical doctoral dissertation, funded by pharmaceutical interests. Western scientists have only begun to acknowledge the sophisticated herbologies of some traditional religions.[27]

Herbology constitutes only a part of Vodou's understanding of healing. Chemically active preparations vary in efficacy according to the social context in which they are applied. The Western medical establishment is increasingly accepting of this fact, and has documented the profound effects of community and family emotional support on the T-cell counts of AIDS patients. In terms of research, as well, the AIDS crisis has put pressures on the medical profession to rethink its strategies. Clinical testing of medical treatments resembles, more and more, the process that Lévi-Strauss called "la pensée sauvage," "primitive" science (Lévi-Strauss himself used the term ironically), haphazard, far-ranging *bricolage*, a willingness to try anything, until something works.[28]

The pharmaceutical speculators in Davis's book are cast in a dim light. Their motivations are evidently not to help the Haitian community cohere and heal its ills. Could Western science investigate Vodou's herbalism without corrupting its meaning? *Mumbo Jumbo* tells us that the Western healer is always a charlatan, a Faust:

> Can't you imagine this man traveling about with his bad herbs, love philters, physicks and potions, charms, overcharging the peasants but dazzling them with his badly constructed Greek and sometimes labeling his "wonder cures" with gibberish titles like "Polyunsaturated 99^1/$_2$% pure."[29]

Faust's magic is deceptive, individualistic, power-hungry. Vodou calls the ill-meaning sorceror a *bòkò*—a figure which stands in opposition to the priest who seeks to heal his people through his knowledge, the *oungan*. "Western man," Reed writes, "doesn't know the difference between a houngan and a bokor."[30]

It is a *bòkò* who would overcharge the peasants for bad herbs. AZT when it first became available cost $8,000 a year, an unconscionable amount for the uninsured. For years it was considered the best treatment available, and it continues to be part of the new therapies, which combine it with the recently developed protease inhibitors. These, too, are extremely expensive. New "cocktail" drug regimens can run upwards of $20,000 a year. AZT's devastating effects are well known: it destroys bone marrow, sometimes further debilitating weakened immune systems. The more recently developed drugs are somewhat less toxic, but nearly all have some negative side-effects. But in fairness, even Vodou recognizes that all medicines are

poisons. Our badly constructed Greek should remind us that the phar-makon, in the Western tradition, as in Vodou, always meant three things: magic charm, medicine, and poison. All healing takes place on three levels, which is why placebos are used in clinical trials (the cipher of the pill is magical), and why our "best" available treatments are toxic.

All this is of course not to suggest that Western medicine cannot be used toward socially responsible, humane ends. And Haitian herbalism is by no means without its hurtful potential. Zombification is a medical and magical procedure performed on socially unacceptable individuals, on the intractable imaginations. It renders them tractable—as do Western psychotropic medications, or "rehabilitating" therapies. A society's notion of its own health always involves violences against what it considers un-controllable or excessive.[31] On extremely unusual occasions, Haitians may figuratively kill, and resurrect, their undesirables. But there is nothing figur-ative about the AIDS deaths now occurring, except as we read them as a violence against the intractable imaginations of homosexuality, black and underclass politicization, and feminism. At first take, the reading may appear excessive. I am not trying to suggest an uncomplicated conspiracy theory. But reading AIDS as a political violence is a logical extension of the argument above: repressing an articulation of political causality is tanta-mount to repressing political conscientization.

I am not the first person to draw together zombification and AIDS deaths. But the Western press has made the connection in a causal, not figural sense. Believe it or not, the *Journal of the American Medical Association* published an article by Dr. William R. Greenfield entitled: "Night of the Living Dead II: Slow Virus Encephalopathies and AIDS: Do Necro-mantic Zombiists Transmit HTLV III/LAV During Voodooistic Rituals?"[32] Hypotheses regarding HIV transmission and certain African diasporic cultural practices, including scarification and circumcision, resurge peri-odically, but they seem consistently to be unfounded.[33] Such traditional practices are usually limited to rural communities, where rates of infection are much lower than in urban communities where transmission is attrib-uted to the familiar means: unprotected anal or vaginal sex, reuse of hypo-dermic needles, or transfusion from an infected blood supply.

"Voodooistic rituals" don't cause AIDS.[34] But some have wondered if invoking the religion might aid in educating the Haitian community about HIV transmission. A social worker in Belle Glade, Florida said:

Many of the Haitian immigrants I talk to are not only illiterate, but living in a situation where they are deprived of accurate information about a lot of things which affect their daily lives. In some ways this results in them having a very simple world view. I ask them what they know about AIDS, and if they relate sickness to evil spirits, I talk to them about AIDS as an extremely mean spirit that tries to trick them, to make them feel well, so that they go out and spread the evil spell among the people they love. And then I follow the voodoo principle by telling them that they can trick the spirit by practicing safer sex.[35]

The problem with this educational strategy is obvious. It is insufficient simply to appropriate the articulations of a culture without understanding its logic. This use of spiritual figures attributes an extremely naive, causal logic to the Haitians. I doubt very much that this misuse of "the voodoo principle" is very successful. Illiteracy and lack of information are problems. But so is the cultural illiteracy of the translator.

BACK TO AFRICA: FIGURES OF ORIGIN

. . . the essential Pan-Africanism is artists relating across continents their craft, drumbeats from the aeons, sounds that are still with us.[36]

Haitians figuratively link mortality to Africa by saying that when a member of the Vodou community dies, his or her spirit goes "back to Guinée." African Brazilians similarly speak of death as a passage "back to Luanda." Such statements are not merely poignant or nostalgic. They mark a political, historical affiliation which transcends the life of the individual.

The West has made quite another kind of figural link between death and Africa—a much more insidious one, which took its most famous articulation in Conrad's *Heart of Darkness*. Readers find varying degrees of irony in Conrad's use of the Congo as a field of psychic disease and deterioration. But more recently, Alex Shoumatoff published a less ambiguously racist account of what he calls *African Madness*. The title is an unironic turn on Reed's "mumbo jumbo." It refers to a general notion of the state of politics, culture, and health on the African continent. Is "African Madness" another name for Jes Grew? It is figured as infectious. In the introduction to the book, Shoumatoff explains that after years of traveling through the Central and South American tropics, he went to Zaire:

... and there, as a Belgian friend who has lived in Kinshasa for twenty years describes the process, I caught *la microbe*: Africa got into my blood. (This was before the AIDS virus was identified and spoiled his metaphor).[37]

AIDS may have spoiled the metaphor, but Shoumatoff is still happy to retain Africa as a figure—not as the site of political affiliation to which one returns, of course, but on the contrary as the very origin of death.

The final chapter of the book is an essay, first published in *Vanity Fair*, called "In Search of the Source of AIDS." Detective-style, Shoumatoff hops from one decimated town to another, on the track of the original carrier. He acknowledges that epidemiologists themselves are not convinced by the theory of an African origin of AIDS. Researchers feel the project of locating an origin of a virus is futile, and furthermore infinitely less important than predicting—and controlling—its future course. But Shoumatoff argues:

> To the Western man in the street, however, the question of the African origin of AIDS is important because he has been told that it's only a matter of time until the pattern of AIDS in the U.S. and Europe becomes "African."[38]

Current epidemiological trends don't surprise us particularly. The only segments of the U.S. population that are "becoming African" are those which share the African continent's problems of inadequate nutrition, health care, and HIV information and protection. These are the urban underclass communities, and they are disproportionately black and Latino.

Shoumatoff and other journalists have justified their search for an origin as epidemiologically important. But the marking of Africa as "source" seems far more loaded when Shoumatoff articulates the eerie, seemingly oblivious wish: "'Wouldn't it be marvelous if AIDS . . . just went away, mutated out of existence, *went back wherever it came from?*'"[39] And as Harlon Dalton has observed from within the African American community, when arguments of origins have arisen: "We understood in our bones that with origin comes blame. The singling out of Haitians as a so-called risk group confirmed our worst fears."[40] Dalton has written an extremely sensitive and powerful analysis of African Americans' understanding of the meaning of the epidemic. Despite the disproportionate toll being taken on this community by AIDS, blacks and Latinos are not forming the kind of

political alliance in the face of the crisis which has formed in the gay community. Dalton argues:

> [M]any African-Americans are reluctant to acknowledge our association with AIDS so long as the larger society seems bent on blaming us as a race for its origin and spread.[41]

Not acknowledging, or in Dalton's words "owning," AIDS is a self-silencing of people of color which may seem disempowering. But it is not naive. It is dangerous to speak the name of Babaluaiyé. It is dangerous to own AIDS, as an individual or as a community.

Dalton ends his essay with a hope that African Americans will work through their silence, and begin to speak for themselves on the problems they are encountering in the crisis. I too am hoping in earnest for the African diasporic text of the epidemic. The drama and poetry now proliferating from the politicized gay community includes diasporic voices.[42] But we continue searching for the text generated by a collective, politicized pan-African community, including women.[43] If the text is missing, the first question to ask is not necessarily "why wasn't it written?," but "if it has been written, will it be published, and will it be read?" Current conditions certainly do not make us think that available funding will be used to encourage literary or artistic productions from marginalized communities, particularly those dealing with AIDS. *Mumbo Jumbo*'s fictional publishers advertise: "NEGRO VIEWPOINT WANTED," but the "real" text of Jes Grew gets rejected. Before he destroyed the text, Abdul submitted it for publication, and received this response: "A Negro editor here said it lacked 'soul' and wasn't 'Nation' enough. He suggested you read Claude McKay's *If We Must Die* and perhaps pick up a few pointers."[44]

Reading means looking for meaning, and perhaps looking for texts. The African diasporic AIDS pandemic, both literally and figuratively, needs to be given voice by writers. But as we have seen, saying the word itself is dangerous. Babaluaiyé must be called by his praise names. That isn't superstition. It is a manner of recognizing the power of a meaningful reading of epidemia. As cultural critics, we bear the responsibility of recognizing that power, even in our reading of absent texts, bodily texts,[45] or texts that predate and seemingly prefigure the AIDS crisis. This is the recognition that may enable the text to come into being. Harlon Dalton writes:

> The black community's impulse to distance itself from the epidemic is less a response to AIDS, the medical phenomenon, than a reaction to the myriad social issues that surround the disease and *give it its meaning*.[46]

When white society begins to understand the diaspora's difficulties in its own terms, perhaps a genuine exchange of information will be possible.

Reed concludes *Mumbo Jumbo* with an image of the "neoned Manhattan skyline. Skyscrapers gleam like magic trees."[47] The United States has attempted to imagine Africa and Haiti as the distant bush, a sequestered world where uncontrollable imagination rules. But I am writing these words from the urban bush, a terrain overgrown with political significance. Ninety-six thousand three hundred and sixty-five people diagnosed in this city already—and thousands more in the years ahead, the vast majority of them people of color. Babaluaiyé: make some sense of this.

Compact World

We were children—compact little people—when we sang along enthusiastically to a song which predated and predicted what we now call multiculturalism:

> It's a world of laughter, a world of tears
> It's a world of hope and a world of fears
> There's so much that we share
> That it's time we're aware
> It's a small, small world

Disney's "It's a Small World" was composed for an exhibit in the 1964 New York World's Fair, and was sponsored by the Pepsi-Cola Company, which recognized an expansive market when it saw one. "It's a Small World," of course, wasn't an anthem to global tolerance so much as it was an anthem

to the global marketing of U.S. goods—*and* U.S. foreign and economic policy. It was the domestic version of a global Disney vision with a history of a quarter of a century. Disney was sent by Nelson Rockefeller to Latin America as a Goodwill Ambassador in 1941, as part of the "Good Neighbor" policy. Neighborliness, however, turned out to be little more than caricature. As Ariel Dorfman and Armand Mattelart have argued, Mickey Mouse and Donald Duck's rolicksome adventures in "Kookoo Coco," "Inca-Blinca," and "Outer Congolia" dehistoricized the true role of the United States in the political manipulation and economic exploitation of tropical nations.[1]

In fact, today, Disney finds itself embroiled in controversy surrounding its own economically exploitative practices south of the border. As the company continues to break ground in "multicultural" market expansion, it has also attracted attention for its international labor abuses. In 1996, the director of the National Labor Committee, Charles Kernaghan, documented dangerous, oppressive conditions at a Disney manufacturing plant in Haiti. "Prior to leaving for Haiti," he later wrote to Disney CEO Michael Eisner:

> I went to a Wal-Mart store on Long Island and purchased several Disney garments which had been made in Haiti. I showed these to the crowd of workers, who immediately recognized the clothing they had made. Everyone pointed to the parts of the shirt that they had sewed while explaining what the quota was for those operations. I asked the . . . workers if they had any idea what these shirts—the ones they had made—sell for in the U.S. I held up a size 4 Pocahontas t-shirt. I showed them the Wal-Mart price tag indicating $10.97. But it was only when I translated the $10.97 into the local currency . . . that, all at once, in unison, the workers screamed with shock, disbelief, anger and a mixture of pain and sadness, as their eyes remained fixed on the Pocahontas shirt. People kept yelling, excited. They simply could not believe what they had heard. In a single day, they worked on hundreds of Disney shirts. Yet the sales price of just one shirt in the U.S. amounted to nearly 5 days of their wages![2]

If Pocahontas represented the multicultural face of global capitalism, Haitian workers had a hard time recognizing themselves in her image—even if they could recognize the seams they had stitched which held her together.

The question is: If not "All the Colors of the Rainbow," and certainly if not Disney's version of "It's a Small World," what *is* the song which might express the current global cultural exchanges taking place? Is it the equally unforgettable—and perhaps equally insidious—"We Are the World"? Or might it be, as George Lipsitz has suggested, a song with more specific, local significances, both cultural and political, in Haiti where it was composed and recorded? Lipsitz's recent *Dangerous Crossroads: Popular Music, Postmodernism and the Poetics of Place* takes its title from "Kalfou Danjere," a 1992 single by the politicized Haitian band Boukman Eksperyans. "Kalfou Danjere"

> drew upon the ideology and terminology of popular "voudou" reli-
> gion to rebuke the corruption and brutality of the military dictator-
> ship. Blending infectious indigenous voudou and rara rhythms with
> imported funk-rock and dance music, the musicians in Boukman
> Eksperyans used their time in the studio to produce an album that
> served as a vehicle for education and agitation among the Haitian
> people.[3]

While Lipsitz here reserves the metaphor of infection for the "indigenous" element of Boukman Eksperyans' music, the larger point of his analysis is to demonstrate that the "dangerous crossroads" are the site of multiple confluences. In Vodou belief, the crossroads are the domain of Legba—known elsewhere in the diaspora as Eṣu, Eṣu-Elegbara, Exú, Echu-Elegua, Papa LaBas.[4] Legba is part of the Yoruba-Dahomean pantheon which I discussed in the preceding chapter, and he figures prominently in Reed's novel. He is the principle of communication (this is why he is found at intersections)—the mercurial dispatcher and receptor of messages—and it is this function which also makes him the principle of confusion. Any communication is potentially a miscommunication.

Lipsitz marks "Kalfou Danjere" as both a place of danger and of possibility. Boukman Eksperyans is the most commercially successful Haitian band in the global market, even as their lyrics often express a political position in conflict with the market system which carries them to their ever-widening audience. Musically, the band stands at the crossroads of various influences, from the sacred drum patterns of Vodou to South African dance grooves to, perhaps, Jimi Hendrix, who seems to be invoked in the "Eksperyans" of their name. "Yet," Lipsitz argues,

internationalism is hardly new to Haiti . . . The same circuits of investment and commerce that bring low-wage jobs to Haiti's factories and fields carry the music of Boukman Eksperyans to a wider world audience. The same connections between U.S. multinationals and Haitian poverty that insures a perpetual presence on the island by the American security state also makes the visibility of Boukman Eksperyans in the U.S.A. a strategic resource for the group as they try to criticize their government and still stay alive.[5]

I will discuss the historical context of the U.S.-Haitian intimacy in detail in chapter 5. But Lipsitz's point is broader than the local significance of "Kalfou Danjere." In fact, that significance can change as the music travels. In the U.S., racist and xenophobic policies implicating Haitians for the spread of HIV have led to the creation of political coalitions between Haitian immigrants and gay and lesbian activists here, giving potentially new meanings to politically resistant music.[6] As Lipsitz argues, Legba's crossroads can be read as the sign of all the dangers and possibilities of the phenomenon of music's diasporic spread, even if that music is seemingly contained and controlled by the hygienic label "World."

WHERE IN THE WORLD ARE YOU?

Theoretical articulations of the "postmodern" return, again and again, to the problem of mapping a transnational world. Appadurai demands a "polythetic, fractal cartography" of cultural flows,[7] while Fredric Jameson has suggested that artists themselves must take on the task of map-making.[8] Recording artists such as Boukman Eksperyans are painfully aware of many of the transnational pressures upon them, political, cultural, and economic. As their music travels, however, it accrues new significances. The map of the crossroads, that is, can't be fixed. And regardless of the signposts they may place in their music, there is no telling how listeners in the U.S. will place themselves in relation to them. At best, they will see themselves in Haiti ("Haiti is here / Haiti is not here"). At worst, they find themselves right at home in the "World."

World Music, of course, is the industry name for non-Western music distributed in the West. (Actually, this is a simplification, as certain "traditional" European musics are also included.) The marketing of this music is based on a notion of cosmopolitanism facilitated by new technologies:

digital audio tape, satellites, fiber optics, all of which are hailed as the components of the prophesied "global village."[9] Technology gives North Americans and Europeans access to global culture in their own homes, in their own home entertainment systems, whether these are multi-media computers with the most advanced of sound cards, or just regular stereos. It doesn't take a lot of critical perspicacity to note that the term World Music doesn't comprehend British or North American popular music, which might well lead one to ask, if your music isn't World Music, where in the world are you?

Being "at home" in the world, however, has particular resonances here in the U.S., as the mythos of national identity here has so much to do with ethnic diversity, even if it was formerly configured as an ethnic meltdown. The banal suggestion that "It's a Small World After All" was articulated, in part, in celebration of this country's professed constitutional cosmopolitanism. But as George Yúdice has argued in an essay aptly titled "We Are Not the World,"[10] there is a danger in "self-servedly celebrat[ing] 'American' multiculturalism as isomorphic with the world."[11] In fact, the United States has proven to be the most recalcitrant of Western nations in its resistance to the marketing of World Music—not on account of a particular concern about the political implications of cultural exploitation, but just because it's "different." Yúdice's essay also makes direct, if negating, reference to a song with particular importance in the global music market. "We Are the World," one of the premiere recordings for a global charity project, bears an important relation to the development of the World Music market.

The expressions "World Music" and "World Beat" emerged in the early 1980s, but of course musical exchanges across cultures have been going on much longer than this. Formerly, Western listeners of non-Western music had "ethnomusicological" interests. It's of interest to compare the liner notes from exemplary recordings of both genres. Angélique Kidjo's CD, *Ayé*, which was recorded in 1994 on the Mango label, situates you, precisely, with a map—of Africa. It's featureless, except for the "sliver"-like demarcation (as the notes put it) of Kidjo's nation, Benin. And beside the map, there is a Fon myth:

In the country of Fons, legend says that at life's beginning (Ayé) the snake Dan and his wife came down to earth to create the world. After 41 days of toil, the couple returned to the heavens tenderly entwined in the form of a rainbow (Aida Houedo). Ever since, anyone upon

whom Dan the snake wishes to bestow his favours is irresistibly drawn to the spot where the rainbow touches the ground. Here there is a deep cave filled with treasures, gold and precious stones. . . . [12]

After the myth, Kidjo thanks the "inspirations" of the recording: "Benin Traditional Singers, Annie Lennox, Neneh Cherry, Aretha Franklin, Peter Gabriel, James Brown, Youssou N'Dour, The Meters, Daniel Lanois and U2." This text is quite representative of World Music's framing. It demands that the artist situate herself as exotic, even as she nods toward Western pop, in evidence of the "sophistication" of contemporary African music.

The liner notes for Colin Turnbull's ethnomusicological album recorded in the 1970s, "Music of the Rainforest Pygmies," at first glance quite resemble those of Angélique Kidjo's. The listener is supplied with virtually the same map of Africa—although here there is somewhat more detail, and the highlighted area is not Benin, but the Ituri rainforest. Ethnomusicologists, as I discuss below, come to music with desires different from, though related to, those of a pop audience. But even in ethnomusicology, when listeners seem to be going to the absolute limit of cultural difference, to a community seemingly uncontaminated by Western "inspiration," they, like Colin Turnbull, get the rug pulled out from under them. As he writes:

> The single recording of the *Twa* pygmoids, from south of the *Ituri*, in the *Kivu* mountains, is a final example of acculturation at its most unexpected. With the help of a *Watussi* friend, I located some of the *Twa*, who long ago had common origins with the *Mbuti* of the *Ituri*. Their music, however was almost pure *Watussi*. After pleading for a *really* old song, one of the great religious songs of the past, an ancient lady finally agreed, but with hesitation, saying it was so old and highly sacred. The surprising result is on Band 6 of the A side. [13]

The track is subtitled "Batwa pygmoids," but Turnbull titles it by the name we too would have to give it. Because the tune the "ancient lady" produced was one we know by heart: "Oh my darling, oh my darling, oh my darling Clementine."

Of course Western music spread concomitantly with colonialism. In more recent history, Western popular music has been heard on radios across the globe for decades. Ironically, it was the development of rock and roll, a musical style associated from its inception with political trouble-

making, which accelerated the global spread of U.S. and British popular music. The 1950s and 1960s represented the musical inundation of the rest of the world with Western pop in English. Many would argue, however, that there was a deep irony in the popularization of rock artists such as Elvis Presley, who patently borrowed an African diasporic style without acknowledging it, on the African continent.

Here in the United States, the recording industry continued to grow throughout the 1970s, until the pop music market hit its first recession in 1979, causing a new urgency to discover untapped markets. As Reebee Garofalo has succinctly described the situation, "the systematic exploitation of the world market *as a condition of further growth* did not become dominant until the 1980s."[14] This exploitation included both the marketing of Third World artists in their own countries and in Europe and North America. But it is reductive to account for this move as simply economic. While the artistic development of the World Music industry was controlled by the United States and Great Britain, most of the recording companies involved were owned by larger multinational corporations based outside of these countries (in Japan, Holland and Germany). As Garofalo points out, "the economic foundation of the cultural imperialism thesis is thus questionable."[15]

Migration and decolonization in the 1960s had already created spaces for musical conversation on a global scale. African and Caribbean migration to Paris and London and Spanish Caribbean migration to New York City inaugurated a "cycle of musical exchange."[16] As little indigenous popular music had been recorded for diffusion in Africa, the broadcasting of African diasporic musics—in particular Afro-Cuban rhumba—became an important, politically coalizing act.[17] Years before the first World Music compilation, Third World countries had been communicating with each other, politically, through musical forms. But the interest on the part of U.S. and British labels of exploiting this market meant that the conversation was expanding—and speeding up.

Jocelyne Guilbault has argued that the recent developments in the recording industry, both the expansion of the global market and global styles, and the multinational conglomeration of recording companies themselves, mean that the industry

can no longer be conceived of in terms of the center/periphery theory, based on the principle of bilateral market. World musics are

an ideal illustration of how they are connected to polylateral markets. From another perspective . . . the musicians of world musics also show that they are cosmopolitans who function in and out, at will, of what has been traditionally perceived as the totalizing "system."[18]

But the breaking of that membrane between center and periphery has provoked the hygienic measure of the World Music label, which "openly encapsulates a very wide range of new musics and, by so doing, succeeds more easily in controlling a market that had so far remained untapped."[19] It also succeeds in recreating the appearance of a center and periphery.

CONTAINING THE "VIRAL STAGE" OF VALUE

If CDs circulate around the globe with this degree of fluidity, how is it that the music industry creates what I have depicted as an artificial membrane of distinction between Western and non-Western musical cultures? Veit Erlmann picks up precisely on the anxiety I am describing, citing Baudrillard on the contemporary "viral stage" of value, in which the West confronts the seeming arbitrariness of its own cultural formation drawn from "pure contiguity, from the cancerous proliferation of values without any reference point at all."[20] Erlmann suggests that while World Music simultaneously celebrates the notion of a global culture *and* the notion of local specificity ("often translatable into another powerful conceptual pair—modernity and tradition"[21]), it *stages* the Western nostalgia for a coherent ("traditional") worldview and set of values at so-called "mega-events"—festivals and charity concerts:

> "World music" festivals . . . like charity rock and mega-events . . . celebrate difference and the interface between different social realms, and sometimes . . . the technology that enables this global communication. But beyond this, the celebration of difference in such festivals, mediated by technology as it is, also conceals as it rests on a more fundamental "sameness."[22]

There is nothing new about Europeans and North Americans turning toward "traditional" cultures as a "cure" for Western cultural ills. But when the consumption of non-Western music was limited to ethnomusicologists, the presupposition was of absolute cultural difference, even if record-

ings such as Turnbull's disproved this. African cultural historians John Collins and Paul Richards note that ethnographers' repeated assertions, until World Music blew the lid off the thesis, that "authentic, traditional" music in Africa was superior to those popular forms inflected by Western styles, were based on the assumption

> that change is an unusual, even improper, process within African music. It would be easy to argue a crude functional link between this kind of scholarly work and the needs and requirements of European colonialism in Africa. . . . But in all probability the reasons are more complex, and to do with a move within European culture to construct the "primitive" and "traditional" as antidotes to the less desirable aspects of industrial progress.[23]

The World Music events, however, give lie to the absolutist distinctions between European and African cultures, even as they recreate them.

Perhaps the only surprise element in this configuration is the relationship between the staging of World Music events, and global music charity events. As Reebee Garofalo argues, "It is, I think, more than a coincidence that the emergence of world beat paralleled the development of charity rock."[24] The charity events helped British and U.S. artists pitch their music to developing markets in the Third World, even as they gave African and diasporic artists greater exposure here and in Europe. Further, as Erlmann suggests, both kinds of events stage simultaneous "sameness" and "difference." This is the membrane: it's *safe* difference.

THE "REAL WORLD"

The three Western recording artists most often associated with the development and diffusion of World Music are Paul Simon, David Byrne, and Peter Gabriel. I have already mentioned briefly Simon's complicated relation to the Afro-Brazilian musicians he featured on *Rhythm of the Saints*,[25] and his use of South African artists on his *Graceland* album was equally, if not more, fraught.[26] David Byrne has also been both lauded and scrutinized for his use of diasporic musical styles and artists in his own recordings and performances, as well as for his work as a producer and compiler of diasporic performers. But Gabriel is the figure who has done most to promote the notion of World Music. Gabriel is also the figure in

the global musical scene most wedded to *both* the ideals of global and local culture, and of technological advancement and tradition.

Gabriel is the founder of one of the premiere World Music labels: Real World. He is also the founder of the most significant long-running World Music festival, WOMAD (World of Music and Dance).[27] Both Real World and WOMAD were financial drains in the early 1980s, and were subsidized by Gabriel's own mainstream pop earnings. In the 1990s, however, Real World began to turn a profit, and WOMAD has had increasing market success, particularly in Europe.[28] But Gabriel has not only been a "pioneer," a boundary-pusher, in the business of global music. He also promotes himself as a pioneer in the brave new world of electronic media.

In 1994, Gabriel released a "ground-breaking" CD-ROM called *Xplora 1: Peter Gabriel's Secret World*, which sounds more like a spaceship than a disc. But if Peter Gabriel presents himself as a man of the world—founder, in fact, of the Real World—he presents his "secret world" as the most local and specific of terrains. *Xplora 1* says, in fact, that it will take you there, directly into Peter Gabriel's secret world, into his family photo album, into the English country garden of his youth where his mother tosses around a ball and English country birds tweet. Appadurai has written that, until the present period, the West configured the past as "a land to return to." But now we have access to a "synchronic warehouse of cultural scenarios, a kind of temporal central casting,"[29] and the surprising result is that Peter Gabriel's secret world contains not only an English past, but an African, Asian, and Oceanic present.

If the challenge we began with was mapping, how do you map this? The disc itself presents itself to you as the map of Gabriel's own face. What the mouth tells you is: "The way you're going to play this disc is by deciding which bit of me you want to know more about. . . . Welcome to my secret world."[30] This means that the different "areas" of the disc correspond to pressing concerns of Gabriel's, be they personal, entrepreneurial, political, or artistic. Non-Western music is, for Gabriel, both an "artistic" and a business concern, if these two categories can be separated. The politics of the West in the Third World is also a political concern for him. I don't mean to belittle what Gabriel has done to facilitate high-quality recording and distribution for the artists he's worked with. But the framing of these musical projects as part of Gabriel's extremely local "secret world" should make us at least vaguely uneasy.

The disc, like all CD-ROMs, is based on a notion of cross-referential

mapping. The most literal map on this disc gives you the contours of the WOMAD park grounds. But the face that you first encounter is the basic map, the one which locates all other more "local" maps. And the music of the "Real World" is mapped in Peter Gabriel's ear. This is a very compact world. When you click into the ear, there are several possibilities. The floating images of several instruments appear. If you click on the "nyatiti," you are given a more detailed representation, with the information that Ayub Ogada plays the 8-string nyatiti. In fact, you can too, with a click of the mouse on one of the strings. Who is Ayub Ogada, and where is he from? If you had come here from another place on the disc, you would have found out that he's an artist whose album, "En Mana Kuoyo," was produced and distributed on the Real World label. You would also have found out that Ogada is from Kenya, which would have given you an alternative map to Peter Gabriel's ear, another way of locating what the disc text tells you: that Luo legend says that the nyatiti is jealous. Granted, as Collins and Richards argue, ethnomusicological contextualization is often based on an essentializing notion of "traditional" cultures. But this extremely compressed gesture toward ethnological framing has quite the opposite effect; it makes the nyatiti—and Ayub Ogada—seem to float on the screen in anything but a "Real World"ly fashion.

By fixing the instrument in the realm of "legend" (alongside Kidjo's snake Dan and rainbow Aida Houedo), the text places the nyatiti, and Ogada, in temporal suspension. If the sins of ethnomusicologists who preceded the acknowledgement of "global" musical style were sins of dehistoricization, Gabriel's disc places Ogada and Luo musical culture simultaneously in the mythic past and in the cybernetic future. But the nyatiti *does* have a history. Ethnographer Cynthia Schmidt, supporting John Collins' own defense of "progressive indigenization," cites Werner Graebner's liner notes for an ethnomusicological recording called *Luo Roots*: "today's *nyatiti*, an 8-stringed lyre of antiquity among the Luo of Kenya, has borrowed some of the up-tempo quality/speed of guitar playing for *benga* (a Kenyan pop musical style)."[31] To really trace that history in detail would lead one from a popified nyatiti sound to Kenyan pop guitar, to U.S. pop rock styles, back through the diasporic influences which likely came from already hybridized Central and West African "traditional" instrumental styles.

A similar complexity is marked in Gabriel's disc in the area represented by the kalimba. All of the instruments in this region of the disc appear to be part of the "Real World" because they are depicted as coming from cul-

tures with limited access to Western technologies. And yet the text itself tells you that the metal used to make the kalimba comes from car seat springs.[32] As with the other instruments, you can "play" the kalimba with your mouse. But the disembodied experience of playing the "thumb piano" with a mouse can only make you feel like you're "all thumbs." What happens to the *body*—not only of Peter Gabriel and Ayub Ogada, but your own—in the "interactive" compact world? If you are only electronic, the sensation of bodilessness is intensified in your impossible contact with this "real world" instrument. The frustratingly safe encounter through the membrane of the computer marks these African cultures as physical even as it marks you as electronically disembodied.

The question of the body—the *place* of the body—in Peter Gabriel's secret world is probably most confusing in the dance workshop of WOMAD. The bits of video that find their way onto the CD-ROM often have a slightly choppy quality, which seems to mark the transfer of media. The dance workshop is one of the choppiest moments on the disc. This seems to compound the effect of Appadurian disjuncture, the bumpy ride of cultural exchange, which replaces the static of old ethnomusicological recordings before the age of DAT, and the bumpy ride of the safari jeep to get to the "real thing." But what really marks this moment as disjunctive is the disembodied dance instructor's quite sweet-humored but pointed remark. In a Caribbean accent, she reports that even those whose "real" bodies make their way to the "real" WOMAD non-Western dance workshop are not expected to "grasp very much."

CHARITABLE CONTAGIONS

If bodies seem superfluous, or at least awkwardly contained, by Gabriel's CD-ROM, one of the most interesting aspects of the disc is its pleas for the "witnessing" of politically motivated bodily injury throughout the world. Gabriel uses his "secret world" as an occasion to promote one of his pet charitable projects, Witness, a program for the distribution of video equipment to Third World countries for the documentation of human rights abuses. It seems appropriate that Peter Gabriel, champion of the liberatory possibilities of advanced mechanical reproductive technologies *and* Third World cultures, should promote global access to precisely the technology that has revolutionized the policing of the

police here. (Of course, human rights abuses need documentation in the First World as well; this was precisely the lesson of Rodney King.[33]) But what is astonishing about Gabriel's claims for the Witness project is that he tells you that having a technologically captured image of an event is fundamental evidence of its reality. Remember, this is Peter Gabriel of the "Real World"—the "inventor of experience," as he has titled himself[34]—the master of illusion. If he demonstrates *anything* on the CD-ROM, it's that media can distort, even invent "reality."

The capacity of video images to invent reality hardly escapes Third World television viewers. Youssou N'Dour, one of the best known World Music stars, recorded "Live Television" in 1992. The chorus, "Live! Live television, live! Live TV, live!," is in English, but the verse in Wolof:

Satellite, show me what's happening
Over there . . . over there . . . everywhere . . .
My television is lecturing to me
Showing me things I really want to see . . .
I get fabulous reception on all channels . . .

Then N'Dour sings in French:

My love, I swear I'll scrimp and save
Until I own my own satellite dish
So we can watch Senegalese TV, the BBC, MTV™ . . . yeah
So we can watch the BBC, CNN, MTV™
Oh, yeah, television, yeah, yeah . . .

Lest the irony be lost on listeners, on another cut, "Things Unspoken," he warns:

Be alert to what you see on television and at the movies . . .
Don't believe everything naively
Don't take everything at face value . . .
Pay attention to what is not said
Thank you
I'm going to read between the lines
Find meanings where the spaces are[35]

Clearly, the gaps between the images from "Dynasty," "Baywatch" or MTV™ videos[36] and the realities of the billions of people who bask in their glow across the globe need reading—as do the untold stories on CNN. This is the underside of Gabriel's claim that video technology allows for the representation of the truth.

Nonetheless, Gabriel's insistence that the global dispersal of media technology has greater liberatory potential than the mere global distribution of capital places him far ahead of the charitable impulses of most of the rest of the music industry. As I mentioned, the World Music phenomenon was concomitant with another feel-good trend in the music industry, the charitable pop mega-concert. The first of these was Live Aid, a collective concert of pop stars staged simultaneously on July 13, 1985 in London, Philadelphia, and Sydney, and broadcast around the world. Live Aid was a spectacle not only of pop stars, but of satellite technology. In this respect, it shared with WOMAD the apparent goal of "bringing people together," and eradicating borders. The profits, which far surpassed anyone's expectations ($67 million), were intended to feed starving Africans. In the wake of Live Aid, questions were raised as to the sensitivity of the organizers to the political conflict between Ethiopia and Eritrea, which had precipitated the famine in that region. To be fair, those involved did retrospectively acknowledge their own gaps in cultural and political familiarity with Africa.[37] Subsequent projects, which proliferated, have been handled with increasing care.[38] But they fundamentally rest on a notion of "charity," which reaffirms an us/them distinction even as it promotes itself as universal. The lyrics to "We Are the World," the hugely successful single recorded for the U.S.A. for Africa project, are indicative of the maneuver.

And lest we forget the Pepsi-Cola sponsorship of the earlier "It's a Small World," one careful listener has identified another connection. "We Are the World"

> . . . sounds like a Pepsi jingle—and the constant repetition of
> "There's a choice we're making" conflates with Pepsi's trademarked
> "The choice of a new generation" in a way that, on the part of Pepsi-
> contracted song writers Michael Jackson and Lionel Ritchie [also
> key figures in the "We Are the World" project], is certainly not inten-
> tional, and even more certainly beyond the realm of serendipity. In
> the realm of contextualization, "We Are the World" says less about
> Ethiopia than it does about Pepsi—and the true result will likely be

less that certain Ethiopian individuals will live, or anyway live a bit longer than they otherwise would have, than that Pepsi will get the catch phrase of its advertizing campaign sung for free by Ray Charles, Stevie Wonder, Bruce Springsteen, and all the rest.[39]

In the shake-down of the years following Live Aid, U.S.A. for Africa, Band Aid, and their subsequent mutations, advocates of the political potential of popular music have tended to sympathize with the impulses of such projects, and to suggest that ever-increasing sensitivity to political context will help politicized pop artists to contribute usefully to populations in distress.[40] But what is disturbing about such events is not simply their self-congratulatory quality, but their fundamental assumption that such populations are isolated in a "world" separate from "our" own. The effort to redistribute world resources isn't, of course, a bad thing, as long as it's done in a self-aware fashion, and as long as the gesture doesn't satisfy anyone as having eradicated the problem. In this sense, the very name "Band Aid" seems entirely felicitous, even if its implications weren't intended. And a band-aid is not a condom. Well, as I will argue further on, not even a condom is a *cultural* prophylactic. But pop charity's real danger, like World Music's, it seems to me, is its implication that Africa is in a different world from Western pop.

AID, AIDS, AND THE "WORLD"

One of the most significant AIDS charity projects in the music industry was the collective recording "Red, Hot and Blue," a tribute to Cole Porter whose songs were interpreted by various queer-friendly pop stars (including David Byrne, who set "Don't Fence Me In" to an Afro-Brazilian beat). The project was not only to raise money for AIDS organizations like the Gay Men's Health Crisis, but also, more subtly, to make a broad audience (not only the contemporary pop audience, but also presumably older and ostensibly more conservative fans of Cole Porter) aware of the queer presence in the history of American popular song—in the person of Cole Porter. The implication is that even as a "low-risk" listener might buy the "Red Hot and Blue" CD thinking he or she is making a charitable gesture to a distinct and separate demographic group, the disc itself belies that separation, demonstrating that queerness (the "risk" population) has always been right at the heart of Middle America's favorite songs.

World Music rarely, and only charily, touches on the subject of AIDS. I opened this book with Caetano Veloso and Gilberto Gil's incredibly intricate and yet understated reference to the pandemic in "Haiti." Other artists, such as Angélique Kidjo, make such subtle gestures toward it that they can easily be read as other allegories. Despite the deaths of several African recording artists (notably Nigeria's Fela, as well as two members of the popular Zimbabwean group "The Bhundhu Boys"), it is virtually impossible to find direct reference to AIDS in song lyrics in World Music recordings. The (then) Zairian pop star Franco recorded an album entitled "Attention Na Sida" (Be Careful With AIDS) for domestic release, but it was never picked up by a World label, despite the global popularity of his other albums. Franco died in 1987, not long after this album was released, after what was reported simply as "a long illness." Rumors circulated at the time, and continue to circulate, regarding the nature of his illness. He denied he had AIDS, and insisted that his drastic weight loss was due to a kidney ailment. The confirmation or denial of Franco's HIV infection is not in itself particularly significant. Certainly rumors about HIV circulate much more rapidly than the virus itself. Caetano Veloso, lettrist of "Haiti," was falsely "accused" of being a "carrier" of HIV several years ago by a conservative local politician whom he had offended. Veloso denied the rumor, without pointing out the obvious: that such manipulation of the figure of HIV was precisely the kind of skewing of a fear of underclass politicization which I have described in prior chapters. Political conscientization took on the name of AIDS. The viciousness of attempting to "accuse" someone of being infected with a devastating virus would seem to need little comment—and yet it *does* need comment, as it happens all too often, all over the world.

This is an unfortunate sameness that rings truer than the sameness of Youssou N'Dour's "The Same":

Sound is the same for all the world
Everybody has a heart
Everybody gets a feeling
"Let's play!" yeah, yeah
"Sound box!" yeah, yeah
Rock, reggae, jazz, mbalax
All around the world, the same
Pachanga, soul music, rhythm and blues, the same

La samba, la rumba, cha-cha-cha, the same
Sound is the same for all the world . . .
Mbaqanga, ziglibiti, high life music, the same
Merengue, funk, Chinese music, the same
Bossa nova, soul makossa, rap music the same
Come on people, dance[41]

That's not to say we shouldn't dance, of course. It's just to say we've all been doing a much more complicated dance than this for a long time.

THREE

Lutte contre les moustiques

The Question of Irony

Curled in the black hold of the ship he wonders
why his life on solid green earth had to end, why
the gods had chosen this new habitation for
him, floating, chained to other captives, no air,
no light, the wooden walls shuddering, battered,
as if some madman is determined to destroy
even this last pitiful refuge where he skids in
foul puddles of waste, bumping other bodies,
skinning himself on splintery beams and planks,
always moving, shaken and spilled like palm
nuts in the diviner's fist, and Esu casts his fate,
constant motion, tethered to an iron ring.

 In the darkness he can't see her, barely feels
her light touch on his fevered skin. Sweat thick
as oil but she doesn't mind, straddles him, settles
down to do her work. She enters him and draws
his blood up into her belly. When she's full, she
pauses, dreamy, heavy. He could kill her then;
she wouldn't care. But he doesn't. Listens to the
whine of her wings lifting till the whimper is lost
in the roar and crash of waves, creaking wood,
prisoners groaning. If she returns tomorrow and
carries away another drop of him, and the next
day and the next, a drop each day, enough days,
he'll be gone. Shrink to nothing, slip out of this
iron noose and disappear.

—John Edgar Wideman, "Fever"[1]

Wideman's stunning story, "Fever," is about an eighteenth-century epidemic of yellow fever in Philadelphia, carried through the "vector" of the *Aëdes aegypti* mosquito. Wideman recounts the epidemiological rumor circulating at the time, that the fever had come from Frenchmen fleeing the Haitian revolution with their infectious African slaves, as well as another seemingly contradictory yet useful rumor, that blacks were immune and so obliged to nurse the sick. Epidemia in the story provokes spreadings of other kinds: "Membranes that preserved the integrity of substances and shapes, kept each in its proper place, were worn thin. . . . What should be separated was running together."[2] This includes narrative voice and historical time. But a coherent epidemiological counter-narrative does emerge from the seemingly inchoate city of infection: "To explain the fever we need no boatloads of refugees, ragged and wracked with killing fevers, bringing death to our shores. . . . Each solitary heart contains all the world's

tribes, and its precarious dance echoes the drum's thunder. . . . Fever grows in the secret places of our hearts, planted there when one of us decided to sell one of us to another. The drum must pound ten thousand thousand years to drive that evil away."[3] The explosive sound that closes the story, however, is not the adamant drum pounding to make sense of centuries of enslavement of Africans forced to traverse the Atlantic, but the "hygienic" measure of the Philadelphia police some two centuries later. It is the 1985 firebombing of MOVE, of the cooperative home of politically "disruptive" African Americans, in which eleven people died, including six children.[4]

Wideman's figuring of the *Aëdes aegypti* mosquito as a woman penetrating a man sexually through a needle-like proboscis (it is, in fact, the female insect who draws blood) will become increasingly significant in subsequent chapters of this book. For my purposes here, I am less interested in how the *Aëdes aegypti* inverts the model of sexual penetration, than how it diverts political and epidemic crises (contemporary police violence against African Americans and AIDS) through another vector, and another disease.

Mosquitoes are not a vector of HIV, although very early in the epidemic medical researchers did consider the possibility. The transmission of HIV depends on much more seemingly controllable, *human* behaviors. The mosquito, then, for us, may appear to be *merely* a deflection of the sign of mortality, an allegorical representation drawn from a distant historical moment.[5] But for much of the world, the mosquito carries perfectly real mortal potential. Because as devastating as AIDS is in the Third World, there are other diseases which represent an even greater public health threat—malaria, in particular. While the West has shown a morbid fascination with other viruses, such as Ebola, which could theoretically have an "outbreak" here,[6] little attention is given to deadly and virulent diseases that represent little or no risk to First World populations.

In the face of this combination of morbid fascination and cynical disregard for non-Western life, it's not surprising that many Africans look back at the West with a mixture of suspicion and irony. The suspicion sometimes gets expressed, in fact, in completely unironic terms. Conspiracy theories of a Western-propagated genocidal campaign to wipe out African and diasporic populations are not really more far-flung than epidemiological finger-pointing at Haiti or Africa. Neither accusation, finally, is of help in keeping more people from getting sick or dying, and in fact, in this respect, both can be extremely counter-productive. But given the prominence of

the blame Africa thesis, despite its epidemiological lack of evidence, a counter-narrative *must* exist. Harlon Dalton has argued that even though use of the term "genocide" within the African *American* community has thus far stopped more productive conversations than started them, one has to concede to the historical examples which give credence to such a notion. He cites the famous Tuskegee Institute experiment in which African American men were intentionally left infected with syphilis, and uninformed of their condition, so that researchers could study its epidemiological patterns.[7] While the Tuskegee study has circulated as a cautionary tale in the African American community since it was uncovered, it has recently gained public attention with a formal apology to survivors and their families by President Clinton. But the acknowledgment of past medical manipulation has done little to reassure black Americans of the current medical establishment's good faith. The lesson of Tuskegee is cited by people of color with HIV and AIDS who refuse new medical treatments when they are made available to them. Not only has historically grounded suspicion fostered conspiracy theories regarding the origin of AIDS—it has made it difficult for many HIV-positive African Americans to accept "experimental" treatment options.[8]

Corresponding stories of medical exploitation and subsequent accusations of genocidal master-plans on the part of the West hold throughout Africa and other parts of the diaspora. The CIA in particular and the U.S. government more generally are repeatedly invoked as the pandemic's sites of origin. As Paula Treichler has argued, the "notion that AIDS is an American invention is a recurrent element of the international AIDS story, yet one not easily incorporated within a Western positivist frame, in part, perhaps, because it is political, with discursive roots in the resistance to colonialism."[9] This is precisely why the unironic counter-narrative of the epidemic's origin is, must be, dismissed—because it covers over a much more threatening spread than that of the virus: this is the spread of political conscientization.

AESTHETIC CONTAMINATION, IRONY, AND THE MUSEUM

In what follows, I am not going to pursue the unironic counter-accusations I mention here. Rather, I want to look at another, more subtle turning over of the figure of African contagion, as it plays itself

out in a seemingly less political, more aesthetic realm: the realm of African visual arts. The argument I have been mounting thus far is that the metaphor of African influence as cultural contagion was constructed in the West in an effort (largely unconscious) to contain or control diasporic flows, whether migrational or cultural. I now want to examine the way in which irony functions in the work of African artists who take that figure and invert it, such that Western influence becomes a contaminating pathogen in the African aesthetic. Imagistically, this turns up in representations of bodily fluids. Sexual transmission is one mode, but other fluids, including breast milk and blood, are also depicted. Other flows—precisely those outlined by Appadurai: of technology, media, and ideology—appear in these works. Some of the specific images I cite in this chapter, particularly video images and computers, will resonate with the preceding and following chapters. That is to say, precisely the kinds of technology Peter Gabriel has insisted need to be transmitted to the Third World are transmitted back to the West in these images, transformed.

The complex cultural products of the Third World demand that we acknowledge that a lack of access to First World technologies does not preclude a postmodern sensibility—if you understand that as an awareness that all of us are implicated in each other's cultures, for better or worse. If we cast the question of cultural influence multi-directionally, we can see that what Western technologies mean to Africans changes—irreversibly— what technology means here. And what African art means to North Americans changes what it means where it was made as well. The contemporary notions of a global village, truly universalized humanity linked by our latest technologies, or of multiculturalism, a celebration of a national culture's internal differences, might appear to get over cultural relativism's fundamental failing: its assumption that while we're all equally and differently human, only the West can understand this. But maybe we haven't come so far.

Before looking at some specific images, I want briefly to consider the contexts in which African art has been viewed in recent years in the West. The summer 1996 exhibit at the Guggenheim, "Africa: The Art of a Continent," was a massive endeavor spanning not only, as the title tells you, the entire land mass, but also vast temporal distances. The show, in a slightly different form, originated at the Royal Academy of Art in London, and the bulk of the curatorial selections were made by a British artist who was not, prior to organizing this exhibition, a specialist in African art. These are

"traditional" works, presented not as ethnological specimens, but as art. This may not seem so novel an approach. And yet the show's catalog includes reflections by Cornel West, Henry Louis Gates, Jr., and Kwame Anthony Appiah, all arguing for the necessity of an acknowledgment of the long history and aesthetic validity of African visual culture, even though, as Appiah observes, the artists themselves considered themselves neither "Africans" nor "artists."

Accompanying "Africa: The Art of a Continent" at the Guggenheim was a smaller show, "In/sight: African Photographers 1940 to the Present," organized by a small group of young African and diasporic intellectuals based in New York. "Insight" appears to have been intended as an antidote to the possible essentializing and dehistoricizing effects of "Africa." Many of the photographs included were portraits, which offered not so much "insight" as an inscrutable gaze turned back at museum-goers perhaps riding on a vision of a timeless, magical African past. The Guggenheim advertised "In/sight" as a show of works which "employ, critique, and exploit notions of photographic truth concerning African representation." But the suspended ironies of "In/sight" are significant not only as critique and exploitation of the "truth" of photography (and, implicitly, of all mechanical reproduction), but as a critique and exploitation of *any* aesthetic representation of Africanness—including the seemingly encyclopedic one of "Africa: The Art of a Continent."

If "Africa" contains the risks of essentialism and dehistoricization, if the Guggenheim even implicitly acknowledges these risks in its accompanying exhibit, then why was it deemed a necessary show? "Africa" needs to be contextualized among other recent exhibits of African art, both traditional and contemporary. The best known and most widely criticized exhibits in recent memory were William Rubin's 1984 "'Primitivism' in 20th Century Art" at the Museum of Modern Art, and the Centre Pompidou's 1989 "Magiciens de la Terre," both of which juxtaposed non-Western "traditional" works with European Modernist ones. "'Primitivism'," despite its scare quotes, was widely perceived as repeating the Modernists' appropriations. "Magiciens" attempted to undo the damage by juxtaposing cross-cultural works without a linear narrative of use, exploitation, and progress. And yet the lack of commentary couldn't erase long-standing assumptions within Western art institutions of the superiority or advancement of Western works, as well as the distorting which took place in the decontextualization of non-Western objects within the museum.

Also in 1989, Jeanne Cannizzo curated a highly controversial show at the Royal Ontario Museum called "Into the Heart of Africa." Linda Hutcheon places Cannizzo's show in the context of the emergence of a "new museology"[10]—a theoretical and practical effort to acknowledge the insidiousness of museum culture, in which any aesthetic, historical, or political disjuncture between exhibits is erased by the architectural unity of the space itself. (This charge was part of the critique of "'Primitivism'" and "Magiciens," and it could certainly have been made against "Africa: The Art of a Continent.") Historically, the museum has bracketed objects under a grand category of ownership, be it a personal collection or accumulated "national treasures." Consider the very name of the Royal Ontario Museum. Part of what gives the holdings of the museum meaning is that they *belong to* Ontario—not that they come from there. The claim of ownership is, of course, also a claim of containment and control. The new museology counters these claims, often, through ironies assumed to be patent.[11] But, interestingly, it was just such an effort in the Royal Ontario Museum show that provoked charges of racism and cultural imperialism from the African Canadian community.

The purported intention of the curator was to cast irony on the title of the show, "Into the Heart of Africa," a clear reference to Conrad's *Heart of Darkness* where Africa appears as a chaotic, savage landscape (the end of the world, place of ultimate *difference*) which is at the same time terrifyingly recognizable to the narrator. (This is, precisely, the Modern tension between universality and difference beyond which "global culture" has ostensibly moved.) How you read *Heart of Darkness*—whether you read Conrad as a racist or a humanist[12]—depends on which side of the coin you look. Another way of saying this is that it depends on what degree of *irony* you find in the title of the book. By the same token, one's reading of Jeanne Cannizzo's title would depend on a reading of irony.

How does irony get read? Hutcheon says that "irony and reflexivity have become almost hallmarks of the postmodern."[13] But locating irony—fixing it, establishing its degree—is no easier in the postmodern context than it was in the modern one. In fact, the new museology ostensibly recognizes the fact that all meaning is contextual. If Jeanne Cannizzo's museological approach had really heeded itself, it would have had to comprehend that the museum *as* a context is differently contextualized for Anglo- and African Canadians. The exhibit wanted to demonstrate Anglo-Canadians' inability to grasp African culture by collecting it:

The openly articulated intent was one familiar to postmodern anthropological theory: to focus on the imperial ideology of those who collected the objects (for which rich archival materials did exist), on how those objects came to enter this museum, and thus on the more general cultural assumptions of museums and of the disciplines of museology, anthropology, and history. In short, the focus was not to be on Africa itself.[14]

But African Canadians wanted to know: What about the real Africa? Soon picketers were protesting the show's repetition of stereotypical and denigrating language in relation to African culture. It wasn't a problem of inability to *see* irony. The protesters "argued that the subtleties of irony could not compete with the power of images of subjugation."[15]

The argument bears repetition, even as we acknowledge the importance of Kwame Anthony Appiah's earlier, seminal caution that we examine, all of us, our desire to locate an authentic African culture. He opens "The Postcolonial and the Postmodern," an essay on the desire for the "real" Africa, with another example of African art in a museum, this time, Susan Vogel's 1987 show at The Center for African Art in New York. The "cocurators" for the show included artists, critics, and collectors from the United States, Europe, and Africa, including James Baldwin, David Rockefeller, and Lela Kouakou, a village woodcarver from the Ivory Coast. Only Kouakou was deemed, by Vogel, unable to judge art outside of his cultural biases—an assumption which Appiah quite effectively blasts:

This Baule diviner, this authentically African villager, the message is, does not know what *we*, authentic postmodernists, now know: that the first and last mistake is to judge the Other on one's own terms. And so, in the name of this, the relativist insight, we impose our judgment that Lela Kouakou may not judge sculpture from beyond the Baule culture zone because he will—like all the other African "informants" we have met in the field—read them as if they were meant to meet those Baule standards. . . . [T]o suppose that [Kouakou] is unaware that there are other standards within Africa (let alone without) is to ignore a piece of absolutely basic cultural knowledge, common to most precolonial as to most colonial and postcolonial cultures on the continent—the piece of cultural knowledge that explains why the people we now call "Baule" exist at all. To be Baule,

for example, is, for a Baule, not to be a white person, not to be Senufo, not to be French. The ethnic groups—Lela Kouakou's Baule "tribe," for example—within which all African aesthetic life apparently occurs, are ... the products of colonial and postcolonial articulations. And someone who knows enough to make himself up as a Baule for the twentieth century surely knows that there are other kinds of art.[16]

Appiah goes on to examine a particular piece, "Yoruba Man with a Bicycle," a Nigerian woodcarving classified in the catalog as "neotraditional." Appiah gives us his understanding of the term:

What is distinctive about this genre is that it is produced for the West.... Most of this art, which is *traditional* because it uses actually or supposedly precolonial techniques, but is *neo* ... because it has elements that are recognizably from the colonial or postcolonial in reference, has been made for Western tourists and other collectors.[17]

Who buys such work is surely of interest to us, but I don't want to limit its significance to that. Neotraditional art points toward the very complexity of cultural exchange of which I have written. The "globality" and "transnationalism" of contemporary culture "does not by any means mean that it is the culture of every person in the world."[18] We don't all *own* world culture, neither in the literal sense that David Rockefeller owns much more art than I, nor in the figurative sense. That is, clearly, if you read what Rockefeller says about it in Vogel's catalog, you can see that he's got his hands on it, but, to paraphrase the dance teacher of Peter Gabriel's CD-ROM, he hasn't *grasped* it.

Susan Vogel went on, in 1991, to curate an even more ambitious exhibit, "Africa Explores: 20th Century African Art," again at The Center for African Art (now renamed The Museum for African Art). Vogel used the occasion of the exhibit to formulate five categories supposedly encompassing all sub-Saharan contemporary visual arts: traditional, new functional, urban, international, and extinct. Sidney L. Kasfir has noted that, aside from the "fluidity" of these categories, there is a significant missing element from Vogel's typology: explicit tourist art. Kasfir argues that "[t]here are two things about 'tourist' art that make it anathema to connoisseurs: the obvious fact that it is market driven, and its subsequent inability to

resist commodification."[19] But ironically, she points out, it is the very fact of collection, of connoisseurship, which raises the specter of commodification: "as soon as urban art develops within a hegemonic (colonial or neo-colonial) collecting context, commodification arises out of the distancing of the patron (both geographically and culturally)."[20] Which is to say, every effort on the part of the West to distance itself from African cultural productions makes it more complicit in the productions themselves. Kasfir has elsewhere noted the historical context of this complicity:

> [T]he fact is that Africa is a part of the world and has a long history. There are innumerable befores and afters in this history, and to select the eve of European colonialism as the unbridgeable chasm between traditional, authentic art and an aftermath polluted by foreign contact is arbitrary in the extreme.[21]

While Vogel's apparent turn-around of the search for African authenticity ("Africa Explores" the West!) assumes that it has gone beyond such essentialist Africanism, Kasfir argues that it simply dislocates the desire for authenticity by rejecting the commodification made too apparent by tourist productions.

Lait sucré bonnet rouge: THE SWEET MILK OF
FREE MARKET CAPITALISM

Given these examples of the desire on the part of new museologists to invoke irony in the subversion of the heart of darkness of African art's past, I want to examine some images, most of them gleaned from Vogel's own 1991 show. The first, however, is a piece that belongs to me. Mine is an "authentic" African painting (it would fall under Vogel's "urban" category). I bought it at an African street fair in Harlem several years ago, and it now hangs over my son's bed. It cost fifteen dollars. The painting appears to be a public service announcement—or appears to have been intended to function as one when it was made. When I bought it, it was in a stack of identical paintings—or almost identical. They were all, after all, hand-painted, but they looked almost just alike. It depicts a breast-feeding woman and child, with the stenciled caption, "GOOD MOTHER." This painting was produced in Nigeria, where, as in many other under-developed countries (and overdeveloped ones, for that matter), many

women fall prey to advertising that promotes (implicitly or explicitly) artificial milk as more modern, clean, and Western. The truth is, bottle-feeding presents significantly more risk of contamination and bacterial infection than breastfeeding, especially in places where there is no clean tap water.

Donna Haraway, citing Nancy Scheper-Hughes' ethnography of poor infant mortality in Brazil,[22] reminds us that simply blaming artificial milk producers for Third World infant diarrhea and death would be reductive. U.S-sponsored "charitable" organizations distributed formula throughout much of the Third World in the 1960s, opening up vast new markets for producers in the 1970s. Subsequent international boycotts led the Nestlé corporation to modify its marketing strategies, but the "culture" of formula had been introduced concomitantly with other shifts in tropical economies. Scheper-Hughes notes, for example, that a 58% reduction in breastfeeding coincided with a period of catastrophic impoverishment of the (formerly) middle- and underclass in Brazil. Economic changes during the past three decades have had more effect on women's ability to nurture their children than the availability of artificial milk. As Haraway writes:

Labor patterns, land use, capital accumulation and current kinds of class reformation might have more to do with the flow of breast milk than whether or not Nestlé has adopted policies of corporate responsibility in its third world infant formula markets.[23]

The image of the GOOD MOTHER in my painting was produced and reproduced (although with minimal technology—a paintbrush and a stencil), apparently with the intention of dissuading new mothers from the use of artificial milk. The man who sold me the painting was unable to tell me whether local health-care authorities where it was produced had financially backed the production of these paintings, or how they came to serve their new function as tourist commodities at a Harlem street fair.

In Western countries, breastfeeding is a significant mode of HIV transmission. In fact, one of the reasons that medical authorities increasingly urge pregnant women to undergo HIV testing is so they will not inadvertently communicate the virus to their babies through breast milk. If HIV infection is diagnosed, mothers here are urged to give their babies artificial milk. While breast milk is just as significant a mode of transmission in the Third World, however, no such advice is administered to pregnant women

and nursing mothers known to be HIV-positive. This is because the risk of infant death from dysentery due to contaminated water in baby bottles is even greater than the risk of HIV transmission. Despite the trenchant truth made obvious by this medical policy, that the *simulacrum* of Similac is more deadly than the reality of HIV in Africa, producers of artificial milk continue to market their products there, under the implicit mark of advanced Western technology. But again, simply vilifying these companies would be reductive. HIV-positive mothers in the Third World *should* have the opportunity to nurture their children *without* risk of exposing them to the virus. That, of course, would necessitate the availability of clean water—and radical infrastructural changes.

"Africa Explores" contained an image that offers an interesting commentary not only on the international politics of artificial milk and world health, but also on aesthetic "contamination," commodification, and the authenticity of African art. This is "Materna" (1984) (fig. 1) by Trigo Piula, a Congolese painter. It depicts a "traditional" African carved altar-piece of a mother with child, topped by a ghostly European head, and surrounded by empty cans of "lait sucré." The mark is "Bonnet rouge." The irony seems to scream out of this painting. In fact, the irony of the painting, its marked awareness of European economic exploitation of Africans, is what seems to mark it so neatly in Vogel's category of "international" art. But irony in contemporary African art can be more complex, and harder to read, than this.

A TYPICAL KINSHASA MAN

Consider Cheri Samba. Samba is the most successful—i.e., marketable in the West—African painter painting today. He is from Kinshasa, Congo (formerly Zaire), and he worked for a time as an editorial cartoonist for the newspaper *Salongo*. Samba always uses extensive text in his paintings, which, as he tells you in a canvas titled "The Draughtsman, Cheri Samba," is part of what makes them so interesting:

> Caricatural drawing is nothing, cause anybody ean doit [*sic*] But it is rich cause it tells you a message especially there are texts [*sic*] I personally use two technics [*sic*]: "caricature (humour) and portrait." This givers [*sic*] a lesson to the ones who only make humour. Yet; I'm a self-taught person.

Fig. 1 Trigo Piula, "Materna" (1984), Courtesy Museum For African Art, NYC

In Susan Vogel's 1987 show, James Baldwin characterized the Yoruba Man with a Bicycle as "polyglot" in his dress, but Samba is polyglot in a more literal sense. He includes text in English, French, *lingala* (Kinshasa "patois"), Ki-Kongo, and combinations thereof. "The Draughtsman Cheri Samba" flaunts his polyglot abilities, not just linguistically, but imagistically. Samba paints himself into an international scene by broadcasting himself on a T.V. screen in the background of the painting. As Youssou N'Dour's "Live Television" tells you, impossible images of the exterior represent a "reality" which can alienate African viewers from the images of their own lives. Cheri Samba has taken matters into his own hands. In an interview, Samba said: "I love making self-portraits so as to reproduce myself, since I am not a tv star. I love to make the artist known. If the mass media does not come to me, I should be the first to make myself discovered."[24] Cheri Samba makes himself a machine for the reproduction and transmission of his own image, the image of the "authentic" African man. The link between his work and that of the "neotraditional" artists is that while the latter incorporate Western material in "traditional" forms, the former mimics

mechanical reproduction in an "authentic" medium. Interestingly, this very reproduction of Samba's own image has been perceived as a quality *both* authentic and postmodern. Bogumil Jewsiewicki has written:

> Cheri Samba, thanks to his own immeasurable ego, which is in keeping only with that of the [former] president of his country [Mobutu Sese Seko], remains himself wherever he is. . . . [He is] the best postmodern man, since he travels everywhere with his culture, keeps intact his personality and the ability to impose himself on others, to bow to no authority, money nor fame. In New York, just as in Paris, he remains a typical Kinshasa man, always resorting to subterfuge to avoid the enemy he cannot confront, only to reappear somewhere else himself again.[25]

Samba points to the complications of the international art market in a painting titled "Pourquoi ai-je signé le contrat?" A forlorn Samba is seated in the center of the canvas with a taut rope twisted around his neck. Various contradictory blocks of text are ascribed to critics, journalists, fellow artists, conservateurs, and Samba himself—all reflecting on the wisdom or folly of a binding two-year contract. One letter on the ground instructs the "CHER AMI CHERI SAMBA" to work day and night to satisfy his clients; another instructs him not to inundate the market with too many paintings. Both receive Samba's succinct "REPONSE: JE NE VEUX PAS TRAVAILLER COMME UN CHEVAL. MERCI." To contextualize this painting, I want to cite another critic—again, European. This is André Magnin, a "close personal friend" of the painter:

> Since 1989 [the year of his "discovery" in Europe] Cheri Samba has taken the entire world as his theme: New York, Chicago, Paris, London, Frankfurt. . . . And he also comments on our "weird" art world that bothers him. He does this by portraying himself directly on his canvases, the man from Kinshasa who has "made it," a self-taught artist.[26]

Samba presents himself not as a naif, bamboozled by European gallery owners and agents, but still as an "authentic" African—an "auto-didacte."

Susan Vogel places him in the category of "urban" artists—a category she applies to sign painters as well, and to the kind of painter who created

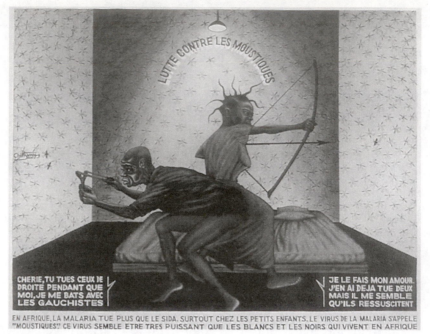

LUTTE CONTRE LES MOUSTIQUES

CHERIE, TU TUES CEUX DE DROITE PENDANT QUE MOI, JE ME BATS AVEC LES GAUCHISTES

JE LE FAIS MON AMOUR. J'EN AI DEJA TUE DEUX MAIS IL ME SEMBLE QU'ILS RESSUSCITENT

EN AFRIQUE, LA MALARIA TUE PLUS QUE LE SIDA, SURTOUT CHEZ LES PETITS ENFANTS. LE VIRUS DE LA MALARIA S'APPELE "MOUSTIQUES". CE VIRUS SEMBLE ETRE TRES PUISSANT QUE LES BLANCS ET LES NOIRS QUI VIVENT EN AFRIQUE

Fig. 2 Cheri Samba, "Lutte contre les moustiques" (1989), Courtesy J. M. Patras, Paris

my public service message, "GOOD MOTHER." She distinguishes that from an "international" African style—such as that readably ironic piece, "Materna," by Trigo Piula, which Vogel reads as influenced by a European sense of irony, as well as technique. There is a *doubled* irony to such a reading, which would imply that both the style and content of that explicitly *anti*-European painting had been imbibed, like "lait sucré" as it were, in its formative stage, prior to its political intent. While Vogel is not arguing that a painter like Piula is less interesting, or inferior, on account of "Western influence," there is still an implication of contamination which separates him from someone like Samba.

How do you read irony in Samba? He leaves it open. In a piece like "Lutte contre les moustiques," (fig. 2) Samba could be read as parodying African inability to handle the problems of health care, and by extension, other social ills. The man hopes to wipe out the "leftist" mosquitos, the woman those of the right. Is the painting about the African continent's political turbulence or is it about a Western failure to offer any solution be it to social ills, or the concrete problems of malaria and AIDS? One would be hard pressed to find irony in its reminder that malaria kills many more

African children than AIDS. That's true. But as I have already argued, the West consistently evidences a greater preoccupation with pandemics which threaten Western populations. Media attention to AIDS in Africa is not so much a response to the gravity of the situation as it is a fascination with what appears as the specter of a Western threat. This is not to say that the situation is not grave. But it does give one some perspective on African responses to the media's representations.

Magnin said Samba "takes the entire world as his theme" and an apparently clear example of this is "Souvenir d'un Africain," a painting depicting a debauched European couple groping each other in the Paris Métro as Samba himself looks on in horror. Samba turns the tables on European stereotypes of African sexuality and shows his own moral critique of French society. But is this completely without irony? Some read Samba as a moralist,[27] but he himself is not averse to talking about his own sexual prowess. In one interview, he claimed to have had 394 affairs, "which means I made love 5 to 8 times a day."[28] He also made a painting called "I embrace French women as much as Philda" (his wife). And what would an unironic reading of "Souvenir d'un Africain" do with the surprising last line of French text: "What bad aphrodisiac do they drink which allows them not to get hard?"

My favorite ironic/moralistic canvas is "J'suis fait pour des africaines." It has a story behind it.[29] Samba frequents an intellectual salon in Kinshasa which is home to a number of African and European artists and writers, among them Jean-Marie la Haye. La Haye left lying about an unfinished canvas depicting a semi-nude European woman alongside his own clothed image, and Samba took it home to "correct" it. He reproduced la Haye's work, diminishing the "vulgar" features (minimizing, for example, the woman's pubic hair), gave it a crummy grade (35/50) and painted into it an apparent quotation from la Haye: "j'suis fait pour des femmes africaines." Is that why la Haye gets fried in the "corrected" canvas, because of his racist attitude toward African women? But Samba is the five-to-eight-times-a-day Kinshasa man! How do you locate irony here?

The themes of sexuality and Samba's own exploitation within the international art market coincide in the image of prostitution. In the painting "Le renoncement à la prostitution" (fig. 3), a defensive African woman tends to her cooking pot, dressed, but with one breast falling out of her blouse. A standing white man gestures toward her, urging (in French): "I've come for that which we've always done together, you and I. Today, I've

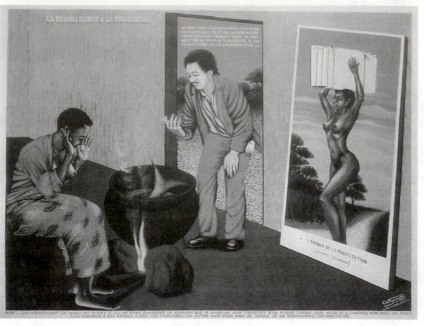

Fig. 3 Cheri Samba, "Le Renoncement à la prostitution" (1990), Courtesy J. M. Patras, Paris

brought a lot of money so you can fill your cooking pot, if you'll just be a little more cooperative.—" Her response is subscribed in the lower margin of the painting: "No!—I have a husband now and it's up to him to heat my cooking pot, which I would like to see well filled every day. But if, in the future, my husband can't fill my needs, I'll look for another, but for nothing in the world would I go back to being a prostitute." Propped up against her wall is an enormous "photo souvenir"[30] of her own "époque de la prostitution": naked except for a tiny thong, she parades down a dirt road with a full artist's portfolio balanced on her head.

That picture-postcard is the eroticized image of Africanness offered up for European consumption—just as the "prostituée" figures the "authentic" Samba in the global art market. It would be too simple to suggest that Samba is renouncing that market entirely in this painting. Even the contents of the cooking pot give one a clue as to how complicated Samba's take on prostitution might be. The *marmite* appears to contain the remains of a particularly familiar image in Samba's oeuvre: Mami Wata. The syncretic Mami Wata is a popular religious figure taken up in parts of Africa in the 1920s—but her popularity increased greatly in the 1970s.[31] She was

derived from European myths and images of mermaids, and she is often painted as a white woman. In recent years, she has come to signify not merely wealth and sexual beauty, but the exchange of the former for the latter: Mami Wata is a prostitute. The image acquired such currency among "urban" artists (often in response to the demands of foreign buyers) that these painters were dubbed "Watistes"—a derogatory term indicating their inclination to milk the theme for all it's worth.[32] Cheri Samba has produced dozens if not hundreds of Mami Wata images.

What does it mean for Samba, who depicts himself as an insatiable consumer of women, to create an image of an African woman consuming the image of her own prostitution in the form of a European mythic figure produced and reproduced for European consumers as "authentically" African? In European *and* African epidemiological narratives, the "prostitute" is frequently cited as a significant vector of HIV—Mami Wata continues to accrue associations. As Cindy Patton has argued, the epidemiological category of "prostitute" is "virtually incoherent," as it is used to describe such diverse kinds of sexual relationships and practices, particularly when applied cross-culturally.[33] Sex work, like other forms of labor *including* cultural production, is circumscribed by relations of economic power. And as Samba's painting shows, global economic inequality means that within the realms of art *and* sex, exploitation feeds on itself.

Given Samba's inclination to locate himself in the global picture, and to "take the entire world as his theme," it is not surprising that he should have produced a number of moralistically and ironically undecidable canvases which make direct reference to AIDS. While "La lutte contre les moustiques" invokes AIDS obliquely, only to deflect his irony toward the hypocrisy revealed by another disease, "Les prêcheurs" (fig. 4) and "Le malade du SIDA" (fig. 5) are apparently explicit warnings about the dangers of HIV transmission. "Les prêcheurs" shows children playing in front of a hotel with used condoms, blowing them up like balloons. The text warns: "Caution! . . . Caution! All means of transmission of AIDS are still not known and the disease itself is still incurable. Lovers have problems. They ought to know where they can throw their USED CONDOMS." The painting was produced during the same period (in 1990) when Samba published a similar complaint in the Kinshasa paper, *Salongo*. He *is* addressing a local problem. But when the painting circulates in the international art market, the image of carelessly circulated, potentially infected sexual fluids accrues new significance. This is partly because Samba's

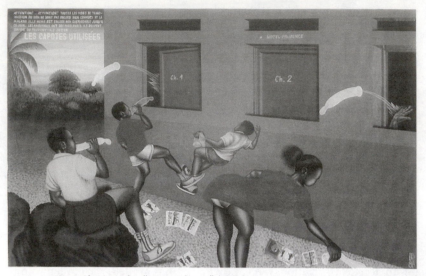

Fig. 4 Cheri Samba, "Les prêcheurs" (1990), Courtesy J. M. Patras, Paris

openness in dealing explicitly with such apparently local issues has contributed to the international fascination with his work.

"Le malade du SIDA," too, becomes increasingly complex as it circulates. It depicts an AIDS "sufferer," supported by two other men, approaching the hut of the "SUPER NGANGA," a "traditional" healer. Samba superscribes, in French, a quandary: "Why until now have people still not learned to protect themselves?" The Nganga, as emaciated as the *malade* and disguised by a lurid blue "African" mask, observes in lingala, the linguistic form of mutual contamination,[34] that the "sufferers'" carelessness results in his own profit. "Protection," in other words, means not only sexual hygiene, but avoidance of the exploitation of "healers." But Samba has already made it clear that exploitation and corruption are not the exclusive property of African medicine men.

AFRICAN ART IN THE AGE OF VIRAL REPRODUCTION

Appiah's exemplary neotraditional piece was the sculpture, "Yoruba Man With Bicycle," which incorporated the Western mechanical element into a "traditional" form. Acrylic and oil paintings on canvas, while not "indigenous," have become authenticated as African cultural forms, as Vogel's emphasis on them in "Africa Explores" demon-

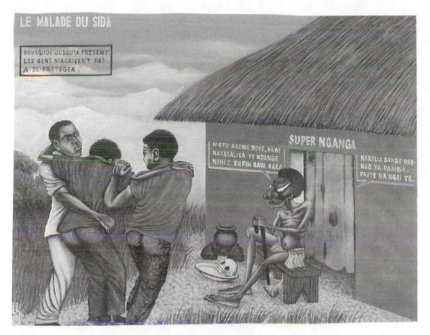

Fig. 5 Cheri Samba, "Le malade du SIDA" (1991), Courtesy J. M. Patras, Paris

strates—as long as they do not too obviously mark their own extra-African commodification by marketing themselves to tourists. But I want to bring this chapter full circle, back to a sculptural image which contains all others. You remember Lela Kouakou, the "authentic" Ivoirian carver in Vogel's 1987 show. Now *try* to map the place of the work of *another* Ivoirian carver, Koffi Kouakou. This Kouakou creates "traditional" wood sculptures of such items as "Baseball Cap" and "Gentleman's Suit". I first saw the work of Koffi Kouakou twice in one day in 1993, on Broadway between Houston and Prince Streets in New York City. There were several pieces for sale in the gift shop of The Museum for African Art (then directed by Vogel): a carved Malcolm X baseball cap, carved Vuarnet sunglasses, a carved Lacoste shirt (a Lacoste shirt, interestingly, also shows up in one of Samba's self-portraits). The same items (or other simulacra of these items) were on display a few steps down the block in the New Museum, a highly ironic postmodern, new museological space which had an exhibit on the global trade network. Which was the "true" context of Kouakou? Contemporary African art is *both* produced for Western consumption (the museum gift shop) and at the same time is an ironic statement about the West's desire to

Fig. 6 Koffi Kouakou, "Portable Computer" (1990),
Courtesy Museum For African Art, NYC

consume and control non-Western culture. If Cheri Samba is a machine for the reproduction of his own "authentic" image, Kouakou reproduces the image of that very image's reproducibility. A final image is the most eloquent, bottomless articulation of this: the hand-carved "Portable Computer" (fig. 6), a light-weight, traveling machine for the communication of images.

To reduce *this* image either to the status of a tourist commodity fetish *or* to an expression of postmodern irony is to imply that it is the representation of a wholly new, unprecedented contamination. The reading itself is, in fact, what infects the computer with the virus of cultural inauthenticity. But as Wideman's story shows all too clearly, there's nothing new about this bug.

FOUR

❦

African
Medicine Men

In the nineteenth century there were, in principle, two kinds of *nganga* (priest, magician), corresponding to two kinds of *n'kisi* [charm, medication], associated with the cults of personal afflictions on the one hand and with the collective cults of political domains on the other. . . . In practice, the distinction between a cult devoted to personal protection and one serving the collective interest was undoubtedly as obscure as it usually is in the world at large, but even that normative distinction was lost at the turn of the century. The political system was destroyed, the memory of what chiefship had been was corrupted by the introduction of colonially designated "chiefs," the local cults paired with chiefships disappeared, and the meaning of *n'kisi* was modified under the pressure of missionary inquiry and indoctrination, which took for granted the reality of a unitary idolatrous phenomenon called "fetishism," whose sinister promoter was the "witch doctor," "fetisher," or "sorcerer," the *nganga*.[1]

Cheri Samba's "SUPER NGANGA," like his very title, straddles linguistic, cultural, and historical divides. And while Samba marks his corruption, there is an indication that this very cultural crossing may have something to do with the contamination of his healing practice. In this chapter, I want to examine two other representations of African healers confronting AIDS. One of these representations is novelistic, the other cinematic. The media of novel and, in particular, film are implicated by the figure of cultural contamination, and like the photographs exhibited in "In/sight," these works both exploit and critique Western representational practices through an ultimately undecidable irony.

WHO'S FICTIONAL, WHAT'S FACT?

Kenyan writer Wamugunda Geteria's 1992 novel, *Nice People*, takes its title from a 1988 statement made by Jonathan Mann as head of

the World Health Organization: "AIDS cases world-wide now estimated at close to 150,000 will double this year partly from the widespread and dangerous belief that nice people are at little risk."[2] "Nice" is a word that keeps popping up in the book, as in this teaser on the opening page:

"Yosevu, you are dirty aren't you?"
 "Oh! why?"
 "You have given me VD."
 "Nḍuku listen"
 "I want a refund of my three hundred shillings first."
 "For what?"
 "See for yourself, my doctor says I have gonorrhoea from you."
 "How does he figure it is me?"
 "I am going to sue you, Yosevu."
 I was not worried by either her threats of suing me or her asking me to refund some three hundred shillings. It was her accusing finger that was particularly irritating.
 "But you flirt around with your *mzungu* lover, don't you?" I began a subject she was loathe to discuss.
 "White men have no VD."
 "What are you talking about?"
 "Mr. Brown is nice, he does not go with prostitutes."
 "How would you know when VD is white or black?"

The narrator of *Nice People* is Joseph (Yosevu) Munguti, a well-meaning physician who returns to Nairobi after completing his medical education in Nigeria, only to find, as the book's jacket puts it, that corrupt local doctors have turned the Hippocratic oath into a "hypocrite's oath." He finds himself supplementing his meager income from the official Kenya Central Hospital with a questionable sideline at a rural "VD" clinic, which soon spawns an affiliate. These private clinics provide Munguti with ample evidence not only of the rampant spread of sexually transmitted diseases, but also of medical corruption, including illegal abortion, "euthanasia," and murder, for the right price. The epidemic called, at different points in the narrative, "the green monkey disease," "the killer disease," and, finally, AIDS emerges in the short course of Munguti's clinical practice. The mounting corruption culminates in the establishment of the Canaan Hospice, an

exorbitantly priced private establishment catering to the "upper echelons" affected by the new public health crisis. Canaan Hospice serves two essential functions. Its clinic provides prostitutes with fraudulent certificates announcing them to be HIV-negative, at a price of ten thousand shillings. Its hospice building is devoted to the care of wealthy AIDS patients who pay a quarter of a million shillings in exchange not only for health care but also for sex (with condoms) with specially recruited locals.

The spiralling of this strand of the narrative into nightmarish levels of medical fraud is paralleled by the narrative strand of Munguti's own sexual relations. He begins innocently enough, stumbling into relationships with a colleague's daughter, a childhood friend, and a patient. One by one, Munguti's girlfriends reveal their secrets (a life of prostitution among foreign sailors in Mombasa, a long-standing affair with a bisexual Englishman, and a sexually abusive husband evidently infected with the "green monkey disease" who has a taste for non-consensual anal sex). They also begin to reveal the symptoms of their various forms of "VD" which, of course, they have begun to share.

Nice People is a disorienting book, not simply because of the increasingly complicated web of corruption and sexual exchange, but also because of its peculiar mix of medical detail (often inaccurate and yet quite specialized, and certainly highly latinate) and wacky distortion. The novel careens between incisive observations about the global context of sexual stereotypes and the politics of pharmaceuticals, and surreal, frenzied replications of a *Heart of Darkness* surrounding a sinking clinic.

Geteria thanks, in his acknowledgments, a number of medical professionals from the University of Nairobi who supplied him with scientific background for the writing of the book. But the "real" medical professional most clearly marked in the novel is Jonathan Mann, who actually appears as a character in the finale, writing the following letter to the narrator:

Dear Dr Munguti,

The World Health Organization has followed with interest the work you have done in Venereology in your country. The WHO would like to interest you in its Global fight against the AIDS menace and wishes to invite you to its headquarters in Geneva for an interview.

AIDS cases world-wide now estimated at close to 150,000 will double this year partly from the widespread and dangerous belief that nice people are at little risk. All the expenses to and from your country will be

paid by the W.H.O. and tickets will be sent as soon as the organization receives a positive reply from you.

Yours sincerely,
Dr Jonathan Mann,
for Director-General,
WORLD HEALTH ORGANIZATION.[3]

Armed with this document and his own authentic, negative HIV test result, Munguti flies off to Geneva with a slightly homely but good-hearted, uninfected nurse, Irene.

Jonathan Mann's words are written into Munguti's world, merging, of course, fictional and non-fictional realms. Medical terminology (*Treponema pallidum, Neisseria gonorrhoea, Trichomonas vaginalis, Haemophilus ducreyi, Herpes simplex, Mycoplasma hominis, Candida albicans. . . .*) also infects the fiction with a semblance of reality, even as the narrative goes spinning into chaos. The fiction of Africa as a *Heart of Darkness* was scripted, of course, by Europeans. Here, a fictional chaos of sexual abandon and disease is reproduced with all the markings of European complicity, and failure to control its spread. The crossing over between European and African worlds laid bare by the conversation between Yosevu and Nduku is literal, banal, and yet important: it is the sexual exchange across races and cultures.

Nduku's "nice" boyfriend, Ian Brown, is identified early in the novel as a practitioner of "the known Western love-making deviant practices such as whipping, trio-some encounters, fellatios, cunningulus [*sic*], use of vibrators and sodomy."[4] He frequents a notorious den of iniquity (the "Club 1900," named after the historical moment Wyatt MacGaffey points to in the opening citation of this chapter as the dawning of cultural "corruption" and the invention of "fetishism"), where Kenyan men and women flock, "mainly to attract the Yens, Dollars, Deutsche Marks and Sterling pounds."[5] Ian Brown appears to appreciate both Kenyan men and women, all of with whom he prefers anal penetration. His racial affinities are so intrinsic to him, in fact, they are inscribed in his own name. If this sounds like a stretch, consider the name of Munguti's other girlfriend's European (Finnish) lover: Captain Blackmann. While these characters are distinctly bracketed in *Nice People* as racially and culturally different from Kenyans, they are also indelibly marked as similar.

Munguti looks back at his childhood perceptions of European sexuality. He remembers the Italian principal of his school, Father Guy Benedicto ("locally referred to as Ventigito Mubea"), who was privately ridiculed by locals for his avowed celibacy. When Benedicto learns of the ridicule, he reprimands his congregation:

> "I understand some of you wonder why Father Guy is not married. He is not married to one person but to all women. Whose wives do you think all these belong?" he challenged.
> "To the father!" the congregation answered in an uproar.[6]

It turns out that this claim is in fact quite literally true—Benedicto is availing himself of all the wives of the congregation, finally disappearing with one.

As a narrator, as a physician, and as a lover, Munguti consistently expresses understanding when it comes to the breaking of impossibly restrictive vows, including the Hippocratic oath. While he distances himself from his corrupt medical colleagues, he concedes to them the hypocrisy of an oath and a legal system that assume ethical issues are always clear-cut. His acknowledgment of the complexity of medical ethics is what leads him down the slippery slope to a position in the evidently exploitative Canaan Hospice. But he doesn't become a moralist.

Wamugunda Geteria gets to the heart of this in an oddly confessional moment in the novel, interestingly not articulated by Munguti, but by Canaan's wildly greedy and deceptive head, Dr Ding-Singh. In response to Munguti's questioning of Canaan's outlandish prices and dangerous services, Ding-Singh argues:

> "Oh! who is not exploiting people through AIDS? The rubber manufacturers of America are making billions out of condoms, blood banks are soaring with business. Writers and film-makers are busy making hay when the sun shines with the AIDS scare. We must hurry, Dr Munguti. We could make millions and each retire comfortably by the time they discover the cure."[7]

Geteria thus writes himself (and me) into a story of the exploitation of suffering that only finds its most *extreme* expression in Canaan Hospice. While the publication of *Nice People* (or *Infectious Rhythm*, for that matter)

is unlikely to turn the kind of profits received by Ding-Singh, it is true that the human tragedy of AIDS has occasioned a body of cultural responses which can't help but be absorbed by the market system. But that absorption only appears to establish control over the cultural productions themselves. Their significances keep proliferating in often unintended ways.

In *Nice People*, the uncontrollable chaos of Canaan Hospice is finally controlled, not by European forces, but by the diligent work of the righteous, seemingly incorruptible Police Inspector Paul Wekesa. Even Munguti's shifty fellow-venereologist, Dr GG, must admit: "'Wekesa is a good man, although a cop. His heart is as clean as a syringe. . . . He cannot visualize a world without cops.'" Munguti goes on to describe the Inspector's philosophy:

> Wekesa equated the police to the tenets of the country as friction is
> to the universe. If anyone doubted the value of the force, one was
> advised to consider a frictionless world—a world with no brakes,
> bodies colliding repeatedly against each other in the universe,
> Inspector Wekesa would argue. It was to him, a chaotic situation
> such as all hell breaking loose.[8]

That image, of a frictionless world of bodies colliding, recalls John Edgar Wideman's figure in "Fever" of a world of dissolving membranes and collapsed barriers. While the Philadelphia police's firebomb in "Fever" is shown as a killing, not healing, act, Wekesa seems to be the hero of *Nice People*—the one hygienic, ethically unquestionable character. But Geteria has set you up from the outset to be particularly wary of such "nice people."

Nice People is a circular story, beginning and ending with Munguti looking into the coffin of his dead girlfriend (and daughter of Dr GG), Mumbi. Her body has been returned from Helsinki, where she died of complications from AIDS. In the course of the novel, Mumbi tells Munguti she is pregnant with his child, but subsequently delivers a baby of mixed race. Munguti deduces that the child is Captain Blackmann's, whom Mumbi joins in Finland before falling ill. But in a sense, the conundrum of how a black man and a black woman could produce a mixed-race child is not so easily solved. How could a black woman and a Blackmann produce this offspring? The child—and the virus—are as much Munguti's, or could be, as they are Blackmann's.

Gérard Louvin's 1993 film, *Ashakara* (a Togolese-French co-production) bears some interesting resemblances to, and some marked differences from, *Nice People.* One of the powerful closing images in this film is also a coffin. It is the coffin of a casualty *not* of AIDS, but of a conspiracy planned by a corrupt European pharmaceutical company. In death, the victim, a Western-trained doctor, is honored by a casket elaborately adorned with a "fetish": his microscope. The indigenization and fetishization of technological equipment is already familiar to us as discussed in the preceding chapter which supplied a number of parallel examples from African visual arts. In fact, a West African coffin-maker, Kane Kwei, is among the best known of those artists Susan Vogel has termed "new functionalists"—artisans incorporating the material of postcolonial cultural mixing into precolonial functional aesthetics to create forms which themselves *become* "traditional." Kwei was "discovered" by a San Francisco art dealer in the 1970s, and since then has had a thriving business creating Mercedes Benz- and rocket-shaped coffins bought for burial by nationals and for display by foreigners. His work is evoked by Kora's honorific casket, which would appear to grant the doctor perspicacity and insight in his death which he lacked during life.

Dr. Kora is a respected physician living in the capital, Lomé. As the film opens, he is visiting with his sister Tata Dodi, a traditional "fetishist" in a rural village. She tells him, "'When the illness came about, even those who were taking the white man's remedies died. So I made the old remedy.' 'And no one in the valley died?' 'Not a single one.'" Dr. Kora isn't so surprised that Dodi's herbal preparation is effective. After all, most Western medicines are derived from plant sources (this is why pharmaceutical companies carry on research in tropical areas, sometimes consulting local healers on indigenous uses of medicinal herbs). What surprises Kora is Dodi's insistence on activating her remedy with a magic stone—a "catalyst," as he calls it.

This stone will also serve as a catalyst in terms of the action of the film. It is what drives all the plotting, scheming, chasing, and killing that ensue. And yet we find out later that it was never effective in a "magical" way. Dodi simply used it to create mystique. Still, it was effective. "Chemically active preparations vary in efficacy according to the social context in which they are applied." That's ritual, whether it involves a black stone, or a hospital room festooned with IV tubes and bottles of little pills.

But back to Dodi's cure. Kora is most forcefully convinced of its efficacy when he sees a familiar face, a patient who had been failing under his care, who now shows vast improvement under Dodi's. The "illness" in question goes unnamed throughout this film, but there are numerous clues dropped leading one to read it as AIDS. Among these are Kora's communications with and referencing of the Pasteur Institute and (as in *Nice People*) the WHO. But the inadequate treatment he's been administering does have a name: not AZT, but "Miriam." Kora wonders if part of this particular patient's decline under Western-style medical care might have been due to his failure to take his medicine. Dodi scoffs at this suggestion, adding that Miriam is "trop cher," and perhaps the man was forced to sell it in order to feed his family.

Why does this film not speak the name of AIDS? And why is it impossible to come up with a reliable estimate of rates of HIV infection in Togo? The answers are complex and interwoven. While Western estimates of seroprevalence in African nations have been distorted by cultural misconceptions and lack of testing resources,[9] many of the governments of these nations have also presented pictures distorted by fears of negative impact on tourism, among other industries. *Ashakara* was paid for, in part, by the national tourism bureau. As I said, it is a French co-production, and there is a significant touristic element to the film—attractive scenes of "local color" and a soundtrack of lively Afropop (the publicity materials on the film emphasize its "infectious rhythm" without ever mentioning the pretext of a literal epidemic). Tourism isn't, in a simple way, the *reason* that AIDS isn't named in the film. But these facts do draw your attention to the complicity of tourism in the AIDS business, and vice versa.

If HIV statistics are unreliable, we do have access to statistics regarding health care in Togo: for every 100,000 people, there are eight medical doctors, and two, yes two, pharmacists. I have already discussed the etymological and practical connections between pharmaceuticals, the *pharmakon*, and "ritual" herbal healing. Western and non-Western healing systems are, in these respects, similar. But there are other factors that distinguish the question of healing in Africa, or, more truly, that distinguish the question of the healing of the underprivileged around the globe. Tata Dodi speaks a trenchant truth often forgotten in discussions of AIDS treatment in the U.S. media: medical advancements mean nothing to people who would have to starve to death in order to pay for them.

After confirming the *in vitro* efficacy of his sister's cure, Kora communi-

cates this information to the Pasteur Institute. He promises Dodi that if her preparation is marketed internationally it will be called "Dodine," but again she dismisses the thought, arguing that as the cure emerged locally, it will remain the property of the village. Meanwhile, the French pharmaceutical company which produces Miriam hears of Kora's findings. The company president dispatches a young ethnobotanist, in the midst of his rain forest explorations, to Lomé to negotiate with Kora. The botanist, Jerome Blanc, is summoned from the forest where he is conversing with a tiny local healer by the sound of drums pounding. The drums, in fact, are transmitting another message: they are alerting Blanc to a satellite communication coming in on his portable computer/video screen, affectionately known as "Val." Val is a technological omnibus, with fax, phone, video, synth-voice, and, apparently, divinational capacities, all powered by a solar panel. Needless to say, the necessity of relaying all this technology through the "primitive" communicative mode of drumming invokes the same irony as the fetishized microscope.

Jerome Blanc becomes an unwitting pawn in the evil pharmaceutical executive's plot to suppress Dodi's cure until Miriam has "paid for itself," and then exploit the new cure for his own profit. The executive is joined in this scheme by a selfish and yet likable lab assistant, the promiscuous fiancé of Kora's virgin daughter, Kofi. Kofi involves some dreadlocked hoodlums, and the plot thickens: arson, kidnapping, theft, murder. Jerome Blanc is framed, Dodi discovers his innocence, she liberates him from jail through a combination of "fetishism" and manipulation, and a rollicking car chase follows. Finally, Kora is killed, but the cure remains in local hands. Jerome Blanc joins forces with Dodi, Kora's daughter, and "Les Nana Benz," rich local market women who, having made their fortunes through the sale of European-produced "African" fabrics, drive Mercedes Benzes. With their financial support, Dodi's cure can be produced and marketed for the medical and economic benefit of Africans.

This, in a nutshell, is the plot of *Ashakara*. But the film is disjunctive in ways which exceed its plot. Its filmic vocabulary shifts dramatically from a classic ethnographic style in the village scenes to a brilliantly clichéd action style in the urban scenes. By ethnographic style, I mean that the camera is mobile, intrusive, in fact invasive, giving the viewer the sense of really *being there*, in the midst of the dancing crowd, at the foot of the diviner as she slits the throat of a chicken. These scenes leave no trace of their scriptedness, of *mise-en-scène*; instead, they suggest spontaneity, and a certain lack

of control on the part of the camera. Off kilter, the film's eye seems swept into the action.

Of course, ethnographic film is hardly so passive. And besides, these scenes only give the *impression* of ethnography. They are thoroughly scripted, and integral to the plot of the film as a whole. But their juxtaposition with the action scenes, which both pay homage to and parody every Clint Eastwood shoot-'em-up ever made, makes their apparent "reality" all the more tempting to hold on to. And while camera work is one element which distinguishes ethnographic film, there is something else that sets the village scenes up for an ethnographic reading: the banal fact that they image non-white people engaged in non-European cultural practices. Despite the fact that there is a growing body of African-produced narrative film depicting rural, "traditional" communities, Western audiences, as well as urban African ones, continue to seek ethnological information from the images.

Ethnographic film, like ethnographic literature, developed from European representations of non-Europeanness. *Ashakara*, however, is an African-European co-production, and its cultural representations stare each other in the face. In what ways does the film represent Europeanness through an African lens? The stylistic mimicry of *both* ethnographic and action films can be read as a representation of European culture. But there are more literal representations. Jerome Blanc is the most significant European character in *Ashakara*—or at least he *appears* to be. When he arrives at Dr. Kora's house to negotiate the sale of the cure, Kora openly tells him that he suspects his motives. Jerome defends himself by explaining that he is not in fact French, but Haitian—"one of you"—the implication being that despite his appearance, he has African blood. In this case, contrary to that of *Nice People*'s Brown and Blackmann, Blanc's name, white man, belies his blackness. Ultimately, his argument that he is "one of you" seems borne out by the film, as he risks his life to keep the cure and its future profits in African hands.

The only other Europeans depicted in the film are the pharmaceutical executive, and the French husband of Kora's second daughter who appears at a dance hall (as he flails on the dance floor, his wife affectionately assures him that he dances well "for a white guy"). It is even a stretch to say that the executive appears in the film; in fact, it is the image of his talking head which appears, transmitted through the satellite receptor on "Val," the techno-wonder. And while the executive assumes a posture of total control, plotting the manipulation of Kora and his people, his very image is con-

tained and transported by a technology which has already been, as I argued above, indigenized—Africanized. In a sense, one could argue that Val himself is a representation of Europeanness, which is contained and finally controlled by African realities. As the film progresses, Val gets increasingly beat up. As the last straw, the rasta hoodlums rip off the solar panel for use on their boom box.

The rastas, too, are a complicated non-African element whose cultural significance is sent spinning in the film. That is, they are Togolese, and yet they insist on speaking English and listening to Jamaican music. As I mentioned in the earlier discussion of World Music's invention, reggae played an important cultural role during the period of African decolonization. As a diasporic music looking back to Africa, it signified pan-African racial and cultural pride. And yet in the film, the superficial signs of rastafarianism and pan-African resistance (reggae, dreadlocks, and pot) are emptied out of political significance by their appropriation by pawns of European exploitative forces. Still, reggae is recuperated by the film itself: the scratchy dub rhythms transmitted by the bad guys' boom box merge seamlessly into the soundtrack of the film. The lyrics of resistance, which ring hollow in the boom box, are refilled with meaning as they become part of the film's own message.

Rasta outlaws are not the only African bad guys in Ashakara. The other obstacle in Blanc's mad race to rescue Kora and the cure is the military police. The mindless bureaucrat guarding the jail where Blanc is held insists: "We respect human rights—the president said so." And yet all evidence indicates otherwise. Blanc discovers one cell-mate dying of malaria with no medical attention at all, until he convinces the guard to allow him to treat him. As Blanc administers an injection, his other cell-mate tells the story of his own political imprisonment. Finally, both Blanc and the political prisoner are freed by Dodi's bribe of a charm to cure the bureaucrat's headaches, and the entire affair remains unregistered in the log book.

All of Dodi's charms are effective. The stone, as I said above, catalyzes the events of the film, as does the cure for headaches in this scene. At other points in the film, her "magic" allows her (and the film's audience) to divine the truth. But Dodi goes beyond divination, seemingly controlling narrative events through her acts. At one point, she tires of the inability of the police, now on her side, to apprehend the car carrying Kora. Sighing, "I have to do everything myself," she casts her spell. The film suddenly cuts to the tire blowing out on the car in question. Of course, the causality implied

by this scene is a function of the film's editing. The cut from "fetish" to tire is Louvin's. But this doesn't necessarily mean that the "fetish" is false. One could read the relation in reverse: the logic of cinematic narrative, of sequence's implied causality, is absorbed by Dodi's system of effective fetishism.

ETHNOGRAPHIC FILM, PERSONAL AFFLICTION, AND THE POLITICAL DOMAIN

The first theorist of the "ritual" nature of film, and of ethnographic film in particular, was Jean Rouch, generally considered the father of African ethnographic film, a founder of the *cinéma vérité* movement, and of the notion of *anthropologie partagée* or "shared anthropology," in which ethnography develops out of a mutual dialogue across cultural difference. Rouch preceded Peter Gabriel by some forty years in arguing that Western recording technologies (in Rouch's case, film technology) should be distributed to the former subjects of ethnography, such that these peoples could create their own representations of themselves and their cultures.[10]

In 1953, Rouch made his best-known ethnographic film, *Les maîtres fous*. The film depicts a "possession cult" in Ghana called the Hauka. As Rouch quite flatly puts it, "The cult is an African expression of [European] culture."[11] The spirits that animate the bodies of Hauka initiates during their ceremonies are spirits of colonial administrators. With violent pomp and arrogance, these figures goose-step around the sacrifical altars. Numerous furious, disdainful, and prudish characters arrive. The incorporation of these entities is accompanied by convulsive physical contortion and copious frothing at the mouth, which is indicated by the film's narrator as a sign of "genuine possession." The activities climax in the slaughter and ravenous consumption of a pet dog.

Les maîtres fous is not an easy film to watch. The uneasiness it seems to provoke in *all* viewers is complex. A young Jean Rouch first screened it in the Musée de l'Homme in Paris for a group of intellectuals, including many young African students and the leading anti-racist anthropologists of the moment. Rouch felt that he had created the most condemning anti-colonial cinematic statement ever made. For him, the ironies of the Hauka were brilliant, incisive, and irrefutable. To his dismay, the audience found the film unwatchably racist. Appalled African students said they left the

theater feeling that the Europeans in the audience must have thought them dog-eating barbarians. Marcel Griaulle, Rouch's advisor, demanded that the screening be stopped. The film has had a wildly varied reception over time. Years later, Rouch saw it as definitively vindicated by its canonical status in ethnographic cinema, and its influence on African national ethnographic filmmakers. But it continues to provoke profound ambivalence among viewers.

This is precisely because of the impossibility of fixing the film's irony. The Hauka both worship and ridicule the European spirits which animate them. You simply can't read the film as a flat parody of European politics and culture. *Les maîtres fous* is perhaps the most stunning film representation of the colonial subjects' mimicry of Europeanness which Homi Bhabha points out is always "resemblance and menace,"[12] always ambivalent. One's viewing of the film, too, is necessarily ambivalent.

According to Rouch, the Hauka died out as a cult with the end of colonialism: they weren't necessary any more. This assertion has been contradicted,[13] although their intensity, by all accounts, has diminished. Rouch says that the resistance once directed against the tyranny of colonialism has since been turned against repressive national morality. This new "cult," the Sasale, incorporates the spirits of "famous singers, prostitutes, playboys":

This new religion is starting the same way [the Hauka did]: it's absolutely underground because the government is against sex. I began a film about it, but they asked me not to show it because of course the people were all, well, they were not making love in front of the camera, but all the dances, all the songs were about sex: "Look at my clitoris," "Oh, your testicles are wonderful," and so on. . . . These religions are a kind of *inconscient collectif.* The people can't explain what they're doing, they can only show what they're thinking of, and it means that during these years from the 1920s to Independence they were thinking of power, military, administrative, bureaucratic power, and now they are thinking of sex and death. The Hauka introduced the idea of people who are outlaws, in the exact sense of the word. . . . But now that the Hauka are inside the law . . . there are new outlaws of sex and death, the Sasale.[14]

There is something, certainly, disturbing about Rouch's account here—the notion that the Sasale, like the Hauka, don't know what Rouch knows

about their own political resistance. Rouch's certainty that *he* knew what the Hauka meant, after all, was contradicted by the initial reactions to his film. It seems that the ambivalences of both the ceremonies and their representations are more complex than Rouch would allow.

And yet Rouch has been admirably self-reflexive about one aspect of his ethnographic filmmaking: its fetishism. I don't mean by that sexual fetishism, although certainly, as the Sasale story indicates, there is an element of this as well. I mean that Rouch has insistently pointed to the similarities between his own "ritual" activities and those that he has filmed:

> [T]he filmmaker-observer, while recording these phenomena, both unconsciously modifies them and is himself changed by them; . . . when he returns and plays back the images, a strange dialogue takes place in which the film's "truth" rejoins its mythic representation.[15]

Rouch compares his own psychic state behind the camera to "spirit possession," and his search for appropriate filmic images to the spirit's search for a "double"—a self divided from itself, and so open to spiritual embodiment.

Michael Taussig has linked Rouch's own notion of ethnographic filmmaking as spirit possession to the technologies of cinema. Taussig cites a moment of stunning montage in *Les maîtres fous* in which ambivalent irony is created by Rouch's own cut (from an egg cracked over the head of a sculptural representation of the Hauka governor to the "real" colonial governor's plumed yellow and white hat ostentatiously worn during a military parade). The crack and the cut are the same: "Here film borrows from the magical practice of mimesis in its very filming of it."[16] This is the same magical practice employed by Louvin as he cuts from Dodi's sacrifice to the blown out tire.

One of the disturbing things about *Les maîtres fous* is its ending. Rouch goes back the day after the Hauka ceremony to film its participants outside of the "cult," in their everyday jobs as "bottle boy" (bottle washer), "gutter boy" (ditch digger), "pickpocket". The narrator observes their radiant good humor, and evident psychic well-being, and wonders if the Hauka don't serve as a kind of pressure release, which allows colonial subjects to maintain a healthy outlook. This suggestion seems to deflate much of the potential political force of the film until this point. Of course, it is far too simple an account of the significance of the Hauka. As Wyatt MacGaffey reminds

you in the citation with which I began this chapter, the healing of personal affliction can never be fully separated from the political domain, particularly not in the context of colonial (and postcolonial) pressures. Likewise, no "cult" dedicated to the healing of the personal affliction of AIDS can be extricated from politics.

Taussig follows his consideration of *Les maîtres fous* with a recollection of an "alternative" healing center he once visited in a predominantly African area of Colombia. The treatment room was illuminated by a blue light, which cast its glow across the decorative items covering its walls: festoons of non-functional IV tubes and cut-out advertisements for medical products labeled "Made in the U.S.A." These fetishes were always magical. The question is whether such magical *and* medical exchanges might conceivably accrue some efficacy as their significances multiply.

FIVE

Voodoo Economics

There is a passage in Maya Deren's ethnography of Vodou, *Divine Horsemen: The Living Gods of Haiti,* in which she tells an anecdote to illustrate the qualities of Gede, the spirit of the dead. Gede is death itself, and yet he is also the most powerful healer of all:

Particularly, Ghede [*sic*] is known as the guardian of children. . . . In one case, the godchild of a mambo [priestess] was gravely ill. The little girl had been taken to doctors in town, had received injections and treatments, both medical, herbal and ritual, yet continued to waste away and it was clear that she was on the point of death. Consequently, as a last recourse, the mambo undertook a strong ceremony for Ghede. It took place at the replica tomb which was erected in Ghede's honor in the court of her hounfor [temple], and was attended not only by her own hounsis [congregation], but by several

mambos, friends of hers, who had come to lend their own strength as well. The songs for Ghede were most fervently sung. Several black chickens were given him, and then the large black goat, an exceptionally strong offering, was killed.

With this evidence of devotion, Ghede agreed to intervene. He possessed one of the mambos, and asked that the child be brought out and placed on the tomb. He took the blood of the goat and, undressing the child, anointed her with it. Then, singing fervently, he reached down between his legs and brought forth, in his cupped palm, a handful of fluid with which he washed the child. It was not urine. And though it would seem impossible that this should be so, since it was a female body which he had possessed, it was a seminal ejaculation. Again and again he gave of that life fluid, and bathed the child with it, while the mambos and hounsis sang and wept with gratitude for this ultimate gesture. Of the life which he had in the past consumed, he now gave forth in full measure. And though there is no reasonable way to account for this, the child lived.[1]

Maya Deren witnessed this incident in 1948 and recorded it in 1951, long before HIV irreversibly changed our understanding of the relationship between Gede's two powerful unguents, blood and semen, and life and death.

It is, certainly, a strange story. In a footnote, Deren herself acknowledges that "no similar episode has been cited in the literature on Voudoun [*sic*], possibly because of a sense of discretion on the part of the writers." And yet no matter how many times I read this account, I find it almost unbearably moving. The body which is both physical and divine, female and male, one and many, produces a fluid which transcends its own literal vital properties, and negates death. In the absence of a divine significance which might make our bodies *this* productive, we stand here dry, empty-handed, impotent.

THE MEANINGFUL BODY'S POLITICAL HISTORY

The body often contains significances that surpass its "natural" functions. In many African and diasporic religious systems, these significances manifest themselves as divine spirits, like Gede. HIV can also be read as a significance in excess of the body, and yet contained by it. Paul

Farmer's brilliant work on AIDS and the political history of Haiti[2] has irrefutably demonstrated that the seroprevalence of the virus, both in the individual and in the nation, is linked to political factors far exceeding any individual's bodily acts. Farmer ties together historical, economic, ethnological, epidemiological, and personal narratives in order to get at the deeper meanings of "case histories."

Effectively, through the accretion of these narratives, what Farmer shows is that the epidemiological is always infected with the economic, the personal with the political. He also shows that the United States is complicit in what it means to be Haitian, and Haiti in what it means to be North American. That means that actions on the part of individuals here affect Haitian lives (a Haitian domestic working in the United States is fired due to her employers' fear that she carries HIV—which she does not—and because she is no longer able to send money to her family in Haiti, her sister's little daughter is forced to abandon her schooling, and any hopes of escaping the spiral of poverty).[3] It also means that individual Haitians affect North American business (an impoverished peasant sells a liter of his own blood plasma for $3.00 in order to feed his family, it is processed by a U.S. chemical company and sold to Europe for seven times the price paid, the transaction facilit-ated by Papa Doc and his Miami business associates).[4]

Earlier, I mentioned one multinational company's intimate entanglement in the lives of Haitian laborers. Of course, not only individual and corporate actions but governmental ones as well have an impact on public health and the economy. Here in the United States, there seems to be a persistent forgetfulness regarding the actions of our government toward that of Haiti. What follows is an extremely compressed version of this history: In the late eighteenth century, France's Saint Domingue (now Haiti) was the most productive colonial territory ever held, supplying most of the world's sugar and much of its coffee and cotton. Such productivity was afforded by the fact that the vast majority of the occupants of the island were ruthlessly driven slaves, who finally responded to their conditions with a bloody revolt in 1791. The reasons for France's consternation over the uprising (which would culminate in the 1804 establishment of Haiti as an independent black-ruled republic) are obvious. North American concern, however, had less to do with Haiti's threat to the old world order (the United States had of course offered the first blow to colonialism in this hemisphere) than with fear of the political conscientization of this country's own slave population.

In 1804, Haiti and the United States were the only independent states in the Western hemisphere. Haiti was the only black-ruled republic in the world, and it represented to the United States a terrifying vision of its own ostensible political philosophy. It was all too close for comfort—and in fact, Haiti's "troubles" began to wash up on U.S. shores. In 1793, French colonists began fleeing the island with their slaves. Many of them went to Louisiana. This Haitian influx is what led to the cultural "contagion" recorded by Ishmael Reed in *Mumbo Jumbo*. It also led to the first wave of epidemiological theories directed against Haiti, including those recorded in Wideman's "Fever."

The United States didn't acknowledge the Haitian Republic until 1862. But that doesn't mean that both Europe and the United States didn't exploit the well established productivity of the island. Haiti was politically ostracized by the rest of the world, but it continued to function, in a thoroughly inequitable way, as part of the trade triangle of Europe, the United States, and the Caribbean. For its political "crimes," Haiti was forced to enter into the most disadvantageous of trade relations. The exploitation of slavery was simply shifted into the exploitation of circum-Atlantic trade.

By the second half of the nineteenth century, the United States dominated trade relations with Haiti, as it did with the rest of Latin America. Because of economic interests, this country maintained a virtually uninterrupted military presence on and off the shores of Haiti. And because of both these pressures, economic and military, the Haitian government, it could well be argued, never stood a chance of stability. Internal conflict prompted the United States to formalize and solidify its role in Haiti: In 1915, the U.S. marines occupied the island, fully assuming its governance. They stayed until 1934. It is true that this occupation came at a time of political collapse in Haiti, which was accompanied by violence. The marines established a form of order, but not without its own violence. Thousands of Haitians died. When they left, the marines had effected a number of infrastructural improvements, but they also left behind a deeper structure: a structure of dependency on the United States

This has proven the most difficult structure to disassemble. It led to a series of Haitian governments seemingly more beholden to U.S. interests than to the people of Haiti. The most famous of these was François Duvalier ("Papa Doc"), who was ostensibly elected democratically in 1957. He was the military party's candidate, and all historians concur that the results of the election were rigged. He declared himself President-for-Life, and

enacted legislation so that his young son, Jean-Claude ("Baby Doc") would be able to assume his position on his death. Papa Doc instituted a shockingly brutal security force, nick-named the "Tonton Makout," who terrorized any and all opposition. The force remained in place during the reign of Baby Doc. Both Papa Doc and Baby Doc were friendly to exploitative U.S. business interests in Haiti, and both had the full support of U.S. administrations, despite awareness of clear human rights abuses. But untenable labor conditions and repressive political violence led to increased desperate attempts by Haitians to escape to the United States. These "boat people" risked their lives to get out, only to be denied asylum as "economic" and not "political" refugees. But their persistence in fleeing, and the success of some in staying here in the United States, began to change public and political perceptions of Duvalierism. Baby Doc was ousted in 1986, when the Reagan administration finally became convinced that his ship, too, was sinking.

After Baby Doc's ouster, Haitian peasants took to the streets, razing images of the oppressive regime. The process was called *dechoukaj* (uprooting). Tonton Makout were killed in retaliation for years of murder and brutality. Meanwhile, the military assumed power. The leader, General Henri Namphy, had served under both Duvaliers. Effectively, little changed in the political stance of the government. But a sense of possibility was achieved, in part through the violent "cleansing" performance of *dechoukaj*. In 1991, elections were held, and at last, a populist, politically progressive candidate came to power. Jean-Bertrand Aristide served as president from February until September, when there was a military coup, spear-headed by Brigadier General Raoul Cédras. Namphy returned with a vengeance, reinstating the terror practices of the Tonton Makout, only apparently "uprooted" after Baby Doc's fall.

The complicity of the CIA in the undergirding of the Haitian military prior to the coup, as well as in a smear campaign of Aristide, is by now well documented and widely accepted. North American consciences, though, seem to have been assuaged by the subsequent U.S. military intervention which allowed Aristide to return. This part of the story, the apparently heroic salvaging of an island torn by political chaos and violence, is more complex than it was presented by the U.S. media. Placed in the context of the history I have briefly outlined here, it becomes clear that U.S. occupation was not a novelty in Haiti, but a deeply entrenched part of a history of oppression. Aristide returned beholden to the United States, and at any

moment that he appeared to have forgotten that, he was sharply criticized by the U.S. press. *Dechoukaj* had seemed for a moment like a rite of purification. But the hardest root to yank from Haitian soil was the root of U.S. political interest.

The entire history I have outlined above could be retold. I have used the terms here that are generally invoked in Western historiography to account for revolution, change, political manipulation, and the struggle for justice. But in popular Haitian accounts, other terms and other explanations are sometimes invoked. Terms like Gede, Baron Samdi, Ogou. These are not simply abstract, mythic, ahistorical principles that serve to configure the significance of events. The *lwa* also enter directly into historical conflicts, and participate in them.

Both popular and official histories of the Haitian revolution hold that the first massive, bloody uprising in August of 1791 was preceded by a Vodou ceremony. A Jamaican-born *oungan* named Boukman (referenced by the band "Boukman Eksperyans") presided. CLR James records the event in his classic account of the revolution, *The Black Jacobins*:

> Boukman gave the last instructions and, after Voodoo incantations
> and the sucking of the blood of a stuck pig, he stimulated his follow-
> ers by a prayer spoken in creole, which, like so much spoken on such
> occasions, has remained. "The god who created the sun which gives
> us light, who rouses the waves and rules the storm, though hidden in
> the clouds, he watches us. He sees all that the white man does. The
> god of the white man inspires him with crime, but our god calls
> upon us to do good works. Our god who is good to us orders us to
> revenge our wrongs. He will direct our arms and aid us. . . ."[5]

While the official histories don't overtly claim that the *lwa*, incorporated in African bodies, actually fought the battles which led to independence, they do imply that Vodou *as a religion of resistance* gave a unity of spirit to the struggle.

If Vodou was an important part of the dynamic history which led to independence, it would return as an important force in Haitian politics. After the 1915–34 U.S. occupation, Haitian nationalists again invoked pop-

ular belief in attempting to reestablish national identity. The renewed importance of Vodou in Haitian political thought was at least in part a *response to* U.S. pressures, and yet it culminated in an ugly irony. François Duvalier was trained as both a physician and an ethnologist. He had a profound understanding of the intimate relation between African religion and political history in his country, and he manipulated the relation in solidifying his power. He named the notorious security force Tonton Makout after a "bogeyman" figure from popular belief. A number of these security officers were Vodou priests recruited to the force because of their already established positions of power among the majority peasant class. Duvalier himself modeled his public appearance after Baron Samdi, a particular aspect of Gede. When Baron Samdi "possesses" a serviteur, he dresses in precisely the uniform in which Duvalier always appeared: a black suit, white shirt, thin black tie and horn-rimmed glasses. This outfit hardly caught the attention of North Americans as African religious garb. No documentation was gathered by the CIA to demonstrate Duvalier's use of his office to promote "voodoo." But every Haitian recognized the cultural referent.

Duvalier claimed not only academic but occult knowledge of Vodou:

> Stories are told about Vodou ceremonies in the National Palace during which Duvalier was possessed by his *gwo* Baron (big Baron)....
> With his Gede riding him, Duvalier made a great show of knowing intimate details about the lives of those who worked closely with him—information that had in fact come from a network of spies.[6]

Whereas Duvalier's public persona, his suit and tie and his academic training as a *docteur* (both of medicine and ethnology), made him appear to the West as a man of Western understanding, it made him appear to Haitians as the ultimate insider of Haitian cultural knowledge.

It is tempting to say that the *lwa* were righteously invoked by Boukman, that they fought the valiant battle for independence, and that they were subsequently falsely manipulated by Duvalier for political ends they would not themselves have supported, being, after all, the African gods of the Haitian people, not puppets of U.S. business interests. And yet this is something of a simplification. The *lwa* and their motives were never "pure." Duvalier *was* a manipulator of cultural images, however, and the political *and* spiritual fall-out has been devastating. One of the "roots" most

violently attacked by *dechoukaj* was Vodou. Because of the association between the Tonton Makout and Vodou, many priests were persecuted regardless of their political involvements. Religious articles were destroyed, ceremonies shut down. This "cleansing" coincided with the U.S. press's morbid fascination with the association between "voodoo" and the political chaos in Haiti.

In an article titled "The Crisis of the Gods: Haiti After Duvalier," Joan Dayan recorded the bitter irony of the *dechoukaj* of representations of Vodou. Instruments of African religious belief were destroyed along with emblems of U.S. political influence, all of which had been identified with Duvalier. Meanwhile, the fascinated U.S. press was giving lurid accounts of the fallen regime's links to "voodoo." Dayan's response was relatively understated:

> When the press talks about Duvalier's dictatorship and how it was supported by houngan Tonton Macoutes (ever stressing the links to vodoun), we should not forget that this dictatorship was staunchly supported by the United States.[7]

What this means, really, is that if Duvalier was "possessed," it was by a thoroughly syncretic *lwa* which was as much the crony of Miami-based businessmen as it was the African master of Haitian cemeteries.

Syncretism is a vexed issue in the scholarship on Vodou, and on African diasporic religion generally. The term has a complex history.[8] It was first a derogatory term used by Christian scholars to discuss "corrupted" Christian belief. Ethnologists adopted the term, ostensibly emptying it of its negative value. In a culturally relativistic context, syncretism simply described the process of cultural mixing, particularly that of religious belief. And yet the evaluative aspect of the term didn't really fall out. In certain ethnological accounts of African diasporic religion, syncretism is perceived either as the unfortunate consequence of the repression of "pure" African belief, or the brilliant, culturally creative solution to political pressures. These discussions are recomplicated by the tensions raised in comparing African-European cultural contact and interaction here in the United States with the process as it played out in Latin America and the Caribbean.

Albert J. Raboteau's *Slave Religion* is an example of what was, for many years, the normative account of Latin American and Caribbean syncretism:

African religions have traditionally been amenable to accepting the "foreign" gods of neighbors and enemies. . . . No fundamental contradiction existed between veneration of the Virgin Mary and the saints in Catholic piety, on the one hand, and devotion to the *orisha* and *vodun* in African religions, on the other.[9]

Raboteau, like Melville Herskovits before him,[10] attributes Latin America's more evident "Africanness" (in comparison to the United States) to the syncretic possibilities afforded by more ritual-friendly Catholicism. Subsequent scholars have argued against this position from a variety of perspectives. Some have held that emptying syncretism of its negative evaluative aspect has depoliticized its history—it must be viewed as a violence perpetrated against the integrity of African cultures. Some argue that it never really took place: that altars containing Catholic imagery were merely subterfuge, a fake Catholic piety which allowed Africans to sustain their true, African beliefs. But increasingly, young scholars influenced by postcolonial theory approach the notion of syncretism with political enthusiasm, using it as a model for a dynamic, flexible response to cultural collisions.

Much of this political debate, however, neglects the fact that cultural mixing within Vodou and other African diasporic religion is not simply the combination of one discrete African system with another discrete European one. Multiple African cultures encountered each other in the Americas, and the various images of popular and official Christianity were themselves sometimes in conflict.

In rural areas of Haiti, certain Vodou communities distinguish themselves according to the particular African cultures (*nanchons*, or nations) which inflect their worship. But in urban areas, the religion is unified, although bifurcated. The two branches, as I have mentioned above, are *Rada* and *Petwo*. As usual, there are conflicting historical explanations for the division of the Vodou pantheon into *Rada* and *Petwo* branches. Cultural historians basing their work on genealogical tracing of forms, such as etymology, argue convincingly that the *Rada lwa* came down a relatively intact line of Dahomean belief. They strongly resemble their counterparts worshiped today in Benin. The *Rada* entities are sometimes referred to as *lwa rasin*: "root" spirits. *Petwo lwa* are traced to primarily Kongo origins, although some other admixture of both African and indigenous religious figures is acknowledged. Zora Neale Hurston posited

basically this genealogy in the 1930s, and it is still argued by contemporary scholars, each mounting of evidence marked by the scholarly community as a new piece of a puzzle.[11]

This argument seems new each time it is elaborated, in part because of the persistence of the other narrative of Vodou's bifurcation. In this story, *Rada* continues to represent a kind of African cultural purity through a Dahomean line. But *Petwo* is held to be "American," not simply by virtue of its indigenous elements, but because it is held to have split off from *Rada* because of the rage provoked by slavery. The *Rada lwa*, as I have said, are "cool" divinities: sweet-natured, water-loving entities who provide images of comfort, luxury, and peace. Most of the *Rada lwa*, however, have their "hot" counterparts in the *Petwo* pantheon: angry, bitter, fire-eating entities who express the community's collective rage. Deren gives a stunning example:

> [W]hereas Erzulie, the Rada Goddess of Love, who is the epitome of the feminine principle, is concerned with love, beauty, flowers, jewelry, femininities and coquetries, liking to dance and to be dressed in fine clothes, weeping in a most feminine fashion for not being loved enough, the figure of Erzulie Ge-Rouge, on the Petwo side, is awesome in her poignancy. When she possesses a person, her entire body contracts into the terrible paralysis of frustration; every muscle is tense, the knees are drawn up, the fists are clenched so tightly that the fingernails draw blood from the palms. The neck is rigid and the tears stream from the tightly shut eyes, while through the locked jaw and the grinding teeth there issues a sound that is half groan, half scream, the inarticulate song of in-turned cosmic rage.
>
> Petro was born out of this rage. It is not evil; it is the rage against the evil fate which the African suffered, the brutality of his displacement and his enslavement. It is the violence that rose out of that rage, to protest against it.[12]

The image, and the argument, have a poetic power and cohesiveness that make them continue to have currency, despite the strong claims of a *Petwo*–Kongo genealogical connection.

The two theses of *Petwo*'s origins are not necessarily in conflict. Karen McCarthy Brown has suggested that a "case can be made that the contrast between Rada and Petwo is that between two archetypal social groups: family members and foreigners, insiders and outsiders, the oppressed and

their oppressors."[13] In this sense, even inter-African syncretism can carry the significance of the threat of otherness incorporated into one's own belief. That is, *Petwo lwa* represent a kind of dangerous foreignness, but foreignness brought together with the familial pantheon.[14] The merging of mythical and historical narratives (the notion that the *Petwo lwa* were born of the violences of slavery) shows that these principles of conflict are not simply abstract.

And what of Duvalier? What was the syncretic significance of his Baron Samdi? Baron Samdi's very apparel shows that he had Western affinities which preceded Duvalier. Yet Duvalier's *lwa* demonstrates how complicated syncretism can become. The United States saw in that Baron Samdi an image of our own business interests—and we were absolutely right. Our own political and economic presence in Haiti means that *the United States is a part of Vodou,* however much our media may represent "voodoo" as antithetical to U.S. values and beliefs.

This doesn't mean, however, that North American interests have "infected" Vodou, leaving it a necessarily compromised religion. Brown, writing in 1991, placed the political possibilities of Vodou in perspective:

> People often ask if I think Vodou keeps the people of Haiti poor and oppressed. I respond that although Vodou, like every other religion, has sometimes been misused by tyrants and scoundrels alike, guns and money have far more to do with perpetuating the suffering of Haitians than religion does. Vodou comments on and shapes life, but it hardly creates it ex nihilo. If the Haitian army were not thoroughly corrupt, if little Haiti were not in the backyard of one of the world superpowers, if Haitians in New York were not regularly losing jobs because someone fears that they have AIDS or practice "black magic," then perhaps a question could be raised as to whether Vodou is a positive force in Haiti. But if those things were different, Vodou would also be different. Vodou works within the realm of the possible and practical.[15]

INFECTING HAITI

The United States has had a hand in Haitian politics—and Vodou—since the revolution. And Haitian culture has been a part of this country for as long. *Mumbo Jumbo*'s celebration of the vital *lwa* in New

Orleans is the flip side of the racist accounts of Haitian "infection" in "Fever." The terrifying contagion which the United States really feared in 1793 was the contagion of black political empowerment. This fear has resurged periodically, and has consistently expressed itself in terms of "voodoo" and epidemia. Farmer cites a 1920 *National Geographic* article (written, of course, during the marine occupation) which estimated that "four-fifths" of the population practiced the "black rites of voodoo magic," while "87 percent of the population were infected with contagious diseases."[16] It is obvious what these statistical estimates are insinuating: that the "black rites of voodoo magic" *are* the dangerous infection. Similar conflations of "voodoo" and epidemia were made in the U.S. media at the time of the most recent military occupation of Haiti. Now, the not-so-subtle insinuation was that "voodoo" could give you AIDS.

The blood of a history of colonial and anticolonial violence, the blood of blood sacrifice, the blood in a test-tube marked HIV-positive—all these bloods ran together in accounts that attributed Haiti's political upheaval to "cultural" factors. And as U.S. news broadcasts played at ethnology, explaining to audiences that they could never "understand" Haitian politics until they "understood" the prevalence of voodoo, Cédras and his crew took full advantage of the situation, warning that they would invoke all manner of weapons, natural and supernatural, to counter any foreign invasion. As journalist Kate Ramsey noted, the Haitian military "tried to turn American ideas about 'voodoo' into a weapon against the invaders":

> Take the notorious "voodoo powder" that got so much media play. Magical and poisonous, reportedly mass-produced and hoarded in "voodoo" laboratories across the country, the powder revived the alarm that spread across the New World colonies in the 18th century with rumors that Maroons were systematically poisoning plantation food and water supplies. But the powder updated these fears of contamination. According to recent pronouncements, it was made out of the bones of Haitians who have died of AIDS, exploiting medical myths of a Haitian or even "voodoo" origin for the virus.[17]

I have already mentioned the astonishing article published in the *Journal of the American Medical Association,* "Night of the Living Dead II: Slow Virus Encephalopathies and AIDS: Do Necromantic Zombiists Transmit HTLV III/LAV During Voodooistic Rituals?"[18] The source of ethnological

information behind this article was also the source of anxiety over "voodoo powder"—a book I mentioned in the first chapter of this one: Wade Davis's 1985 ethnobotanical adventure story, *The Serpent and the Rainbow*. Wade Davis's depiction of himself in this book bears a remarkable resemblance to the character of Jerome Blanc in *Ashakara*, and the thought has struck my mind that the latter was based on the former—now transforming him from merely a Haitian sympathist to an authentic Haitian. Davis (the character in his own "non-fiction" book) is a well-meaning, politically astute ethnobotanist, funded by pharmaceutical interests out to make a buck. He is charged with discovering the chemical preparation which provokes zombification. After "swashbuckling" adventures (as the book's jacket puts it), Davis finds a powder with some interesting chemical properties, but concludes that this substance loses its specific efficacy when cut off from its cultural context. Along the way, Davis remarks not only on the admirable humanistic healing tradition of Vodou and its herbalogical sophistication, but also the righteousness of the struggle of Haitian people to escape political exploitation.

The arguments are, of course, similar to the ones I have been making. The reason I mark Davis's narrator, however, as distinct from Davis as writer is that he proceeded to allow his book to serve as the basis for one of the most astonishingly racist and xenophobic films ever to depict Haiti and Vodou. The film *The Serpent and the Rainbow* was directed by Wes Craven, of *Friday the 13th* fame. Why Davis decided to sell the rights of his book to the most sensational, gory director of perhaps all time (despite his own descrying of "the sensational and inaccurate interpretations [of Vodou] in the media, Hollywood in particular")[19] is not so difficult to imagine. A tame ethnobotanically inflected documentary about a "pharmacologically active compound" could hardly have paid the fee Craven was able to offer. And so Davis's inconclusive hypothesis that a white powder might possibly lower metabolic function when applied topically or inhaled, such that an individual might temporarily appear dead, was translated into screen images of black men with bulging eyes whose heads explode off their necks, slithering snakes wriggling out of their gaping decapitated bodies. Meanwhile, voodoo priests are running around gleefully blowing fistfuls of something that looks like baking soda into the faces of unwilling victims.

At the time of the most recent occupation, Wade Davis was again in demand. He appeared as a cultural consultant on CNN, and was introduced as the author of "the book and the movie," *The Serpent and the Rainbow*.

Asked about the significance of Vodou in the political crisis, Davis repeated the argument he put forth in his book: that Vodou is an ancient, community-oriented, sophisticated cosmology accompanied by an equally sophisticated tradition of herbal healing. As he spoke, however, Davis's talking head was shifted over to one side of the screen. The other side ran stock footage of a writhing, sweating serviteur in the throes of spirit possession. There is little satisfaction in seeing Wade Davis's own talking head severed from his message by the same sensational images he helped to propagate.

This "documentary footage" was in all likelihood shot in the same context in which Davis himself admits to having first encountered Vodou: in a "commercial" ceremony open to paying tourists.[20] Outside of such a context, filming of the *lwa* rarely takes place. The fact that Vodou is performed for tourists (or was, until fear of AIDS and political violence virtually shut down the tourist industry) is not to say that these ceremonies are necessarily inauthentic. As I have already argued, the desire to locate "pure" ritual is always questionable, and the *lwa* have been known to adapt to circumstances in sometimes surprising ways. But it does mean that a U.S. camera and the "voodoo" beliefs of a U.S. audience are reflected in the *lwa* who dances for them. This is precisely what Jean Rouch argued when he acknowledged that his own filming of the Hauka was itself a form of "possession."

Finally, Clinton justified the U.S. intervention to the "American people" not on the basis of international human rights, but on the basis of the threat of Haitian immigration. Whether that was Clinton's true, personal motivation or not is as impossible to determine as Wade Davis's "real" feelings about Vodou. In any event, the argument worked. But if North Americans thought they achieved a hygienic barrier between themselves and Haiti through the military operation, they were simply not aware of the voodoo ritual they themselves enacted each night as they watched the news.

There is also, of course, a literal Haitian presence here in the U.S. Vodou practitioners like the gracious, wise, and strong woman depicted in Karen McCarthy Brown's beautiful book, *Mama Lola: A Vodou Priestess in Brooklyn*, are sometimes forced by U.S. cultural misconceptions to express their beliefs within the closure of a supportive community.[21] But the Haitian-American community is also capable of righteous public displays of their convictions. On April 20, 1990, eighty thousand Haitian-Americans partic-

ipated in a demonstration against the policy that prohibited them from donating blood. In retrospect, all public health experts recognize that the ban on Haitian blood was epidemiologically uncalled-for. The isolated policy of *ethnic* association of Haitians with HIV could only have happened within the context of the history of fear I have outlined in this chapter. That policy only served to augment North Americans' voodoo beliefs: it resulted in increased discrimination, including a surge in violent attacks on Haitians here. But the unprecedented and completely unanticipated show of public solidarity on the part of this community succeeded in reversing the racist policy.[22]

Brown writes that while she once assumed that Vodou could be seen as having two sides—a side of herbal healing of personal ills, and a side of public, community-binding ritual—she later came to see that "there is no Vodou ritual, small or large, individual or communal, which is not a healing rite."[23] The political manifestation, too, is a healing act fighting a greater ill than HIV. North Americans need have no fear of a foreign element infiltrating this country with the contagion of racism. The question is what ritual will heal our own ills.

RE-POSSESSING FILMIC IMAGES

Maya Deren didn't set out to be an ethnographer. In 1947, she landed in Haiti with a Guggenheim Fellowship to make an experimental—*not* an ethnographic—film. She had already produced four such films ("Meshes of the Afternoon," "Ritual in Transfigured Time," "Atland," and "Choreography for the Camera"), but even her experimental filmmaking had developed out of her first artistic impulse: dance. Her plan was to spend eight months shooting, and ultimately to create a film "in which Haitian dance, as purely a dance form, would be combined (in montage principle) with various non-Haitian elements."[24] When she wrote the preface to *Divine Horsemen* in 1951, she noted that the reels of film remained unedited "in a fireproof box in the closet." Her experiences in Haiti ultimately convinced her that an "artistic" appropriation of Vodou's choreographies without attention to their context and meanings would be—precisely—meaningless. And so, "defeated" as an artist, she devoted the next four years to fieldwork and bibliographic research of the religion, and to the writing of her own ethnography.

While Deren rejects her initial desire to record and manipulate Haitian culture within her own aesthetic, she does suggest that her position as an artist allowed her to perceive certain aspects of the religion which were not apparent to methodologically trained anthropologists:

> I am not suggesting that my attitude was or could be one of complete passivity. Rather, it was a deliberate discretion, reflecting a strong distaste for aggressive inquiry, staring or prying, and which both resulted from and was rewarded by a sense of human bond which I did not fully understand until my first return to the United States.[25]

This deliberate discretion is precisely the attention to silence which I have called for throughout this book.

Silence is what rings in the ethnographic film "Divine Horsemen," which was posthumously compiled from Deren's long-stored footage. Deren herself had considered editing her "artistic" material into a film that would correspond to her ethnographic book, but she never did it. Deren died in 1961, at the age of forty-four. The film, shot between 1947 and 1951, was composed posthumously, in 1985. The sound was edited by Teiji Ito, who lived with Deren for the last nine years of her life. The images were edited by his wife, Cherel Ito. The narration is derived from fragments of the text of Deren's book, read alternately in male and female voices. As an ethnographic film, it seems disconcertingly, almost stodgily authoritative—particularly when Deren's words are given male voice.

But given what we know of the circumstances in which the film was shot, given what we know of Deren's own inability (or disinclination) to force the material to fit into a systematic mold, what seems to resonate in this film is not its staid posthumous narration, but rather the apparent fact that it really wasn't meant to be. That doesn't mean that the images aren't powerful. Virtually all the footage was shot in slow motion, with close attention to formal elements. The killing of a sacrificial chicken becomes an exquisitely graceful ballet of undulating mass and splayed white feathers. The throes of dancers receiving the *lwa* become perfectly abstracted motion—slowed down as though they moved through water. The play of cinematic light and dark (the footage is all, of course, black and white) recalls the phrase that Deren used to describe the experience of spirit possession: "the white darkness."

"The White Darkness" is the title of the last chapter of Deren's book—its climax, where she describes her own possession by the *lwa* Ezili.[26] The book, like the film, articulates silence: at the moment of her possession, Deren's prose breaks off. She gives you three asterisks, a strange, italicized, lyrical consideration of "abysses," and three more quiet little stars.[27] But if Deren possessed by Ezili couldn't appear in the book, there is an image of Ezili in the film. As the narrator duly notes Deren's observation that virtuosic dance in a Vodou ceremony is not a sign of the individual dancer's skill, but rather of divine inspiration, the camera, in slow motion, is loving—is *worshiping*—the motion of a woman dancing for the *lwa* of seduction. Like Ezili herself, it is almost unbearably graceful.

Deren was a dancer, and she understood how rhythm provokes possession. African diasporic possessional music is syncopated—that is, it produces a regular irregularity in the rhythm—and that rhythm is further "broken" in order to facilitate the entrance of the divinities. This means, in part, the sharp slap of a stick or the palm of the hand where a beat is unanticipated. But anyone who has danced the choreographies of the *lwa* can tell you that the *suspended* beat, the silenced beat which precedes the slap, is what propels the body, pitching it into the abyss of sound.[28]

The film "Divine Horsemen" says most when one senses its own suspension. Deren couldn't bring herself to bring it to completion—but its images *are* powerful. Could she have suspected they might be exploited (like Davis's) or misunderstood (like Rouch's)? Despite their years in the closet,[29] or maybe because of them, Deren's images are perhaps the most eloquent counter-representation to the racist and xenophobic film depictions of Haiti that preceded and followed it. Deren knew she couldn't, as an artist, possess the external forms of Vodou, and finally she desired to be possessed by them. What do we possess when we possess this film? The image of "passive" ethnography's impossibility, perhaps, but also the significance of deliberate discretion, and silence.

SIX

Mixing Bloods

The L.A. Riots[1]

It seemed utterly spontaneous. On April 29, 1992, the Simi Valley jury announced its verdicts, and minutes later Los Angeles was "out of control." But of course it didn't all begin at that moment. It didn't even begin in March of 1991, when Rodney King was savagely clubbed by the LAPD, as George Holliday videotaped the beating from his apartment. The body being beaten like a drum had a long history, and the rhythm of the blows was all too familiar, even if the soundtrack was silent on the repeated national broadcasts.

Shortly after the incident, George Holliday tried to present his videotape to the LAPD. When they appeared disinterested, he took the tape to a local television station, which aired it. The image was immediately picked up by the networks and within twenty-four hours it had gone global. The spread of the image, its reproduction and transmission from one network to the next, was provoked and accelerated by what the image itself implied:

that it was not an isolated incident, but one recorded event among many others which went unrecorded. The possession and reproduction of the video image of Rodney King seemed to be the filling of a vacuum of images of other beatings. That vacuum was made sensible by King's image. Of course, black residents of Los Angeles were not unaware of endemic police brutality—nor were black residents of other cities unaware of pandemic violence. This was why the image resonated across the country, and across the globe. The shocking thing about George Holliday's videotape was not that the beating occurred, but that Holliday had managed to capture it. The absence of a record of other beatings is what made the reproduction of this one so compelling.

While most analyses of the significance of the riots have focused on the specific conditions in Los Angeles in 1992, what was expressed was an outrage which transcended its local context and its historical moment. The fact that the violence didn't spread, or that "outbreaks" in other cities appeared contained and controllable, led many to the conclusion that L.A.'s problems were specific, not isolated, but of a more virulent strain. But the theory of particularly tense relations between the LAPD and an economically and socially oppressed black population couldn't really explain the riots. When the dust had settled, this black-and-white explanation seemed too simple to accommodate other factors, such as the apparent targeting of Korean businesses, and the large number of Latinos apprehended.

The 1992 riots were more complicated than the Watts uprising in 1965. David O. Sears was part of a team of social scientists who attempted to analyze the 1965 riots. Although some commentators had initially viewed Watts as an example of "social contagion"—violence which spreads spontaneously by pure proximity—Sears and his colleagues found that "whereas social contagion was no doubt widespread and accounted for some of the rioting, the data argued against its being the *principal* or primary explanation."[2] The basis of the riots, they concluded, was real and reasonable social discontent, which was expressed as meaningful black *protest*. Sears argues that although in contrast to Watts the 1992 riots appear more chaotic and unreadable,[3] there was again a *basis* of significance, which was black protest. What made the message of 1992 harder to read was the complexity of L.A.'s changing demography. Latinos actually appeared to have taken a greater role than blacks in the disturbance, at least

according to arrest statistics. Korean businesses suffered disproportionate damage. And yet one could not simply assume political sympathies between Latinos and blacks, Asians and whites. Interethnic racism and xenophobia exists between all of these groups in Los Angeles.

Sears sees the apparent chaos of 1992 as brought on by a process of contagion—but not "social contagion." It wasn't the violence of the riots themselves provoking further violence, but historical violence. And that historical violence—the violence of slavery—continues to infect social relations in this country even as the population becomes more diverse: "We continue to reap the diseased harvest of decisions made in the 17th and 18th century."[4] The disease of history manifests itself in the propagation of racism and xenophobia among the increasingly global population. It was, as Haki Madhubuti put it, "same song, different rhythm."[5] It was infectious polyrhythm.

So I return to a question I posed in the preceding chapter: If North Americans need have no fear of a foreign element infiltrating this country with the contagion of racism, if rather the danger is the transmission of our own historic racism and xenophobia to the increasing immigrant population, what is the ritual which will heal our disease? Was the videotape of Rodney King's beating a re-possessed image of our culture's violence? And were the riots that followed it a kind of *dechoukaj*, an uprooting of the kind that followed the downfall of Baby Doc? If they served as a form of ritual uprooting of a history of injustice, then was there any healing?

One event spurred by the riots forced even those who had viewed the violence as "social contagion" to acknowledge that something significant had come of it. That was the truce between the two major rival black gangs in Los Angeles, the Bloods and the Crips. The stark images of interethnic violence, including the tape of Rodney King's beating, made it all too clear that if *any* violence was senseless, then it was black-on-black. The Bloods mixed with the Crips. They composed a proposal to the City of Los Angeles for restoration and restructuring of South Central. They demanded business opportunities for black residents, improved living conditions, educational resources, and health care. They also proposed a "buddy system" in which former gang members, armed only with *video cameras*, would accompany the LAPD on arrests. If the city collaborated with them on these demands, the Bloods and Crips promised to eradicate the drug trade in Los Angeles. And they promised something else:

Additionally, we will match funds for an aids [*sic*] research and awareness center in South Central and Long Beach that will only hire minority researchers and physicians to assist in the aids [*sic*] epidemic.[6]

This promise, which was also a demand, demonstrates the degree to which the prevalence of HIV in the black community is tied, in the mind of that community, to political oppression, and specifically to police violence.

If the Bloods and the Crips were concerned with a community's self-healing, the same couldn't be said of the LAPD. Daryl Gates was Los Angeles Chief of Police from 1978 until shortly after the riots, when he was forced to step down due to criticism from virtually every side for his actions during the riots. Gates had a long history of inane and insensitive responses to accusations of police brutality. In one case, a jury even demanded that he pay part of a victim's damages out of his own pocket because his in-court dismissal of suspects' rights was so offensive. As Mike Davis wrote in his 1990 *City of Quartz*, "'physician heal thyself' is not Chief Gates's favorite motto."[7]

The truce between the Bloods and the Crips was a gesture toward healing. But gang violence will only cease when systematic violence, including police violence, ends. Gang violence isn't restricted to black areas. Davis reports:

> Aside from the 230 Black and Latino gangs which the LAPD have identified in the Los Angeles area, there are also 81 Asian gangs, and their numbers are also rapidly growing . . . everywhere in the inner city, even in the forgotten poor-white boondocks with their zombie populations of speed-freaks, gangs are multiplying at a terrifying rate, cops are becoming more arrogant and trigger-happy, and a whole generation is being shunted toward some impossible Armageddon. . . . This very real epidemic of youth violence, with its deep roots . . . in exploding youth poverty, has been inflated by law enforcement agencies and the media into something quite phantasmagoric. . . . Meanwhile an Andromeda Strain of Crips and Bloods is reported to have infected the entire West, from Tucson to Anchorage, before invading Middle America itself (with new sightings from Kansas City to Buffalo).[8]

Davis acknowledges that gang violence is real, and yet argues that the proliferation of exaggerated media accounts provokes a scare which fulfills itself. As fear rises, policing increases, and so does the violence. The invocation of white zombification as a part of the epidemic of course resonates with depictions of mass unrest in Haiti. It may be an unfortunate metaphor, but it only confirms what we have already suspected: legitimate black political protest, "black magic," and brown, yellow, and white blood are all in the discursive mix.

THIS IS NOT AMERICA

Asian gangs in Los Angeles are not exactly offshoots of the black gangs, and yet their existence demonstrates that some Asians in the city are dealing with some of the same social problems that have led to the proliferation of gang culture among young blacks and Latinos. And yet during the riots, this connection seemed to fall out—at least in media representations. David Palumbo-Liu has argued that during the riots the media projected images of Asians as ciphers for whiteness, such that whites could effectively remain spectators, with Asian "doubles" filling in for their own fears of property loss and personal violence.

Palumbo-Liu examines, in particular, a striking photograph that appeared in *Newsweek* magazine with the caption, "This is not America." The photograph shows a young Korean man holding a gun. The smoke of arson billows behind him, but he himself seems to embody the more immediate threat: his gun is raised and ready, and on his t-shirt is a photographic image of Malcolm X in an almost identical position, gun raised, but gaze averted as he peers through window blinds over the legendary phrase, "By any means necessary."

Newsweek was not alone in juxtaposing the image of Malcolm X with that of the events provoked by the image of Rodney King. In the opening of his film, *Malcolm X*, Spike Lee inserted, without commentary, the video footage of King's beating by L.A. cops which brought to the public eye the violence perpetrated on a black man, first by the police, and consequently by the justice system. The reductive account of the riots was that these two public revelations were "the straw that broke the camel's back," leading to mass violence against individuals and property. In the film, this contemporary image precedes a linear, historical account of X's life. Despite the lack

of commentary, the point seems painfully clear. The racism which necessitated Malcolm X's politicization still exists. We still need to take seriously his political directives.

The meaning of an image of Los Angeles, 1992, in the context of a film on Malcolm X is perfectly clear. The meaning, however, of the image of Malcolm X in the context of the L.A. riots is much more complicated. Palumbo-Liu reads *Newsweek*'s use of this photograph like this: While the framed photo shows Malcolm in opposition to the police, the bigger picture shows the Korean standing in their place, protecting personal property. His vigilanteism seems to give a skewed meaning to Malcolm's words, turning them *against* black resistance. "This is not America," then, an observation attributed to another disheartened Korean, appears to imply that Koreans came to the United States after the American dream, but somebody wrecked it. And the finger of blame seems stonily aimed at black Americans. Palumbo-Liu asks: "How has an icon of Black Power been uprooted from its historical specificity and appropriated, so that it now seems to sanction and even prescribe counterviolence against blacks and others who might *threaten* the dominant ideology?"[9]

The apparent vigilanteism of the photograph implicates the viewer/reader—calls on you to identify with the pain of loss of property, the loss of the American dream—and to acknowledge the necessity of violence in protection of that dream. Of course, there is another, even more explicitly racist reading which is possible of this photograph and its caption. That would be "This is not America"—i.e., white—it's a Korean immigrant who seems to feel entitled to white protection, but why should he be? That may sound extreme, and yet many have argued that this was precisely the thinking behind the LAPD, which did in fact fail to protect the property of the Korean American community, even as it hunkered down to ward off any possible assault on more affluent, white areas.

This is the irony, of course, of racially inflected violence between communities of color. Palumbo-Liu argues that the media manipulated the image of an Asian man to make him appear as the "deracialized" (in fact, reracialized) version of a Clint Eastwood- or Charles Bronson-style vigilante. If the heroic figure fending off a black threat had been imaged as white, then the racism of that figure would be too readable, merely justifying the outrage expressed in the riots. Palumbo-Liu ties this racial elision (Asians standing in for whites) to the racial elision of Latinos, whose mass

deportation in the wake of the uprising took the place of an illegal, unrealizable hegemonic desire simply to *get rid* of African Americans.

Palumbo-Liu's reading of the *Newsweek* photograph is multi-leveled and nuanced, but it does seem to me that one might argue that the image is more open than this reading admits. Every photograph implies a narrative—demands, in fact, that we create a story to accommodate it. One might read the narrative of this photo not just as a cowboy flick commencing with the image of an Asian vigilante. One might also read this picture *backwards*. That is to say, and it seems to me an obvious question, where did this man get this shirt, and what was he thinking when he bought it? What was he thinking when he put it on in a rush, to get over to the site of the riots?

There *are* impoverished Asians in L.A., and there are underclass Asians who identify with the black struggle. Malcolm X was also concerned about personal property. Palumbo-Liu points this out, although it seems to me something he ultimately downplays in his own reading. He quotes Malcolm X on the legitimate use of firearms when "the government has proven itself either unwilling or unable to defend the lives *and property* of Negroes."[10] Palumbo-Liu suggests that the defense of property is specious when the greater necessity is the defense of life. But this argument may not adequately address the gravity of loss of property even in Malcolm X's view. And loss of property and lack of economic opportunity are comparable terms—a suggestion with which Malcolm X surely would agree.

The *Newsweek* photo offers a possible reading of genuine Asian American-African American affiliation, rather than a stand-off. That may not be the "truth" of the photograph, but the possibility seems written into it. Finally, the image contains two contradictory meanings: Malcolm X's negation *and* embodiment in the body of a Korean man. This contradictory image, ironically, *is* America, and is Los Angeles, even as it locates both the city and the nation at the confluence of multiple diasporas, at the "dangerous crossroads" invoked by George Lipsitz, the place where bloods mix.

CONCRETE ARTERIES

If in Haiti the "crossroads" evoke Legba and all the dangerous possibilities of communication and miscommunication, in Los Angeles they evoke something else: traffic. At the time of the riots, New York

was tense, and yet the very place where that tension was most palpable was also the place where it seemed to be releasing itself: in the subway. New York is stratified by race and class, it has been the site of conflicts over police brutality, and yet it has something Los Angeles doesn't have: public transportation. Great snaking veins where diverse riders meet every day, body to body. Los Angeles has freeways. Mobile Angelenos strap themselves into their hermetic cars and go, never really needing to bump into another body at all. Laurie Hawkinson has put this in terms as hermetic as the cars themselves: "The situation—of the prosthesis or the car as a prosthesis for the body—is at a hyper condition in Los Angeles."[11]

Those who are carless in Los Angeles are essentially immobilized, confined to neighborhoods which are clearly demarcated by class and ethnicity. Los Angeles is often cited as an exemplary "global city"—and a sign of things to come, as urban populations diversify. "This is not America," as I have said, is both true and untrue, since cultural diversity is held as the sign of the nation. L.A. can be mapped as a U.S. metropolis—or as a miniature confederation of diasporic sites held in tense contiguity ("It's a small world after all"). The stark division of the "heteropolis"[12] into ethnically defined neighborhoods, as well as the disembodied, prosthetic way in which one travels through them, would appear to have created the most socially hygienic of terrains. And yet, as Foucault has argued, "the utopia of the perfectly governed city" is "the plague-stricken town."[13] That is to say, the disciplined metropolis, the hygienic city which contains populations, emphasizes individualism, eradicates crowds, is based on an assumption of infectiousness, which becomes, in effect, its reason for being. The notion of epidemia must be maintained.

The policing of the city and the control of its population takes place at the level of city planning, but also at the level of architectural design. Los Angeles' architecture has been read as the purest formal expression of postmodernism.[14] Its heterogeneity seems to evoke plurality, "multiculturalism," and yet it also evokes control. The L.A. architectural aesthetic of the last twenty years is characterized by brutal façades. Frank Gehry's famous armored constructions were viewed by some as an ironic, engaged response to brutal urban inequality, but others merely saw them as literal armor: the hunkering down of the privileged. Mike Davis describes "Fortress L.A.":

Welcome to post-liberal Los Angeles, where the defense of luxury lifestyles is translated into a proliferation of new repressions in space

and movement, undergirded by the ubiquitous "armed response". This obsession with physical security systems, and collaterally, with the architectural policing of social boundaries, has become a zeit-geist of urban restructuring, a master narrative in the emerging built environment of the 1990s.[15]

Davis paints a landscape of constant reminders to feared "intruders" that they are being watched. The ubiquity of surveillance cameras—outside of both affluent residences and public buildings—is intended not only to record intrusion, but also to deter it. The great irony is that it was precisely a video recording—of police violence—that provoked the storming of boundaries.

Foucault's observation on the necessity of the "plague-stricken town" in the development of urban control, interestingly, occurs in the opening pages of his consideration of "panopticism"—of the technique of surveil-lance. Jeremy Bentham's proposed "panopticon," an architectural model for disciplinary control through complete visibility, was published, coinci-dentally, in the year of the Haitian uprising. Foucault exploited the archi-tectural model as a theoretical model for the historical development of a notion of policing by surveillance. The panopticon "disindividualizes" power, apparently, as it is the mechanism, the architectural structure itself, which imposes a policing force. In this sense, those who operate the machine of surveillance avoid physical confrontation. In Foucault's words, in the panopticon, the external power "tends to the non-corporal."

The prevalence of machines of surveillance in Los Angeles, however, only appears to disembody power. Not every body is hermetically sealed in its social prosthesis, nor does all policing take place through surveillance. Rodney King was stopped for a traffic violation, removed from his prosthe-sis, and hammered back into a body.

"World City" Los Angeles, as it is marketed to national and internation-al tourists, is a remarkable admixture not only of cultures, but of social forms. Foucault demonstrates that a disciplinarity of surveillance in the West developed simultaneously with a social logic based on sex. Whereas feudal society had operated by a symbology of blood—not merely of lin-eage, but also of bloodshed, including social control through public dis-plays of violence—bourgeois society emphasizes sexual relations, the fami-ly, and control through the visibility of these relations. And yet within Los Angeles, these logics mix. The world of the Bloods and the Crips bears a

powerful resemblance to Foucault's description of a "society of blood":

> For a society in which the systems of alliance, the political form of the sovereign, the differentiation into orders and castes, and the value of descent lines were predominant; for a society in which famine, epidemics, and violence made death imminent, blood constituted one of the fundamental values. It owed its high value at the same time to its instrumental role (the ability to shed blood), to the way it functioned in the order of signs (to have a certain blood, to be of the same blood, to be prepared to risk one's blood), and also to its precariousness (easily spilled, subject to drying up, too readily mixed, capable of being corrupted).[16]

And while a seemingly feudal structure organized around a symbology of blood may appear anachronistic, it contracted its logic from the residue of blood society that has survived the transition in the West from "sanguinity" to "sexuality": racism.

> Racism took shape at [the] point [in the nineteenth century] ... that a whole politics of settlement (*peuplement*), family, marriage, education, social hierarchization, and property, accompanied by a long series of permanent interventions at the level of the body, conduct, health, and everyday life, received their color and their justification from the mythical concern with protecting the purity of the blood and ensuring the triumph of the race.[17]

Of course the infection of sexual society with sanguinity in the form of racism *also* took place in the aftermath of the first demonstration of significant black political power in the form of an uprising.

The irony of the 1992 riots is that they made manifest all of these historical and political contagions. Racism's infection of the nation of "family values" and "civility" with the spectacle of police brutality burst like a bloody lesion on the television screen. That blood spread, and mixed, as did the historical rhythms of other beatings. Mass violence, and particularly the destruction of property, was a resounding response to the lack of economic opportunity and to the hypocrisy of policing which held itself to be civil, but was at its root feudal, and oriented toward "protecting the purity of the blood." And it was finally those who had been depicted as car-

riers of the disease of feudalism and urban violence—the Bloods, the Crips, Rodney King himself—who called for civility.

Charles Jencks has argued that the configuration of Los Angeles as a fractious world polity "throws into sharp relief an overlooked truth: the city's problems are pre-eminently global and they will not be solved if they are treated as local or urban problems alone."[18] I would add that they must also be read in *historical* context. But Jencks goes on to argue that an understanding of the broader context of L.A. will mean, should mean, the dispersion of Gehry's aesthetic of "defensible" space. We need, he says, "to learn both greater tolerance *and* greater respect for boundaries."[19] And yet cultural, racial and class hermeticism seemed to provoke the tensions in Los Angeles in the first place. Boundaries are hardly lacking, nor are distances. The architect Michael Sorkin's solution, in contrast to Jencks', was to re-embody the city. He proposed an admittedly utopian "local code," a set of commands which could "infect" a plan for urban (re)construction. The fundamental goal of the "local code" is a city "which takes its measure from people on foot."[20] The Bloods and Crips made the same demand: embodied access to essential services, including health care. Deprostheticized, body to body, could Los Angeles be infected with undefensive tolerance?

EMBODYING TOLERANCE: ANNA DEAVERE SMITH

Understanding L.A. globally, ironically, means imagining it ever more locally. It doesn't stop at the level of the city block, of a space of walking distance. The real significance of the riots, while it comes from the furthest flung historical moments and geographical sites, rests, finally, *inside* the individual body that has been infected by this history. And this, finally, may be where the ritual of healing takes place.

Without a doubt one of the most therapeutic performances in the wake of the L.A. riots was Anna Deavere Smith's *Twilight: Los Angeles, 1992*, one installment of a long-term documentary theater project called *On the Road*. An earlier installment, *Fires in the Mirror*, was a response to racial violence in Brooklyn's Crown Heights. *On the Road* has literally taken Smith to different sites of conflict, and yet the idea is hardly a prosthetic journey: Smith's method for composing and internalizing her work is intensely intimate, face-to-face contact with the diverse players in each of these scenes. She conducts highly personal interviews with people

involved—white, black, Asian, Latino, rich, poor, frightened, angry, violent, damaged, compassionate. Smith records their words, records their gestures, inflections, mannerisms, and then, through repetitive rehearsal, attempts to *embody* them on stage. Critical responses to her performances have equally emphasized her astonishing mimetic capacity and her sensitivity to the complicatedness of race politics. Smith herself refuses to step outside of the language of the performance in order to situate her own political perspective. While she gestures toward the importance of tolerance, she speaks of her own project, generally, in spiritual rather than political terms.

Richard Schechner has located Smith's work outside of a Western theatrical tradition:

> Her way of working is less like that of a conventional Euro-American actor and more like that of African, Native American, and Asian ritualists. Smith works by means of deep mimesis, a process opposite to that of "pretend." To incorporate means to be possessed by, to open oneself up thoroughly and deeply to another being.[21]

Schechner goes on to argue that Smith's role in the theatrical ritual is like that of the shaman, who opens herself up to another entity in order to heal a "diseased or possessed patient" by exorcising his or her demons. In this configuration, spirit possession is both the disease and the cure. Schechner says that the violence of racial conflagrations reveals a society "possessed: by anger, racism, fear, and much misunderstanding."[22] When one says that Los Angeles was "diseased or possessed" by racism, which is the primary metaphor—disease or possession? Both terms operate as figures not only for racism, but also for each other, in a context in which spirit possession is held to be merely mimetic and "spiritual" disease is not accommodated by bio-logic. And yet possession also figures the cure. When I argued above that bodies in Los Angeles re-embody historical beatings when they are brutalized, I was describing a phenomenon that elsewhere would be enacted as the literal incorporation of ancestor spirits, in a ritual intended to heal history's repercussive wounds. And when I said that racism was "infecting" the increasingly global population, I was describing something that elsewhere might be illustrated by literal physical lesions requiring a spiritual salve.

Because of racist representations of African religion in the West, the

assumption is that when one speaks of a population or an individual "possessed," one is speaking of an atrocity. But spiritual incorporation is most often a technique of social *and physical* healing, as illustrated by the ceremony invoking Gede with which I opened the last chapter. Spirit possession is an opening of the body to divine principles that surpass the power or understanding of any individual. This is why the individual can only describe the experience of possession in insufficient terms, as something beyond her capacity to explain.

Anna Deavere Smith has sometimes appeared either unable or unwilling to acknowledge the political complexity of her own project. In response to Carol Martin's question regarding the feminist implications of her work's non-linear, polyvocal structure, Smith acknowledged that such a significance might exist, but she denied having developed it consciously. The only philosophical precept which Smith *does* say guides her method is an African spiritual one. After having been frustrated by the Stanislavsky acting technique, which has been mapped by "straight lines with arrows," she discovered:

> a book about African philosophical systems and saw a picture of a wheel that had all these little spokes with arrows pointing towards the center. I knew then that I wanted to try to find a way of thinking or a structure which was more like that.
>
> As you know, the black church is not only about speaking to one God. The whole thing is supposed to be an occasion to evoke a spirit. This was one of the things that led me to thinking in more circular ways and resisting the through-line.[23]

Smith attributes her understanding of this African diasporic circular spirituality and aesthetic to her grandfather, who told her that "if you say a word often enough, it becomes you." This doesn't mean, she insists, that you *understand* others' language through repetition, but that you become "possessed, so to speak," by the person whose words you take on.

Twilight takes its title from Twilight Bey, a "graceful, dark skinned" gang member who was one of the organizers of the Bloods-Crips truce. He explains that he took his name not only from the fact that as a child he was always up at night, dusk to dawn, but also because he understands himself to have "twice" the "light," twice the wisdom and experience he ought to have at his age. And he sees himself, Twilight, as existing at "that time

between day and night. Limbo. . . ."[24] He says he embodies that undecidable space between dark and light, as he is literally a "dark individual" who carries a tremendous light. He tells Smith that he "can't forever dwell in darkness . . . just identifying with people like me and understanding me and mine." Smith quotes these lines in the introduction to the published version of the play,[25] as an explanation of her own technique of embodying racial and cultural difference, and it is perhaps the moment where she comes closest to articulating a political position of tolerance.

A clearly painful embodiment of this position takes place in Smith's playing of Walter Park, a middle-aged Korean American who was shot "execution style," as his son explains, by an "Afro-American." Park underwent a lobectomy to remove the bullet, and was left unable to think rationally. Smith repeats his rambling, disconnected narrative that somehow communicates, through the confusion, a distinct sense of isolation and humiliation. She then embodies Park's son and wife, both evidently pulled apart by Park's pain.

A less devastating and yet incisive moment is Smith's reenactment of her interview with Otis Chandler, former editor of the *Los Angeles Times* and member of one of the richest families in Los Angeles, known, as he points out, for its philanthropy. Chandler is a liberal, and he says that the lesson of the riots is that "it's gonna cost all kinds of money. . . . I think businesses should give some, government should give some, and I think we're gonna have to be taxed." And after animatedly suggesting sales tax, gasoline tax, "some kind of fund," Chandler pledges his own commitment to spending money in order to avoid another conflagration. He concludes: "And I realize what I'm gonna hear from people who want money for education and AIDS and health care. Those are very, very important. This is more important to me, 'cause if our cities deteriorate into jungle land, which they are now. . . ."[26] It isn't clear what "this" is which is so important, if not "education and AIDS and health care." The Bloods-Crips proposal made it clear that these were basic elements in (re)constructing a civil Los Angeles. But the "jungle land" figure seems to imply that Chandler thinks the riots exposed a heart of darkness even darker and deeper than a "mere" literal epidemic like AIDS.

The *Newsweek* photo I discussed above imaged a Korean American man who both embodied and negated the embodiment of African American resistance through another photographic image projected onto his t-shirt. In *Twilight*, Anna Deavere Smith, an African American woman, embodies

black, white, Asian, and Latino actors in another ritual, which was the riots. While Smith claims that her goal is "possession"—the utter incorporation of not only the language but also the thoughts and feelings of these people—some critics have read a subtle but distinct irony in some of these representations. Sun and Fei, for example, suggest that Smith's portrayals of the characters, which many viewers might identify as representatives of hegemony (such as Chandler), are "masked" by a slight, ironic half smile that lends a Brechtian distancing to her performance.[27] Smith denies this distance—and yet it's not necessarily a *wrong* reading, as ironic distance might come *either* from Smith as two-faced trickster, or from the projection of the viewer's own politics. As I argued in the preceding chapter on Haitian images, and earlier in relation to Jean Rouch's film representations of possession, such rituals are always multiply meaningful, *especially* in a context of confluent cultures.

Twilight Bey's revelation, which closes the play, is foreshadowed by Homi Bhabha's observation that the "fuzziness of twilight allows us to see the intersections of the event with a number of other things that daylight obscures for us."[28] The statement resonates with Bey's call for civility in order to gain a fuller understanding of race relations, but it also casts a fragmented light on Smith's own project. Bhabha taught us well to view all mimicry of hegemony as ambivalent. That includes deep, "possessional" mimicry, even if some may think this comes out of "jungle land."

Cyberspace, Voodoo Sex, and Retroviral Identity

If violent conflagrations like the L.A. riots have forced us to reconfigure our ways of thinking about individual and group identity, so has AIDS. In particular, the ostensibly controlling mechanism of "risk group" epidemiology forces us to locate ourselves within or without the racial and sexual communities most profoundly impacted by the virus. But HIV has, precisely by crossing communities, begged the question of the way we categorize populations, and see ourselves as identifiable, even unto ourselves. Simultaneously, racial and sexual identities appear to be breaking down in another universe of "promiscuous communication" and border crossing: cyberspace. The architects and city planners of the virtual world constructed through fiber optics and telephone wires seem to be particularly self-conscious of the kind of paradigm shift (or collapse) I'm describing, but their own ability to control its significance is questionable.

If the prosthesis of the car in Los Angeles failed to maintain hygienic relations, cybernetic prostheses are all the more leaky.

An alternate, "virtual" reality sounded *too* paradigmatic when it was first hypothesized, whether by William Gibson's *Neuromancer* or by the theoretical propositions of cyber enthusiasts like Donna Haraway. Cyberspace appeared to be the allegorical representation of a simultaneously utopian and dystopian world of undecidable identity. And yet as people, particularly young people, have gotten increasingly "wired," as the technologies of electronic communication have spread, the fictions and theories of cybernetic identity are becoming embodied, and real. The cyborg is a postulation of a hybrid of machine and organism. And as Haraway argues:

> In the traditions of "Western" science and politics—the tradition
> of racist, male-dominant capitalism; the tradition of progress; the
> tradition of the appropriation of nature as a resource for the
> productions of culture; the tradition of reproduction of the self
> from the reflections of the other—the relation between organism
> and machine has been a border war. The stakes in the border war
> have been the territories of production, reproduction, and the
> imagination.[1]

The imagined reconfiguration of the boundary between nature and technology, in other words, also brings into question other boundaries: those between genders, races, and cultures. And although Haraway wrote her "Manifesto for Cyborgs" in 1985, when this reconfiguration had been most fully articulated in fiction (most particularly by Gibson), she predicted that even *this* distinction—between fiction and non-fiction—would soon be swallowed by the organic machine it had created.

I'm going to chart here a figural strand—of voodoo, sex, and viruses— from fiction, through the "real" virtual world, into a fiction that seems most uncannily real, and finally to another which, for all its apparent *unreality*, marks out a political strategy for the present moment. The confluence of African diasporic religious figures with the principle of epidemia should not be so surprising, given the historical context that I have elaborated in the preceding chapters. But I don't want to posit a simple conjecture here, that in the mid-1980s, as our understanding of the mechanism of HIV's transmission was growing, anxiety over the notion of permeable,

vulnerable populations was projected onto an older Western fear of African diasporic politicization. As I said, cyberspace's disintegrated borders are dystopian *and* utopian, frightening and liberatory. Ultimately, everyone seems to want to be possessed by the *lwa*—or at the least, sexually penetrated by cultural difference.

EZILI FREDA JACKS IN

William Gibson's trilogy *Neuromancer, Count Zero,* and *Mona Lisa Overdrive* explores the hypothesis of mediated organic/technological experience through "simstim," electronically communicated sensory information into which characters can "jack" themselves. The model for this prosthetic experience is the television soap opera, but this is "live television" in a way which surpasses even the prosthetic African lives Youssou N'Dour warns against. Simstim actually bears a stronger resemblance to Anna Deavere Smith's technique of "acting as incorporation."[2] In simstim, "stars" have their sensory experience, thoughts, and emotions electronically recorded for downloading into the bodies of viewers, or rather sensors. Such information transmission is not isolated to the sphere of entertainment. It is also used as a tool in transnational corporate espionage.

No matter how professional these communications may be, they always smack of the sexual. In *Count Zero,* a corporate mercenary plugs a "biosoft" of a brilliant medical researcher into a socket implanted behind his ear, and a "machine dream" of life experience is downloaded into his "memory":

> The *intimacy* of the thing was hideous. He fought down waves of raw transference, bringing all his will to bear on crushing a feeling that was akin to love, the obsessive tenderness a watcher comes to feel for the subject of prolonged surveillance.[3]

This of course resonates with everything we observed in the city of panoptical visibility, L.A.: *total* visibility *doesn't* produce a hermetic boundary between watcher and watched. It creates complicity. The body observed possesses its observer—possesses, and *penetrates*. This penetration is literalized in the implanted socket; but all this talk of love and intimacy demands that you read it as a sexual penetration as well.

There are plenty of other moments in Gibson's work where the sexuality of virtual reality is more explicit. The eponymous sub-hero of *Count Zero*

is an adolescent hacker (also known as Bobby Newmark) whose hormone-charged fantasies are realized through "holoporn" 3-D images projected around his bedroom, including "Brandi, the one with the blue rubber pants."[4] But when he almost dies from a flash of electronic feedback off of a dangerous, classified program whose "ice" he tries to break, it's Bobby who is penetrated: "And something *leaned in,* vastness unutterable, from beyond the most distant edge of anything he'd ever known or imagined, and touched him."[5] That something, like Brandi, is beautiful, sensual, and feminine—but infinitely more real. It is Ezili Freda.

Hours later, the bruised and battered hacker finds himself on an enormous floor of the "projects" devoted to the worship of the Haitian deities.[6] A man named Beauvoir (seemingly the same *oungan* Max Beauvoir who guided Wade Davis throughout *The Serpent and the Rainbow*!) explains to Bobby what it was that hit him: the "*Vyèj Mirak*," Ezili Freda, sent to save him by none other than Legba, "master of roads and pathways, the loa of communication."[7] In Bobby's white-trash, mall-bound experience, this particular explanation doesn't compute, and so Beauvoir goes on to translate. Vodou, he says, is a system, a structure, much like a computer program. Unlike Christianity:

> "It isn't concerned with notions of salvation and transcendence.
> What it's about is getting things *done.* . . . In our system, there are
> *many* gods, spirits. . . . There's a ritual tradition of communal mani-
> festation, understand? Vodou says, there's God, sure, Gran Met, but
> He's big, too big and too far away to worry Himself if your ass is
> poor, or you can't get laid. Come on, man, you know how this works,
> it's *street* religion, came out of a dirt-poor place a million years ago.
> Vodou's like the street. . . ."[8]

Even Beauvoir's street definition of Vodou as "any means necessary" isn't quite straight enough to get through to Bobby, particularly when he tries to explain another character's habitual spirit possession: "Jackie is a mambo, a priestess, the horse of Danbala."[9]

It takes yet another translation, by another character, off the street and into cyberspace, for Bobby to understand:

> "Beauvoir said that Jackie's a horse for a snake, a snake called Dan-
> bala. You run that by me in street tech?"

"Certainly. Think of Jackie as a deck, Bobby, a cyberspace deck, a very pretty one with nice ankles." Lucas grinned and Bobby blushed. "Think of Danbala, who some people call the snake, as a program. Say as an icebreaker. Danbala slots into the Jackie deck, Jackie cuts ice. That's all."

"Okay," Bobby said, getting the hang of it, "then what's the matrix? If she's a deck, and Danbala's a program, what's cyberspace?"

"The world," Lucas said.[10]

Lucas's own demise is foretold by the *lwa* through Jackie their horse, but it actually happens on the street. Jackie, however, dies while *electronically* jacked in. All of these streets, finally, converge at Legba's crossroads of communication. The Vodou story is actually only a subplot of *Count Zero*. The apparent stakes are much higher in the stories of Turner, the corporate mercenary, and Marly, the art dealer tracking the last living creative "genius." And yet finally these plots converge as well, so that all networks—economic, political, and cultural—are crossed by spirit possession.

INFLATABLE VOODOO DOLL

The outrageous violence of *Count Zero*'s world is what makes it seem so evidently fictional. And yet the characters—and violences—it depicted were all too quickly embodied in the closest "real" approximation we have—or had—of cyberspace. Julian Dibbell documented this transition from the fictional to the "real" in a 1993 article in the *Village Voice* called, "A Rape in Cyberspace; Or, How an Evil Clown, a Haitian Trickster Spirit, Two Wizards, and a Cast of Dozens Turned a Database into a Society." And it was precisely Dibbell's argument that this shifting from fiction to reality was more fluid than he had suspected which provoked a storm of controversy *within* the cyber community.

"Reality" here both should and should not remain in scare quotes—that is, should and should not be read with irony—because it operates on two levels. The reality described by Dibbell is real people using real computers, real modems, and real communications networks to socialize, unlike the obviously fictional Count and his friends. And yet the society created by these real people is, apparently, fictional: made up of language and subject to no particular laws of nature. Dibbell tells the story of a MOO (a "Multi-user dimension, Object-Oriented"—an architecturally imagined

and specified internet "chat space") populated by the electronic manifestations of a geographically far-flung assortment of mostly college and graduate students. Why doesn't it surprise us that one of the most prominent of these manifestations was "legba, a Haitian trickster spirit of indeterminate gender, brown-skinned and wearing an expensive pearl gray suit, top hat, and dark glasses"?[11]

And yet this legba was hardly *master* of communication. S/he was the MOO manifestation of a white female graduate student in Seattle, who set her *lwa* in motion by typing at a keyboard. But one Monday evening as she typed away, she found her legba utterly out of her control, manipulated by an electronic "voodoo doll" in the hands of an "evil clown" MOO inhabitant called "Mr. Bungle." Bungle, in reality a member of the New York University Computing Facility (incidentally, my own network), was entering instructions to a sub-program that would attribute acts and actions to other MOO inhabitants independent of their "will":

> And thus a woman in Haverford, Pennsylvania, whose account on the MOO attached her to a character she called Starsinger, was given the unasked-for opportunity to read the words "As if against her will, Starsinger jabs a steak knife up her ass, causing immense joy. You hear Mr. Bungle laughing evilly in the distance." And thus the woman in Seattle who had written herself the character called legba, with a view perhaps to tasting in imagination a deity's freedom from the burdens of the gendered flesh, got to read similarly constructed sentences in which legba, messenger of the gods, lord of crossroads and communications, suffered a brand of degradation all-too customarily reserved for the embodied female.[12]

Dibbell came upon this story in the virtual world of the MOO, but as a journalist followed its trail back into the real world, through the more old-fashioned kind of communication via telephone wires. In a phone interview, the woman whose Haitian effigy had been attacked told Dibbell that in the wake of the incident "posttraumatic tears were streaming down her face—a real-life fact that should suffice to prove that the words' emotional content was no mere playacting."[13]

Dibbell goes on to deduce from this experience that the "disembodied enactment of life's most body-centered activity" forces one to acknowledge

that sex is *always* more psychic than physical, which does nothing to reduce its power. "I know, I know," Dibbell writes, "you've read Foucault and your mind is not quite blown by the notion that sex is never so much an exchange of fluids as it is an exchange of signs."[14] Still, the *experience* of cybersex is "full-bodied," particularly when virtually all participants are young people "in the grip of hormonal hurricanes" that set both real and virtual experiences spinning.

The major ethical questions raised in Dibbell's account are not merely civility and censorship on the internet, but crimes of sexual assault and capital punishment. Ultimately, after extensive debate within the MOO community, Bungle was "toaded"—his account wiped out—which Dibbell compares to execution. Of course, the NYU student didn't actually die. He went over to the computing center, filled out a form, got a new account, and reappeared under a new but recognizable fictive identity. "Mr. Bungle had risen from the grave." Dibbell doesn't say it, nor does legba, but Bungle's resurrection means that there was never any execution at all—just a zombification. Like all zombies, Bungle came back significantly subdued.

The metaphor of execution, however, didn't provoke anxiety. The flurry of controversy that took place shortly after publication of this article, both in print and on the internet, was concerned with Dibbell's use of the term "rape," which many felt trivialized the experience of victims of real sexual violence. "Feminist pornographer" Lisa Palac, however, entered an on-line argument in Dibbell's defense:

> I can't tell you how often I am interviewed by reporters who are under the assumption that taking on an online identity is "risk-free." And that for some reason, going online will be free from the social/cultural shapes as we know them. . . . [The subject of] this article may be extreme, but it disproves the "all is safe in cyberspace" notion.[15]

I myself am less bothered by the suggestion that sexual violence can take place in virtual reality than by the implication that no matter what racial and sexual transformations they may effect in their electronic manifestations, it is always real *women* who are susceptible to violent penetration.

Cyborgs are not of woman born—nor do they get pregnant. As Haraway writes:

> The cyborg is a creature in a post-gender world; it has no truck with bisexuality, pre-Oedipal symbiosis, unalienated labor, or other seductions to organic wholeness through a final appropriation of all the powers of the parts into a higher unity.[16]

Cyborgs don't dream of the perfect wedding, nor of future generations. They don't procreate: they regenerate. But that doesn't mean, as Dibbell argued, that they can't be sexy. Many of us, in fact, are having sex *not* in order to get pregnant.

So what difference does gender make in cyberspace? And what happens when you go there in drag? Is your sexual fate always as delimited as legba's? And is that fate somehow tied to your racial and ethnic identity as well? The MOO that Dibbell described was purely textual, but there are subscription on-line entertainment services which currently allow users to "construct" pictorial images of themselves, and these images can socialize in chat rooms. You can choose your hair and skin color, shape of face, eye color and shape, etc. You can also "spice up" your language by adding the range of affective diacritical codes recognized on the internet: smiley faces, frowning faces, winking faces. These, you are told, can let people know your mood ("happy, sad, surprised, . . . even sarcastic")[17] in a way that simple language doesn't. But the primary choice you have to make is your gender. This isn't expressed as a "choice," although we're all aware a good deal of transsexuality goes on on the internet. The relationship between your on-line hair, face shape, eyes, happy expression, and of course genitalia and your real world self can be read as either a hypothetical, imagined identity or a prosthetic one—one which is an extension of your "real" self. Unless your "real" self turns out to be both hypothetical and prosthetic.

Despite Haraway's hopefulness, the virtual public at large is less willing to allow for total free-play of gender. Gender-switching may be an acknowledged aspect of virtual reality, but when addressed it often provokes more anxiety than celebration of new freedom. Even more disturbing to people, as evidenced by Dibbell's story, is the possibility of the loss of control over one's own virtual body.

Part of that terror of loss of control seems to be related to the new fear attached to real rape in recent years: the fear of infection. If cyborgs are the technological infected with the human, the male infected with the female, the West infected with the non-West, as Haraway optimistically prophesied, then amid all this infection, should cyborgs be worried about sexually transmitted diseases? More specifically, can cyborgs get AIDS?

Allison Fraiberg has argued that the discourse of AIDS has been shaded by theoretical propositions on the postmodern networking of information, capital and bodies—and vice versa. Whether in the Jamesonian mode of making the best of a bad situation or Haraway's mode of celebration, postmodern theory bears a remarkable resemblance to epidemiology. Fraiberg marks a transition from the nostalgic desire for the organic integrity of the individual, through a newly complicated notion of morality in an intimate, complicit world, into a *new* kind of bodily closure, which acknowledges people's and populations' interconnectedness: "The realities of AIDS dissolve the boundaries of the discrete body, and the cyborg, still needy for connection, integrates it into its discursive network."[18]

Fraiberg makes explicit a pun which has been implicit in this book from the outset: the idea of *discrete* bodies is translated through that of *discreet* bodies—morality is imposed at the surface, visibility, or articulation. This is related, of course, to the Foucauldian connection between surveillance—visibility—and family values. But *indiscretion,* in the sense of an understanding of interconnectedness, allows for a responsible, one might even say civil, recuperation of bodily closure through latex barriers and clean needles. These aren't merely more realistic, effective preventative measures than sermons on family values, they are actually part of a reconfiguration of bodily identity. And Fraiberg links this configuration to Haraway's proposition of a cyborg ontology as feminist political model.

The question, then, which I posed above—can cyborgs get AIDS—might be rearticulated as: can a virus be infected with a virus? To say that the cyborg is infection made manifest (and to imply that the literally infected body is cybernetic) is not to make it monstrous. As *Mumbo Jumbo* demonstrates, the figure of contagion can *animate* the body.

PROSTHETIC POLITICIZATION

I want to move back into the realm of fiction to see how these figural confluences have been worked out in a model which, ironical-

ly, seems more real, more familiar, than Dibbell's real life MOO. In Neal Stephenson's 1992 novel *Snow Crash*, cyberspace is called the Metaverse—and it appears to be an alternative world to an over-commercialized, unbearably restrictively brand-name real world. In the Metaverse, there is still "public" space, but like in L.A. (main locus of the novel), people enter it prosthetically, through "avatars" resembling the populace of Imagi-Nation:

> Your avatar can look any way you want it to, up to the limitations of
> your equipment. If you're ugly, you can make your avatar beautiful.
> If you've just gotten out of bed, your avatar can still be wearing
> clothes and professionally applied makeup. You can look like a gor-
> illa or a dragon or a giant talking penis in the Metaverse. Spend five
> minutes walking down the Street and you will see all of these. [19]

But in the Street you also see a lot of "regular" people. There are loads of straight couples out on dates. Those who don't have particularly sophisti-cated computer systems and don't know how to program their own avatars have to get standard types:

> Brandy and Clint are both popular, off-the-shelf models. When
> white-trash high school girls are going on a date in the Metaverse,
> they invariably run down to the computer-games section of the local
> Wal-Mart and buy a copy of Brandy. The user can select three breast
> sizes: improbable, impossible, and ludicrous. Brandy has a limited
> repertoire of facial expressions: cute and pouty; cute and sultry;
> perky and interested; smiling and receptive; cute and spacy. Her eye-
> lashes are half an inch long, and the software is so cheap that they
> are rendered as solid ebony chips. When a Brandy flutters her eye-
> lashes, you can almost feel the breeze. [20]

Clint is also "limited," although Stephenson doesn't give you the graphic detail of his lack of graphic detail. Why are women in particular marked as prosthetic? The simulated Brandy calls up not only the image of Count Zero's holoporn inflatable doll, but also "real" simulated breasts. What she makes you look at is the prosthetic nature of real women's lives. By that I don't mean literal prosthetic breasts. But the "necessity" of implants—prostheses for women who haven't necessarily *lost* any limbs—points

to women's habitual forced confrontation with the added-on nature of bodies.

Clint isn't Brandy's only counterpart. She has a more radical one in the character of Y.T., who first appears, not in the Metaverse but in the "real" street. The car of the hero protagonist, Hiro Protagonist, has been "pooned. As in harpooned" by a "person on a skateboard," a Kourier from RadiKS, Radikal Kourier Systems. The poon is an electromagnet on an arachnofiber line and Y.T. is hitching a ride. Hiro is outraged by the Kourier's balls. "What a prick! . . . He is going to shake this scum, whatever it takes."[21] But it's Hiro who crashes, and Y.T. comes to the rescue, offering to complete his pizza delivery. "'Where's it going?' someone says. A woman. . . . The Kourier is not a man, it is a young woman. A fucking teenaged girl."[22]

Y.T. is literally a fucking teenaged girl. She is fifteen and fully sexually *active*. And she seems to have taken her sexuality into her own hands. Y.T. enters the narrative, as it were, in drag. That's not just because she is dressed in a body-obscuring coverall and helmet. It is her physical daring that throws off both Hiro and you. Her world is a dangerous world, replete with STDs. In fact, these aren't sexually transmitted diseases, but Serious Tire Damage booby-traps which she has to maneuver her way around, a mile a minute. Or *are* they sexually transmitted diseases?

Y.T.'s world is dangerous in the same mundane and dead serious way that Brandy's world is dangerous. If science fiction was once perceived as a utopian genre pointing toward the future, the near-future of *Snow Crash* has some familiar—in fact intensified—problems. Herpes is one of the more benign examples. AIDS is clearly more serious. But there's more. Racism foments in L.A.'s New South Africa franchises, and sexism is as bad as it ever was. So is police violence. Everywhere Y.T. goes, she's pursued by gawkers and lascivious Metacops. When a couple of them threaten to strip-search her, though, she's unintimidated. That's because Y.T. has her own prosthesis: her "dentata."

Sexism isn't just rampant on the street, or the Street. Even the famous, sophisticated programmer Juanita Marquez, who designed the technology which made possible truly life-like facial expressivity in the Metaverse, has to contend with it:

> [A]t this phase, the all-male society of bitheads that made up the power structure of Black Sun Systems said that the face problem was trivial and superficial. It was, of course, nothing more than sexism,

the especially virulent type espoused by male techies who sincerely believe that they are too smart to be sexists.[23]

Scientific sexism, like epidemiological racism, is *virulent*—like a virus. You can't see it, but it proliferates.

The "hard" sciences, including both computer science and biology, continue to resist self-consciousness about their own sexist and racist constructs, despite the impressive documentation of feminist critics.[24] That's because of the illusion of objectivity when we speak not of people, or groups of people, but of bytes and cells. In *Snow Crash*, Stephenson keeps reminding you that computer science is based on binary codes. It functions by dichotomies and can only make order by maintaining them. What makes a program *crash* is a virus, which disrupts the binary code, in much the same way that a human virus disrupts the genetic code of a cell.

A computer virus is a metaphor, at least prior to the fictional fusion of informational and bio-technologies recounted in *Snow Crash*. And the source of the metaphor is AIDS. In a 1988 *New York Times* article, the chairman of the Computer Virus Industry Association made this clear in his description of the challenges to informational hygiene: "The most stringent [protection] procedures—telling people not to touch other people's computers or to use public domain software—is a little like telling people not to have sex in order to stop the spread of AIDS."[25] Interestingly, it is the AIDS epidemic's challenge to individual and group identity that puts pressure on scientific discourse's false oppositions.

Disrupting binarism, of course, is what contemporary feminist, postcolonial, and critical race theory are all about. Poststructural politicization of all stripes is about this kind of disruption of order. *Snow Crash* marks a catastrophic moment in the struggle to deconstruct patriarchal, Western, corporate order. "Snow Crash" is itself both a human and a computer virus, because it refuses to acknowledge a difference between reality and virtual reality. That is only one of the dichotomies that it deconstructs. Like Haraway's cyborg, the human/machine-disrupting bug allows for all kinds of other disruptions to take place. The danger of the "metavirus" is that it makes it possible for other viruses to proliferate, creating chaos. And lesser viruses, which were previously of little threat, become especially malignant. The software-generated "Librarian" who guides Hiro Protagonist on his path to understanding the significance of *Snow Crash* reminds him that

viruses have been around for a long time. He traces the notion to Sumerian mythology, and Asherah, the promiscuous consort of El, or Yahweh. Her worshipers participated in a cult of prostitution. "'Bingo,'" observes Hiro. "'Great way to spread a virus.'"[26] The Librarian suggests her lineage:

> "[Y]ou may wish to examine herpes simplex, a virus that takes up residence in the nervous system and never leaves. It is capable of carrying new genes into existing neurons and genetically reengineering them.... herpes simplex might be a modern, benign descendant of Asherah."
>
> "Not always benign," Hiro says, remembering a friend of his who died of AIDS-related complications; in the last days, he had herpes lesions from his lips all the way down his throat. "It's only benign because we have immunities."

Asherah was purged from religious tradition by the deuteronomists ("Nationalists. Monarchists. Centralists."), who codified social behavior in a book of the Pentateuch. Textual codification constituted "informational hygiene." But in the age of electronic communication, textuality has torn open like a bad condom. There's no way to control information from leaking everywhere. In this way, we're seeing something like the oral tradition, which Hiro likens to "sharing needles."[27]

Asherah spread the virus through sexual fluids, and through breastmilk to her adopted human off-spring ("GOOD MOTHER"). She even infected Enki, her son, the very principle of order, who according to the Sumerians created the *me*, the *basis* for social order. *Me* might also be read as *me*—the first person, individual identity, distinguishable from others. The inherent infection of Western identity from its mythological beginnings gives one a clue as to where this reading is going.

Despite the deuteronomists, it is precisely the Christian Right that turns out to be behind the plot to propagate Snow Crash. L. Bob Rife, corporate head of Reverend Wayne's Pearly Gates chain, is an all too familiar character. His employees are under 24-hour surveillance for "unacceptable lifestyle choices" like sodomy. But he's running around with hypodermic needles filled with fresh, warm tainted blood serum. Here, the heavy hand is Stephenson's, but the subtler point behind the blunt political irony of corporate Christianity behind a plague spread by infected bodily fluids is

that even the most "orderly" of contemporary "lifestyle choices" is already infected with others.[28]

BEING PREPARED

Hiro Protagonist is a hacker, a promiscuous interfacer in the Metaverse, so his risk of contamination is through on-line contact. Despite his racial marking as a product of sexually crossed communities (he is African-Korean-American), his own trespasses are electronic. But Y.T. is indiscrete, and indiscreet, about her "real world" sexual partners, so her risk factor is bodily fluids. She almost gets jabbed by the High Priest with a hypodermic needle, but she manages to zap him with a can of neon-green Liquid Knuckles and make her escape. That action scene, however, rings less true to the realities of Y.T.'s life than a much more banal one—a familiar one to plenty of adolescent female readers. She's having her cover-all unzipped by a muscle-bound, tongue-kissing hulk named Raven:

> Then he's in between her tight thighs, all those skating muscles strained to the limit, and his hands come back inside to squeeze her butt again, this time his hot skin against hers, it's like sitting on a warm buttered griddle, makes the whole body feel warmer.
>
> There's something she's supposed to remember at this point. Something she has to take care of. Something important. One of those dreary duties that always seems so logical when you think about it in the abstract and, at moments like this, seems so utterly beside the point that it never even occurs to you.
>
> It must be something to do with birth control. Or something like that. But Y.T. is helpless with passion, so she has an excuse. So she squirms and kicks her knees until the coverall and her panties have slid down to her ankles.[29]

She's not thinking about Snow Crash. But, despite her "helpless" state of passion, she's perfectly cognizant of the risk of pregnancy. And of AIDS.

What does pregnancy have to do with AIDS? Everything. Hiro interprets the Sumerian myth of Enki's semen as the source of the earth's waters:

> "To these people, water equals semen. Makes sense, because they probably had no concept of pure water—it was all brown and

muddy and full of viruses anyway. But from a modern standpoint, semen is just a carrier of information—both benevolent sperm and malevolent viruses. Enki's water—his semen, his data, his *me*—flow throughout the country of Sumer and cause it to flourish."[30]

Benevolent sperm and malevolent viruses. But to a fifteen-year-old girl, those sperm are anything but benevolent.[31] The assumption of the benevolence of sperm is rife (as in L. Bob) in scientific writing, as Emily Martin has observed.[32] This is the very unself-conscious, "virulent" sexism of the sciences, which is remarked early on in *Snow Crash*. It's related to the notion of semen as the carrier of *me*, of individual identity, which irrigates the earth and brings forth life.[33]

Y.T. has some serious dangers in her life. "Serious Tire Damage" is the least of her worries. But are sexually active women under siege? Paula Treichler has commented on the figuring in AIDS scientific literature of the vagina as a weak fortress, full of "fissures" and openings where the virus can get in.[34] Martin notes that the militaristic rhetoric extends to descriptions of the immune system itself, where cells are distinguished from one another according to the sophistication of their "weaponry"—and not surprisingly, this is put in gender-marked terms. The T-4 "killer" cells are the "Rambos" or "Mr. Ts" of the immune system, zapping foreign intruders with metaphorical firearms. The macrophages are the less fancy defenders: the "drudges" and "housekeepers" of the immune system, they "mop up" messy germs.[35]

Women may be under siege, but it's as much by scientific rhetoric as anything else. It is vital for women, including, of course, fifteen-year-old women, to understand the mechanics of HIV transmission and the risks they run in having unprotected sex. It is also vital for women to understand the mechanics of pregnancy. But the figuring of women as defenseless, contaminable victims in sex is also bad for their health. It is also the reason that Dibbell's well-meaning concern for the "real" woman behind legba may be more worrisome than Mr. Bungle's virtual brutality. Concern for susceptible young girls may have more to do with why even a smart slick Kourier like Y.T. gets "helpless" (stupid) in the heat of the moment than with what she calls "passion."

But Y.T. puts a spin on all this. After the fact of the hot and heavy scene with Raven, it turns out what she'd forgotten wasn't what you thought it was:

She has finally remembered what that nagging thing was that bothered her for a moment, right before the actual moment of fucking.

It was not birth control. It was not a hygiene thing.

It was her dentata.

And if that wasn't good enough, it turns out that the dentata is not what you thought it was, either:

> Which means that at the moment Raven entered her, a very small hypodermic needle slipped imperceptibly into the engorged frontal vein of his penis, automatically shooting a cocktail of powerful narcotics and depressants into his bloodstream.
>
> Raven's been harpooned in the place where he least expected it.[36]

The penetrable, contaminable woman has penetrated the killer whale-like anti-hero, rendering him defenseless.

The flipping of gender roles at this moment is only one of Y.T.'s tricks. As I said, she enters the novel in drag. And if not Asherah in the flesh, she does much to infect the *me* of Enki, and the novel's world. Her disruption of the social code—her risk-taking in the Kourier trade despite her gender—occurs in racial terms as well. She's white, and some understand her name as "Whitey." But she repudiates racial dichotomies as well. Y.T. stands for Yours Truly. Me. And in this way, she even manages to infect the narrative voice, which calls itself by her name every time it mentions her. Y.T. might even be read as the omniscient narrator in drag—or vice versa. If Hiro Protagonist conforms to all our assumptions about a hero protagonist's masculinity, Y.T. gets into that more subtle notion of omniscience, of universality, which doesn't call itself male, but may be a more virulent strain of sexist assumptions.

The first poststructuralist maneuver, of course, is to question the dichotomy between literal and figural language. *Snow Crash* refuses to isolate the Metaverse as metaphor, as a hypothetical world opposed to a real one, and as I have already argued, there may be a salutary effect of taking seriously the metaphors that circulate around AIDS. Questioning the dichotomizing principle might make us see the insidiousness of group identity as it serves to make some feel "safe"—and unimplicated. The global pandemic marks the trail of infection, of the most intimate kind of contact between different people of different nations, even if epidemiology, as

well as xenophobic and misguided U.S. immigration policy, would rather ignore it.

The danger of current internal U.S. epidemiological trends is that as HIV increasingly disproportionately affects communities of color, the "identities" of people in relation to HIV risk will appear increasingly fixed. I have argued in the preceding chapters that the acknowledgment of the prevalence of HIV in a given community is extremely complicated—both necessary and dangerous. But that acknowledgment is not only dangerous to the community that makes it, risking discrimination and even violence by voicing the problem. It is also dangerous to those outside the community, who may have a false sense of hermeticism. People like Y.T. who pay no mind to the "boundaries" of racial and cultural communities when they choose whom they will love aren't the ones who create these dangerous misconceptions. They are the ones who prove the boundaries deceptive.

There is a particularly painful irony in the final dichotomy that AIDS appears to pose itself: HIV-positive/negative. This seems to be a division which allows all the other divisive oppositions to proliferate.[37] Individuals find themselves on opposite sides of a latex barrier. Latex is all well and good—it is certainly a necessary response to the pandemic. But the illusion that it creates separate identities is the most virulent aspect of HIV. It allows for all kinds of other insidious dichotomization to take place. Women of all races clearly need to take their sexuality into their own hands, which means one should never go out without latex—or without a dentata. That's the really significant form of defense: the subversion of the thesis of one's own "helplessness."[38] Cyborgs *can* get AIDS, particularly when they start believing that nice white girls can't.

GOOD MOTHER OF OTHERNESS

If the AIDS pandemic might teach us anything, it is that xenophobia, racism, sexism, and homophobia all rest on a false assumption of the hermeticism of identity. Of course, acknowledging one's own incorporation of difference does not mean embracing the virus. But as Ishmael Reed has shown us, contagion can be recuperated as a positive figure for cultural mixing.

Octavia Butler is an African American science fiction novelist who, over the course of her career, has repeatedly explored the confluent figures of racial, cultural, sexual, and viral intimacy. Butler is not a "cyberpunk"

writer: she eschews the complications of the virtual world, dwelling rather on those of the physical, and of the classic preoccupation of science fiction: alien beings from other planets. But her work is perceived as "cutting edge" within the genre because it grapples with the most pressing of political issues in the most "human" terms.

The central metaphor of Butler's extensive oeuvre is alien-human miscegenation. "Literal" (racial) miscegenation always coincides with the near-future scenarios of meta-mixing. Butler dwells on the most embodied aspects of alien hybridity: the act of "sex," the experience of gestation, childbirth, lactation. The merging of self and other is always ambivalent—a combination of desire and horror. Butler's aliens are threatening colonizers, and yet their way of being is completely anti-hierarchical. By infecting Earth with their colonizing presence, they begin to cure it of the disease of its own colonial history.

And disease is precisely the figure Butler invokes. She published the novel *Clay's Ark* in 1984—one year after the virus today known as HIV-1 was isolated in the laboratories of the Pasteur Institute. In the novel, an African American astronaut named Eli returns to Earth, the sole surviving carrier of alien genetic material which infects humans like a virus (similar to HIV, it operates through a process something like reverse transcriptase, rewriting the genetic code). The "disease" is dangerous, life-threatening (producing emaciation, excessive sweating)—and yet, like Reed's Jes Grew, it also endows its carriers with vitality, a remarkable ability to heal from "human" infections and injuries, and a vastly increased sensuality. It is *both* plague and anti-plague.

Eli tries to contain the contagion by creating a small colony in isolation, although eventually misguided epidemiological containment strategies (contacting the authorities) leads to a global pandemic. The offspring of the alien-infected human couples in the colony is thoroughly hybrid. Among those infected (and cured) by Eli is Keira, a mixed-race young woman suffering from leukemia. The genetic reprogramming effected by the "disease" puts her cancer in remission, while much of the rest of the "human" world spirals into violent chaos:

> San Francisco is burning. . . . Fires are being set everywhere. Maybe uninfected people are sterilizing the city in the only way they can think of. Or maybe it's infected people crazy with their symptoms and the noise and smells and lights. L.A. is beginning to burn, too.

... In Louisiana there's a group that has decided the disease was brought in by foreigners—so they're shooting anyone who seems a little odd to them. Mostly Asians, blacks, and browns.[39]

Keira closes the novel beside her Japanese-Alien-American mate, Stephen Kaneshiro, her pregnant belly beginning to swell with meta-hybridity. "We'll be obsolete, you and me," he tells her. GOOD MOTHER, she answers: "They'll be our children."[40]

In the same year of *Clay's Ark*'s publication, Butler published a short story, "Bloodchild," which more specifically focuses on alien-human pregnancy. The story takes place on a human "Preserve" on an alien planet. "Terrans" and "Tlic" coexist there in a precarious but symbiotic state. Still, the planet "belongs" to the Tlic. In an afterword to the story, Butler professes: "It has amazed me that some people have seen 'Bloodchild' as a story of slavery."[41] The reading, however, is not surprising. Despite the intimate description of a Terran-Tlic relationship that Butler explicitly depicts as loving *and* sensuous, the human who gestates Tlic offspring is painfully implanted with a devastating, potentially mortal parasitic infection. And, foreshadowing Y.T.'s 'pooning of her lover Raven, it is a female Tlic who impregnates the male Terran narrator. "I wanted to see," writes Butler, "if I could write a dramatic story of a man becoming pregnant as an act of love—choosing pregnancy in spite of as well as because of surrounding difficulties."[42] That kind of choice is surely not "alien" to many of Butler's women readers.

Perhaps Butler's most ambitious project so far has been the "Xenogenesis Trilogy." The three novels combine Butler's preoccupation with the crossing of races and genders. The first, *Dawn* (1987), introduces Lilith Iyapo, an African American woman who cooperates with the alien Oankali. The Oankali have rescued the planet from its own internal conflict, and proceeded to merge genetically with humans. In *Adulthood Rites* (1988), Lilith's hybrid child, Akin, comes to understand that his miscegenation—and his hypersensuality—connect him to all those he touches: "within them, he could find fragments of himself. He was himself, and he was those others."[43] This is the Oankali lesson for humans, transmitted to them genetically.

In the final book of the trilogy, *Imago* (1989), Earth's hybrid children ("constructs") finally achieve the most significant change linking them to the Oankali: another of Lilith's children develops into a state of being the

aliens have had all along—*ooloi*, or third gender. Jodahs is the genetic fusion of two human and three Oankali parents. All sexual contact is mediated through ooloi, perfect transmitters not only of genetic information, but also of sensual experience. As an ooloi, Jodahs can shapeshift, taking on more masculine or feminine attributes in order to attract "its" sexual partners. Jodahs is extremely "sexually precocious"—and like other ooloi, it can cure most any ailment or injury. But because of its potent mix, Jodahs can also be virulently dangerous. Its ooloi parent warns it: "'You could give Humans back their cancers [previously defused by Oankali ooloi]. . . . Or you could affect them genetically. You could damage their immune systems, cause neurological disorders, glandular problems. . . . You could give them diseases they don't have names for.'"[44]

Meta-miscegenation is dangerous—but for Butler, it is the only hope. *Imago* ends with a Latina female human savior, Jesusa, waiting to be impregnated with a hybrid future. Women of color, in this country and across the globe, currently comprise the fastest growing segment of the AIDS pandemic. The risks to their health and lives are not aliens from another planet, but the all too familiar "Terran" problems of poverty, sexism, and racism.[45] Would that some strange creature could infect this scenario with difference.

Benetton

Blood Is
Big Business

I*mago*'s gender-bending, mixed-race ooloi creates an image that is not so much "alien" to contemporary U.S. popular culture as it is iconic *of* its aesthetic. *Snow Crash*'s social circle, too, an African-Asian dreadlocked hacker, his elegant Latina love interest, a skate-boarding white girl and her buff Inuit squeeze, looks familiar. And not to say that you wouldn't find this foursome walking down the real street in L.A., but if you saw them, it would be hard not to resist the thought: they look like a Benetton ad. How did cross-racial, cross-cultural sexual exchange come to look less like a political statement than like a fashion statement?

There are other resemblances between the worlds of *Snow Crash* and Benetton: these are the rampant spread of privatization, of the "flexible" franchise system, and of post-Fordist methods of production. And although all this sounds infinitely less sexy than Hiro Protagonist, Y.T., and their partners, the futuristic manufacturing and marketing techniques

exemplified by the Benetton corporation have everything to do with the fashion of interracial love. And in the world of Benetton, as in the world of *Snow Crash*, the proliferation of the idea of difference falls under the sign of AIDS, and circulates through a computer.

ANIMATING MANUFACTURING

"Big Charlie," Benetton's central computer system, is located in Castrette, Italy. The company promotes Big Charlie as an animated embodiment of the Benetton system of product distribution. I use the term animated in its etymological sense of having an *animus*, or spirit. The 1994 Spring/Summer catalog showed a three-page comic strip called "BIG CHARLIE: ¡32 SEGUNDOS DE MIEDO!" that chronicled a thirty-two-second glitch in communications, easily restored to order by a technician. The story of a negligible break down in the system seems to be intended to demonstrate not only the high standard of efficiency, but also the "humanity" of the computer at the heart of the company. The technician explains that "Big Charlie just needed to catch his breath," and later tells his co-workers, "I control him, as if he was a child of mine, and he—he won't disappoint me!" Still, despite Big Charlie's humanity, the comic sets out to show his super-human powers. Benetton employees in South Africa, Brazil, and Japan are shown relying on his punctuality to supply customers with their desired goods precisely when they need them (Tokyo: "By the way, when will your Fall collection be in?" "Next Thursday, at 3:21 in the afternoon. We'll look forward to showing it to you"). Electronic communications networks between the Castrette warehouse center and some seven thousand Benetton franchises across the globe allow for "real time" orders to be processed immediately. The same day you buy a red sweater in Tokyo, in other words, its replacement is being knit in Italy. Since the immediate response takes place at the level of manufacture, Benetton central is "stock free," another part of its economic brilliance. The product is made "Just in Time" (JIT), not "just in case," preventing wasteful over-production and the expense of warehousing. JIT manufacturing was developed by Japanese auto companies, but has spread to other industries and global sites.

JIT production is one reason the Benetton system describes itself in terms of "flexibility": immediate supply means guaranteed availability of virtually the entire product line, which means greater selection for the consumer. Production also responds immediately to shifts in demand, such

that the company can follow changes in taste—particularly important in the sphere of fashion which is inherently change-oriented. Fashion is a series of mutations, and electronic communications allow for spontaneous reaction.

While consumer convenience is the focus of the Big Charlie comic strip, the other kind of "flexibility" afforded by computer-integrated manufacturing (CIM) is *corporate*. CIM is a major component of so-called post-Fordism—the decentralizing trend in contemporary industry. Benetton was one of the early enthusiastic proponents of this trend in the West, and is often cited as an exemplary case. Speaking generally, post-Fordism is a mode of production, facilitated by computer technologies, which identifies, on an on-going basis, target markets and their changing needs, and then relays these demands, again through electronic communications, to sub-contracted parts or piece manufacturers, often globally dispersed. Sub-contracting allows corporate "flexibility" in the sense that internationalizing the work force circumvents certain national labor laws. The post-Fordist work force is increasingly made up of women, most particularly underclass, "unskilled" women, often working out of small sweatshops or their own homes. This kind of manufacturing also circumvents, usually, unions, and of course worker benefits, which can be particularly expensive for women workers in need of maternity leave and child care.

Some enthusiasts of post-Fordist trends argue that the feminization of the work force is in fact a sign of increasing opportunity for women in the global economic context. They also argue that home labor allows these women flexibility (particularly if they are raising families) through part-time and temporary contracting. And yet the wages earned by sub-contracted, unorganized labor are almost always substandard, in comparison to those earned by unionized workers. The establishment of Free Trade Zones has, of course, contributed to the economic feasibility of this type of system.

Rapidly developing communications technologies are, without a doubt, opening up new possibilities for labor configurations. "Flexible specialization" proponents argue that if industry chooses to act humanely, if major manufacturers develop "human-centered" applications of these technologies, workers' opportunities can be increased.[1] But others argue that network-configured industry doesn't so much *do away* with the hierarchical, institutionally oppressive aspect of the traditional Fordist, "vertically integrated" system, as it decentralizes it, and makes that oppression less visible,

simultaneously defusing the counter-threat of labor organization.[2] In the case of Benetton, for example, subcontracting to small firms allows for circumvention of Italian labor laws applying to employers of fifty or more workers. Most of Benetton's subcontracted labor takes place in what is often referred to as "third Italy." This phrase was coined to distinguish the northeastern cluster of small towns, which have experienced a recent industrial boom, from the older industrial area bounded by Milan, Turin, and Genoa, as well as the southern manufacturing pocket. And yet to some critics, the phrase "third Italy" seems all too apt, as labor conditions there increasingly approximate to the exploitative conditions of Third World piece workers. Many of Benetton's subcontracted laborers are registered as "artisans," which not only liberates the company from supplying benefits, but also exempts the workers from taxes and welfare contributions, which are required of "non-artisan" registered homeworkers. And while it may sound like women "artisans" produce their work spontaneously, for the pleasure of their craft, the truth is that many of these women need the work badly, and also need badly many of the benefits which they forego.

In 1991 Donna Haraway wrote, with characteristic perspicacity: "The 'New Industrial Revolution' is producing a new world-wide working class, as well as new sexualities and ethnicities."[3] The "new sexualities" are taking form through the feminization of the labor force, which means not only the literal employment of women, but also the pressure on men to work under conditions previously reserved for women workers. As Haraway argues:

> Work is being redefined as both literally female and feminized, whether performed by men or women. To be feminized means to be made extremely vulnerable; able to be disassembled, reassembled, exploited as a reserve labour force; seen less as workers than as servers; subjected to time arrangements on and off the paid job that make a mockery of a limited work day; leading an existence that always borders on being obscene, out of place, and reducible to sex.[4]

As the muscular Brazilian stock workers complain in the Benetton comic strip, "They got us working Sundays, too! Big Charlie doesn't fool around."

None of this is to say that Benetton's labor practices are inherently more evil or exploitative than most any other clothing manufacturer's. They *are* more sophisticated, and, as is the case with its competitors, Benetton's bot-

tom line is profit. The clothing industry has long exploited cheap labor, particularly in Asia and Latin America. What is interesting about Benetton and "third Italy," though, is that they demonstrate the decreasing currency of the notion of an exploitable Third World in isolation from the West. This, precisely, is a function of the "new ethnicities" that Haraway identified a decade ago. The Third Worlding of parts of Europe is well under way.

Italy does have progressive legislation in place to protect homeworkers and other "informal" laborers, but as the artisan escape-hatch shows, there are ways of getting around protection laws. Meanwhile, developing countries have few, if any, such protections for unorganized workers. And yet companies like Benetton are serving as the model for Third World manufacturing. Because of catastrophic debt, many African and Latin American countries have been forced to deindustrialize in the last fifteen years, necessitating a reliance on transnational industry for continued employment of the work force, which is increasingly informal. The only feasible, competitive response is for Third World industry to replicate the decentralized model. In parts of Africa, fully seventy percent of the labor force is in the informal sector.[5]

The Benettonization of Third World industry and the Third Worlding of the Italian informal labor sector have occurred simultaneously. But the United States is implicated as well. Luciano Benetton, the company's founder, is a member of the Italian parliament, a nationalist, and the most vocal pro-ponent of all legislation facilitating free trade. And despite his Italian nationalism, Benetton's debt to this country's foundational commitment to the free market system is obvious. While post-Fordism would appear to have developed in opposition to U.S. Fordist manufacturing, as I mentioned above, many see it as a direct continuation of Fordism which maintains much of the older system's ideological basis.

BLOODY BUSINESS

I want to turn from this admittedly condensed account of Benetton's manufacturing philosophy to the other "exemplary" aspect of the company, which is its advertising campaign. I am certainly not the first to note the political complications of the "multiculturalism" and multiracialism of this campaign. As Henry Giroux has argued, "the harmony and consensus implied in these ads often mock concrete racial, social, and cultural differences as they are constituted amid hierarchical relations of

struggle, power, and authority."[6] In recent years, Benetton has begun using images of AIDS and HIV infection in its advertising. The visual images were supplemented in 1994 by a special issue of the Benetton magazine, *Colors*, devoted to the topic of AIDS. AIDS here is used to represent the very reconfiguration of our notions of individual and group identity which correspond to the post-Fordist exploitation of difference—whether this is transnational companies' exploitation of cheap Third World labor or Benetton's exploitation of a Third Worlded, feminized domestic labor force. The advertising phenomenon really isn't separable from the question of production, as the AIDS issue of *Colors* tells you: "(BLOOD IS BIG BUSINESS)."[7] One could reverse the terms, just as one could reverse the order of the discussion, using the advertising campaign as a starting point for considering post-Fordist production.

That stunning line, parenthetical and yet fully capitalized, "(BLOOD IS BIG BUSINESS)," is intended as a short-hand explanation for "a few scandals" regarding the infection of the world's blood supply in the 1980s. And its assumption (that business will always place profit above human life) gives one fair warning about how to read the advertising campaign that constantly invokes the sanctity of human life.

Here, in brief, is an overview of the history of the company whose full corporate name is "The United Colors of Benetton" (in English—further evidence, if any is needed, of Luciano Benetton's admiration of the United States, even as an Italian senator). As the company's own promotional materials begin the story, "The Benetton Group is at home throughout the world."[8] But it was founded in Ponzano Veneto, northeastern Italy, in 1965. Luciano Benetton's sister, Giuliana, began knitting at home, and her brother took up marketing her production. Luciano's savvy early implementation of computer automation was the first step in the company's development. Today, the "hub" of Benetton's network remains in northeastern Italy, but some piece manufacturing takes place in Africa, Latin America, and Asia. The company markets its products through franchise stores, independently owned and operated, and yet standardized by the company. There are currently more than seven thousand "points-of-sale" in more than 110 nations, mediated by an "interface" staff of eight hundred.

The successful growth and sustained profits of the company are due, in part, to its product design, quality control, and economically astute manufacturing process. But success is also due to advertising. Benetton's promotional materials describe this: "Through innovative, sometimes

provocative advertising campaigns, the Benetton name has become synonymous with multi-cultural diversity, inter-racial harmony and an upscale approach to fashion retailing."

What was the brilliant maneuver that took Benetton from a post-Fordist manufacturing venture to multicultural, multiracial peace, love and understanding? The advertising shift began in 1983 (year of HIV's isolation), when the company launched in Italy and France what was then graphically experimental: print ads showing only the product itself, colorful knitwear, with no model. The following year, Benetton developed a new strategy: "All the colors of the world." As Benetton describes them, these ads showed "jumping groups of laughing young people . . . pictured together." While this description offers no mention of the race of these "laughing young people," they were, in fact, multiracial. The promotion was expanded to fourteen countries, and the new slogan was translated into various languages.

In 1985, the company further developed the prior year's strategy: "colors and nationalities are mixed," as they put it. Flags and other national symbols appeared in the print ads. 1985 also marked the birth of a slogan, United Colors of Benetton, which later became the company's trademark. The national juxtapositions of these ads were intentionally controversial. Americans and Soviets, Germans and Israelis, Greeks and Turks, Argentines and Britons were photographed side by side, grinning amicably. According to Benetton's own reading, these "images seem to be a call for peace in the world." But they have alternatively been read as trivializing political conflict.

In 1986, the company took on a new symbol: the globe. Simultaneously, the campaign began using models who were deemed to have "accentuated ethnic features" such that despite the fact that "they [were] dressed in Benetton apparel, it seem[ed] that they [were] wearing national costume." This was a graphic illustration of the simultaneous "Third Worlding" of Italian sweaters and "Benettonizing" of the Third World that I charted above.

The issue of race was pushed further in the 1989 campaign. One ad showed a black and a white man handcuffed together. Their faces were obscured, but you could see they were wearing Benetton shirts. In another image, a heavy black woman was shown breastfeeding a white baby, a Benetton sweater draped over her naked shoulders. Benetton's promotion materials explain that in these photographs, the "product has only a

symbolic value." Yet it could be argued that here, it is *race* that is held as "merely" symbolic, as the ads appear to attempt to dehistoricize its significance. The second of these images was particularly controversial here in the United States, and Benetton subsequently withdrew it from U.S. publication, "because the campaign is intended to promote equality and not friction." The same image, however, received various advertising awards throughout Europe. In the same year, Benetton formally adopted the slogan "United Colors of Benetton" as its trademark, because the race angle was working, and working well. Sales had increased dramatically. The controversy of the withdrawn image involved what was to American eyes its obvious referent (*not* GOOD MOTHER, but exploited domestic laborer forced to give up her own milk). In this country, there was no hope of fully decontextualizing the historical image of the black mammy. Giroux notes that this image, like the image of handcuffed hands, is contextualized not only by historical race relations, but also by the history of racial representations in other ad campaigns and forms of popular culture. The Benetton ad which caused the greatest "friction" also brought about the greatest exposure, and the greatest "brand recognition." Scandal itself is big business.

In 1990, the advertising images, in the company's words, became "more symbolic, but still with strong contrast and without the presence of any product." It is unclear if the "contrast," in the company's thought, was graphic or political, but certainly the exclusion of any clear product reference was the beginning of something quite radically new in fashion marketing. In the following year, AIDS finally entered the picture, along with more "racial harmony" images. In one shot, "a white boy gives a big kiss to a happily surprised black girl." In another, an Asian, a black, and a white child stick out their tongues "in an expression common to children all over the world." It is of interest that Benetton began to stress the notion of universality at precisely the moment that the company began to fully explore the global market. Another 1991 image showed colorful condoms arranged in the same graphic style of the 1983 product-only ads. Benetton's account of this image was an effort to "promote social responsibility relating to overpopulation and sexually transmitted diseases such as AIDS . . . the themes touched on are socially-oriented and universal because Benetton is speaking to audiences in one hundred different countries around the world." That is, Benetton was *selling* to audiences around the world. In fact, what this campaign was selling was the notion of universality itself: what's good for Italians (Benetton sweaters) is good for Mexicans and Japanese as

well. So the "absence" of the product image is not so important as the very premise which says that a *global* product is universally desirable.

This seems to be an interesting inversion of the earlier suggestion that "accentuatedly ethnic" models made Benetton garments look like diverse national costumes. In fact, it's the flip side of the same coin (and this time coin—currency—is a particularly apt metaphor for the flip). "National costume" may have appeared to appeal to difference, but it was only difference based on similarity, on the sameness of Benetton garments. Now, "universal" expressions make all faces look the same, regardless of their race. One wonders what difference another expression might make. What if, for example, the "happily surprised black girl" were, rather, terrified, or what if she wore an expression of devastated resignation? What if the photograph of a black man and a white man had shown *their* expressions, and the one had been furious, the other pleased with himself? The ads, then, would have to be read not merely as an acknowledgment of racial politics, but as its dramatization. In that sense, one could still get around the question of "real" racism.

But what if the photographs weren't posed? In 1992, Benetton's marketing strategist Oliviero Toscani had his greatest brainchild. He began selecting journalistic photos taken by documentary photographers of various controversial, "global" sites of tragedy and conflict. Scrambling Haitian "boat people" aboard a leaky vessel, a soldier's bloody corpse, an emaciated man evidently dying of AIDS. In Benetton's words, these images were "intended to generate discussion of serious social issues while creating brand awareness." The small green and white Benetton globe logo appeared in the corner of each of these ads; other than that, they came with no instructions for reading. Again, these images were presumed to summon "universal truths" in the minds of viewers. The brilliance was in subsuming "reality" in the dramatization that the ad campaign appeared to be, but wasn't, because it was real. That is, it *made* reality fictional. For all the company's insistence that these ads were supposed to generate a political response, the opposite is true. The "universality" of the viewer's anticipated response defuses any possible personal politicization vis-à-vis the image.

The most famous of the photo-journalistic images was that of a man named David Kirby dying of complications from AIDS as his grief-stricken family watched over him. ACT-UP protested the use of the image as exploitative, arguing that it was obscene to use the suffering not only of Kirby but of all those affected by HIV to sell Italian sweaters. The activist

group staged "die-ins" in front of Benetton stores in protest. But McKenzie Wark has argued that the Benetton-ACT-UP encounter was finally mutually beneficial. Controversy is what both entities survive on. As Wark put it, "Silence = Death for both social issue campaigns and corporate advertising."[9]

In 1994, three AIDS images opened the campaign: "an arm, a lower abdomen, a backside, each stamped with the words 'HIV Positive' with the words underscor[ing] the literal and figurative branding of people with HIV in our society." What does that mean—literal and figurative branding? AIDS branding takes place in a figurative sense, yes, as in all nations individuals known to be HIV-positive are subject to forms of social control and discrimination. But "literal" branding—tattooing—is not a global common practice. In the United States, and presumably elsewhere, certain individuals have chosen to tattoo themselves HIV-positive, in protest of the figurative branding. And at one point William F. Buckley (who also thrives on controversy) proposed that "Everyone detected with AIDS should be tattooed in the upper forearm, to protect common needle users, and on the buttocks to protect the victimization of other homosexuals."[10] But it seems that in its explanation of these images, Benetton inadvertently made a link between HIV and another kind of literal branding altogether: that is, the promotion of "brand awareness" through an advertising ideology which might be compared to the very logic of the virus. The Benetton advertising campaign operates not by infecting the consumer with images of its product, but by debilitating one's system of critical resistance to its commercialism. Consumption becomes just an opportunistic infection, harmless enough unless one's defenses are down, which is precisely what the advertising aims to accomplish.

Wark argues, though, that Benetton simply multiplies and accelerates the complications introduced by modernity, once confined to "the space of art where, as Burroughs said, everything is permitted and nothing is true." Today, "this space is replicating, like a virus, throughout the information landscape."[11]

EL SIDA ES LA MODA DE LÁTEX

As I have already argued, AIDS has reconfigured our ways of identifying ourselves racially and sexually, individually, and as members of communities. The pandemic course of the virus is proof of the spe-

ciousness of human categorizations—of national and racial boundaries, of "sexual orientation," or "risk-taking" communities. People don't always make sexual decisions based on their own categorizations. Take Y.T., or Hiro. Or Sara. The AIDS issue of *Colors* magazine reports that "Last night Sara and Miguel slept together." In the center spread of the issue, there is an eight-page photo collage of a hypothetical couple and their sexual contacts—and their contacts' contacts—during the last twelve years. The photo album is necessarily incomplete, as by the magazine's calculations, the participants would number 531,441 (enough to fill more than 728 pages). Sara and Miguel live in Paris. She's blonde, he's Latino. A cursory examination of the people with whom they've been sleeping over the last year reveals that they are real Benetton types: into diversity. The subsequent array of photographs shows that in the four preceding years, the sexual ties have exponentially increased the racial types—and, more stylishly still, a lot of these people are choosing same-sex partners, either occasionally or consistently. During seven years, they seem to have covered every possibility. Aside from their common lovers, these people appear to have just two things in common: they're all young (target range for Benetton products), and they all have a strict regimen of three sexual partners per year.

So despite superficial difference (according to Benetton, race is superficial, as are nationality and sexual orientation), everybody (or everybody who counts, target-wise) is fundamentally the same: young, and three-times-a-year fun-loving. But then there is a footnote, or properly, as *Colors* tells you, a "Tiny footnote: this didn't really happen. The people in these pictures don't know each other. We don't know who slept with who. We are saying this here because our lawyers made us."[12] Are people—races—nationalities—*really* connected?

Of course, but Benetton (even if they blame it on their lawyers) has to maintain, and constantly recuperate, the notion of difference. To make difference visible, you need contrast, and for contrast, you need contact—skin on skin, if possible. This is precisely the kind of interracial "safe sex" skin shot which appears throughout the *Colors* issue. But if genitalia are involved, then you need a barrier. The magazine suggests either a pair of Benetton jeans, or latex. All issues of *Colors* are printed bilingually (more contrast), and in the Spanish-English version of this one, the table of contents tells you, "El SIDA es la moda de látex. AIDS is latex fashion."[13] This sounds suspiciously like (BLOOD IS BIG BUSINESS). Benetton doesn't

actually market a line of latex fashion, but they market a philosophy of *safe racial intimacy*—it's all right as long as we all remember who we really are. One needs dichotomies, that is, in order to have diversity, and vice versa. So what looks like a campaign to "promote racial equality and fight AIDS" ends up resolidifying racial dichotomization and utilizing the virus's logic to make consumers susceptible to "brand awareness."

The photo collage of Sara and Miguel insists on its own fictionality. In that sense, it resembles another widely discussed magazine image of recent history: the cover of *TIME* magazine that used computer imaging to "create" the face of "America's future": an amalgam of races.[14] The final product looked like a Latina woman who conformed to current Western standards of beauty. That is, on looking at her, you might have thought, "she could be a model." But the technology involved in producing this image insists that you remind yourself that she *couldn't* be a model, because she doesn't exist. Technological miscegenation doesn't just image literal racial mixing—it *replaces* it. It makes it, in effect, unnecessary. The *TIME* cover imaged the United States as the land of the free and the home of the multicultural. But its manufactured nature gives lie to that image. The imaging of the United States is of interest here, because despite Benetton's insistent Italianness, it continually invokes the United States (in its American spelling of "Colors," and, as I've mentioned, the fact that they're "United").

The *TIME* cover is not so unusual as it appeared at the time it came out. Computer imaging is increasingly used to modify "real" models' images in more complicated ways than what used to be performed by airbrush. Features are "corrected" with regularity, and a composite photo derived from several faces has already appeared on the cover of *Mirabella* (lest one imagine that Brandy's prosthetic existence in the Metaverse was far from home).[15] This same technology of photo composition was used by *Colors* magazine to create a "corrected" photograph of Ronald Reagan. He appears toward the end of the issue, gaunt, dappled with "real" Kaposi's Sarcoma lesions grafted from the images of several PWAs. The accompanying text tells you that the former U.S. president died of AIDS in February of 1993, but that he will be "best remembered for his quick and decisive response to the AIDS epidemic early in his presidency" as well as "his courage and foresight but above all, for his boundless compassion."[16] An even tinier footnote than the "Tiny" one, however, tells you, "The editorial about Ronald Reagan is fiction. It is what could have happened."[17]

The photo image of Reagan with AIDS was plastered all over metropolitan streets at the time the issue of *Colors* hit the newsstands. Again, it was the cause of some controversy. Reagan's spokeswoman, Cathy Busch, responded promptly:

> Capitalizing on the tragedy of AIDS for commercial purposes is insensitive at best. The truth is no one will be saved—nor will a cure or vaccine be found sooner—through irresponsible attempts to commercialize on human suffering. The AIDS crisis requires compassion, not animosity.[18]

Oliviero Toscani responded succinctly: "It was Ronald Reagan who gave us the opportunity to capitalize on AIDS." *Colors* editor Tibor Kalman responded with more emotion:

> It is unbelievable to me that Ronald Reagan—who did not utter the word AIDS until 4 years after the CDC findings, until 28,000 died in the U.S. alone and millions were infected worldwide—has the gall to allow a spokesperson to use the word "compassion."[19]

One would concur with Kalman's accusation of Reagan, while simultaneously concurring with Reagan's representative's characterization of Benetton, and noting Kalman's own considerable gall. It's a real gall toss-up.

That doesn't mean the image is without value. In fact, the entire issue of the magazine might have value, as might other questionable Benetton images. Wark's depiction of the David Kirby ad as "a very open image" is right—even if it "means" to discourage politicization, it presents all kinds of possibilities for a politicized response. That includes a politicized response to the logo in the corner. Brand names, of course, do not create separate identities any more than latex barriers. Benetton's effort to make the "United Colors of Benetton" recognizable as the brand that subsumes all races and all cultures is particularly insidious because it sells false racial dichotomies in the name of universality, and false economic equality in the name of difference. That may be a tricky move for an Italian knitwear manufacturer, but it's all too familiar to those of us living in another "United" state.

I have tried to tie together the manufacturing technologies of "flexible specialization" with the notion of a "viral" spread of ambiguous images that call themselves multicultural. Haraway has made this kind of link much more explicit, and generalized, marking the transition in the 1980s from hierarchical cultural configurations to systemic ones. These include the shift from "family/market/factory" distinctions to a notion of "women in the integrated circuit," and the shift from a preoccupation with microbiology to a concern with the immune system.[20] And while, as I have discussed in the previous chapter, Haraway celebrates the liberatory potential of some of these reconfigurations, she also marks their complicity in various forms of exploitation.

> My thesis is that the immune system is an elaborate icon for principal systems of symbolic and material "difference" in late capitalism . . . the immune system is a map drawn to guide recognition and misrecognition of self and other in the dialectics of Western biopolitics. That is, the immune system is a plan for meaningful action to construct and maintain the boundaries for what may count as self and other in the crucial realms of the normal and the pathological.[21]

And Haraway notes that this notion of "selfhood" and "otherness" has arisen in a historical context rife with the confluence of figures of epidemia and race:

> Expansionist Western medical discourse in colonizing contexts has been obsessed with the notion of contagion and hostile penetration of the healthy body, as well as of terrorism and mutiny from within. This approach to disease involved a stunning reversal: the colonized was perceived as the invader. In the face of the disease genocides accompanying European "penetration" of the globe, the "coloured" body of the colonized was constructed as the dark source of infection, pollution, disorder, and so on, that threatened to overwhelm white manhood (cities, civilization, the family, the white personal body) with its decadent emanations.[22]

Following Haraway's lead, Emily Martin's recent *Flexible Bodies: The*

Role of Immunity in American Culture from the Days of Polio to the Days of AIDS demonstrates, through both a review of various literatures and through diverse ethnographic fieldwork, a contemporary cultural trend toward viewing biological, economic, and political processes as complex systems. "At the beginning of my research," Martin writes,

> I wondered whether it would be possible to understand how the economic and social formation of late capitalism can influence "culture," in particular, internal and external forms of the body in health and illness. . . . Now that my research has been concluded, it seems to me that, when it comes to the disciplines of science and medicine, given their cultural preeminence in the United States, one could as feasibly argue that the ideal models of being in the world that these disciplines generate . . . could be acting as templates for ideal forms of conducting business or making products.[23]

Martin shows that an increased emphasis in both medical and popular perceptions on the importance of the immune system bears a remarkable resemblance to economic emphasis on a systems approach to production. Martin gives a somewhat more sympathetic account of the ideology of "flexible" labor systems than the one I give in the brief sketch above. But she also acknowledges that the seductions of a reconfigured, potentially liberatory view of labor must be tempered with suspicion:

> There is a propensity to extol harmony within the system and reliance on the group while paradoxically (and distractingly) allotting individuals a dynamic, ever-changing, flexible role. . . . [Yet] concealing conflict between those who have different amounts of resources and power for the sake of the appearance of harmony usually hurts the disadvantaged.[24]

This was precisely Giroux's argument when he wrote that Benetton's images of multicultural and multiracial harmony "mock concrete racial, social and cultural differences as they are constituted amid hierarchical relations."

A parallel warning is articulated in the interviews that Martin conducted with people who identified themselves as economically, racially, or culturally vulnerable, who viewed their biological immunity as inextricably

tied to these social factors. An underclass community activist told the interviewer:

> We think it [AIDS] could kill us. It could just kill a lot of people in our community . . . because they say that you get AIDS through needles, and a lot of our people shoot up. They say you get AIDS through gay sex, and a lot of our people function as prostitutes, and are [a] really sexually active population, so, and then you get it through having relations with one another, and you pass it by being close to one another, and our people are very close to one another. . . . [IVDUs are] part of our community, and having relations in our community, and there's people who, you know, are involved in male prostitution, you know what I mean? And they're over here, you know, and there's a gay community over there, you know. It's integrated in our community. So our fear was, oh my God, you know, when I first heard about it, I thought, Jesus, we're going to be like death.[25]

This man speaks of "integration" in a way which simultaneously parallels and negates the notion of system integration in the economic sphere. Biologically, he also acknowledges the complexity of viral activity and the immune system, but argues that preoccupation with such micro-systems within individuals will detract attention from the more significant systemic problems of poverty.

Martin places the discourse of flexible systems, prevalent in the spheres of biology, computer science, economics, marketing, New Age philosophy, government, psychology, and even feminism, in historical context, arguing that this configuration arose in contrast to the figure of warfare. Specifically in medical discourse, the metaphor of military combat of "good guys" and "bad guys" within the body is being countered both by certain physicians and researchers, as well as many alternative practitioners and patients, with the figure of a basically harmonious system intended to balance itself. Viruses, then, are not "alien" to the body, but an integrated element that must then be accommodated by the immune system.

In contrast to the figure of warfare, this depiction of viral infection has its obvious attractions. The challenge, clearly, is understanding such systems as they are integrated into other systems, including systems of economic exploitation, and acknowledging that imbalances do exist. In addi-

tion, one needs to be suspicious of apparently "harmonious" models which in fact replicate structures of oppression. This is the argument of those who say that post-Fordism would better be called neo-Fordism. It is also Étienne Balibar's argument, cited by Martin, when he writes that contemporary emphasis on "cultural difference" constitutes a "neo-racism," in which racial dichotomization is replaced by a "naturalization" of the notion of culture.[26] This is why the Benetton ad depicting Haitian "boat people" represents, to many Americans, a threat of viral infection: the fear would perhaps not be articulated as a fear of "blackness," but of "voodoo," and of AIDS. It's still racism.

Martin points out that even the "flexible system" model can lead to a form of "post-Darwinism" that looks remarkably like neo-Darwinism, a philosophy of the "survival of the fittest" in which certain bodies, certain communities, and even certain cultures are deemed capable of making it. One medical researcher interviewed by Martin predicted that the spread of HIV would slow down in this country, but would continue to accelerate catastrophically in Africa and the rest of the Third World. His prediction was based on cultural difference: "It's very easy for us to wrap our minds around the notion of AIDS as an infectious disease as a contagious thing. ... That notion of a virus itself is alien to a Ugandan tribesman." He summarizes "our" distance from the "tribesman": "We're on the far side of the jungle floor."[27]

A medical student, however, offered an account of HIV itself which figurally turns the body—any body—into that very "jungle floor":

> I think that we're part of an environment. I think AIDS is an interesting disease because it ... actually causes the boundaries of the human being to be blurred between self and environment. The things that can't [usually] grow in you can grow in you. ... People become culture mediums. I mean, you become a substance upon which many things can grow, can grow and flourish. If you look at it from the microorganism's point of view, they can now grow and flourish in you. You become this kind of incredible rich ground upon which to multiply.[28]

This man acknowledged that his configuration might look good to microorganisms, but would be "disturbing from the human being's point of view." Still, Martin notes that a danger in the harmonious system

approach is that it can lead to "an indifferent attitude toward distinctions among subsystems."

But the notion of a "human culture medium" is perhaps more telling than it seems. A person living with AIDS might be understood not merely as a human petri dish, a system allowing other microsystems to proliferate, but also as a part of a larger network of cultural systems that are inextricably integrated, even if risk group epidemiology and the politics of neoracism would have it otherwise. Perhaps that configuration offers as little comfort as the image of the petri dish. But the activist's acknowledgment that those living with HIV are "integrated into our community" is another more meaningful, comforting, *and* honest way of saying the very same thing.

NINE

Penetrable Selves
("Paris Is Burning")

Out on the sidewalk, under the bluish cast of the street lights, Angie Xtravaganza lifts up her blouse, exposing her medium-sized, soft and very natural-looking breasts. A man gleefully brags, "I bought her her tits—I paid for them!" Angie obligingly shakes these tits for her happy children, two grown moustachioed men, who then greedily suck them as Angie lifts her head nobly. "Our mother even nurses us," says the child who bought the tits. "She's a good woman."

Is this the GOOD MOTHER of my anonymous painting, the replication of an image of African womanhood already mass-produced in Nigeria, now so far-flung she seems a world away? Or is she rather the image of African "tradition" depicted by Trigo Piula, a whitened woman offering the sickeningly sweet milk of free market capitalism? Angie Xtravaganza is both of these and neither. She is "Ezili Dantò, the hardworking, solitary, sometimes raging mother; and Ezili Freda, the sensual and elegant, flirtatious and frustrated one."[1] She is also the prostheticized Brandy, just as she

is Y.T., appearing both illusively white and female but armed with a penetrating 'poon between her legs. She is Butler's ooloi, versatile, mixed, seductive. More so than any model Benetton could procure, she is multicultural fashion. But to the children sucking those breasts, she is simply Mother.

Jennie Livingston's 1991 film documentary of the Harlem gay balls, *Paris Is Burning*, has provoked an enormous amount of critical discussion.[2] Commentary on the film has tended to focus on drag as the exemplary site of the construction of gender. But the balls are also the site of another kind of ambivalent mimicry—that of racial and cultural identity. When Livingston began filming, the mainstream audience was completely unaware of the gay ball phenomenon. By the time the film was released, health clubs and dance studios across the country were beginning to offer "voguing" classes. The film had unexpectedly broad appeal, largely due to the perception of its subject matter as original, distinct, and *fashionable*. The dance style that had developed in the balls was yet another "infectious" form of black performance. But the balls were hardly new. They emerged from an on-going history of African diasporic community-defining practices. The most obvious secular diasporic practice to which the balls bear a resemblance is carnival—long recognized as a politically charged moment of the inversion of race, sex, and class.[3] But even more stunning similarities can be found in the less public, more discreet practices of diasporic religion.

A WOMAN WITH A MOUSTACHE

Jim Wafer, writing about his experiences in the late 1980s in a Candomblé community in northeastern Brazil, recounts a farewell meeting between himself and a female trickster spirit, Pomba-Gira. After downing a few glasses of sweet red wine, Pomba-Gira sang, danced, and gave Wafer some ritual instruction regarding his obligations as an initiate upon his return to "his land." Wafer listened attentively:

> I was standing at the door. "Would you like to kiss me?" she said.
> "Yes," I said.
>> In Brazil there is a folk saying:
>> Mulher de bigode
>> Nem o diabo pode.
> "Not even the devil can (bring himself to kiss) a woman with a moustache." The folk are not always right.[4]

Certainly Angie Xtravaganza, loving mother of those two moustachioed nursing babes in arms, would agree.

While it is not possible to apply this generalization to African diasporic religion, or even to Candomblé as it is practiced throughout the rest of the country, in the northeast of Brazil, homosexual men play a significant role in the worship of African divinities and spirits. I have written elsewhere on the question of sexuality, and specifically homosexuality, in this context.[5] This is a vexed issue in the ethnographic bibliography on the Candomblé. One of the earliest and, in the eyes of many, most indiscreet writers on the subject was Ruth Landes, who celebrated Bahia as the "City of Women" in an eponymous book, which extolled the Candomblé as a matriarchal—and empowering—subculture.[6] In this book as well as in academic articles for psychiatric journals, Landes wrote that the only men who could take *full* part in the ceremonies, incorporating divinities through dance and spirit possession, were those who were "passive homosexuals" who, like the women, were "mounted" by the gods.[7] Spiritual penetrability, in other words, was equated with (and dependent upon) sexual penetrability.

Landes' account was refuted by a number of Brazilian and North American critics at the time, but as anthropological doctrine has increasingly abandoned the view of homosexuality as social pathology, more and more ethnographers and members of the Candomblé community have come forward to support Landes' claims.

It is interesting to note that Landes, a Jewish American woman who grew up in Harlem surrounded and fascinated by African American culture, was ostracized from anthropological circles for yet another professional "indiscretion." During her fieldwork in Bahia from 1938–39, she became the lover of a black Brazilian anthropologist, Edson Carneiro. Her biographer, Sally Cole, has noted that *this* indiscretion may have led to the underacknowledgment of her contribution to the field of African diasporic religious studies.[8] Carneiro also hinted as much.[9] But even Carneiro remained relatively tight-lipped on the topic of sexuality in the Candomblé. As a black Brazilian intellectual, he perhaps had more at stake in "outing" the Candomblé in a period of intense homophobia both in the United States and Brazil.

There is a growing body of gay activists in Brazil,[10] and an increasing turn toward the models of gay community definition supplied by the United States[11] And yet sexuality—and perhaps particularly homosexuality, has been configured historically in such different ways throughout Latin

America—and in African America as well—that some translation is neces-
sary in the cross-cultural dialogue of activists.[12] Don Kulick has gone so far
as to argue that in Latin America, the popular understanding of sexual
penetrability precedes and, in fact, constitutes gender determination:

> One of the basic things one quickly learns from any analysis of Latin
> American sexual categories is that sex between males in this part of
> the world does not necessarily result in both partners being per-
> ceived as homosexual. The crucial determinant of a homosexual
> classification is not so much the fact of sex, as it is the role per-
> formed during the sexual act. A male who anally penetrates another
> male is generally not considered to be homosexual. He is considered,
> in all the various local idioms, to be a "man." . . . [T]he *sexual division*
> that researchers have noted between those who penetrate and those
> who are penetrated extends far beyond sexual interactions between
> males to constitute the basis of the *gender division* in Latin America.
> . . . Gender in Latin America should be seen not as consisting of men
> and women, but, rather of men and not-men, the latter being a cate-
> gory into which both biological females and males who enjoy anal
> penetration are culturally situated.[13]

Kulick makes this provocative, and ultimately convincing, claim, in the
context of a study of transgendered sex workers in Bahia. The community
that he is considering shares many of the economic and social pressures
experienced by the community depicted in *Paris Is Burning*. If Donna Har-
away argued, as I cited in the preceding chapter, that male workers' increas-
ing vulnerability put them in a "feminized" position, constituting a "new
sexuality" within Western culture, the vulnerable communities depicted in
Livingston's film and Kulick's article, while only "new" in the degree of
their ability to medically alter their bodies, occupy just such a dangerous
space, carried to an extreme degree.

It is because of the implicit danger of living in this kind of space that
such communities are compelled to define themselves *as* communities,
and as families. As in Santería, Candomblé temples and their congrega-
tions are referred to as "houses". They are run by *mães* (mothers) and *pais*
(fathers) *de santo* (in Santería, *madrinas* [godmothers] and *padrinos* [god-
fathers]). Their initiates are referred to, regardless of their age, as their chil-

dren. In *Paris Is Burning*, the "children" of diverse "houses" repeatedly articulate their own vulnerability due to their race, class, and sexuality. They also make it clear that this last identification, in many cases, has led to their exclusion from their "literal" families. As Judith Butler writes:

> What becomes clear in the enumeration of the kinship system that surrounds the ball is not only that the "houses" and the "mothers" and the "children" sustain the ball, but that the ball is itself an occasion for the building of a set of kinship relations that manage and sustain those who belong to the houses in the face of dislocation, poverty, homelessness. These men "mother" one another, "house" one another, "rear" one another, and the resignification of the family through these terms is not a vain or useless imitation, but the social and discursive building of a community, a community that binds, cares, and teaches, that shelters and enables.[14]

While Butler urges that viewers of the film "[consider] the place and force of ethnicity in the articulation of kinship relations,"[15] and while she reminds us that the houses are demarcated as specifically Latino or African American, she doesn't actually read the kinship structures in their ethnocultural context. Part of that context, certainly, is the African diasporic tradition of religious families.

Reconstitution of "family" means something different when the "literal" family is, in all likelihood, *not* the nuclear family, but an extended family, an economically vulnerable family in flux, in which grandmothers, aunts, and sisters are as likely to nurture children as mothers. This is one reason a psychoanalytic approach, based on the notion of a fixed bourgeois household, to *either* the gay balls *or* to diasporic religious communities is likely to fall short. The other reason is that, as Mary Douglas has argued, such collective configurations may well have therapeutic effects upon individual participants, but they have a larger significance, which is "an attempt to create and maintain a particular culture."[16] This is the inverse of Karen McCarthy Brown's argument, cited above, that all Vodou rituals are, on some level, attempts at healing.

They are also acts of worship. African diasporic religion that depends upon the incorporation of divine principles is an on-going effort to make manifest the fundamental beliefs which will allow a community to survive.

Demarcated within a larger, hostile social context, such a community must act out aesthetic, ethical, and *political* precepts which will affirm their individual and *group* identities.

Paris Is Burning begins and ends with two literal children, aged thirteen and fifteen (they say), young boys hanging out in the middle of the night in front of the hall where the balls are held. Tenderly entwined as they speak, they explain that they are gay, and that while one continues to live with his family, the other is staying with a friend. This one, the more childlike of the two, ends the film with an analogy of precisely the kind I am trying to make. "A religious community," he says, "they want to pray together. . . . This gay community . . . they, like, want to be together." The extraordinarily structured, coded manner of their "being together" is a rite with enormous personal and political implications—as well as potential to keep these children alive and nurtured in a hostile world. Remember the Haitian mambo who, mounted by Gede, crossed the limits of her body and her sex to save the life of a child. There are plenty of things, in Haiti and in Harlem, to be afraid of—among them police violence and virulent attacks on both diasporic religious and gay communities. But one thing *not* to be afraid of is the expression of a community's love for a child.

THE WOMAN WITH A PHALLUS

The mambo who expressed both a mother's and a community's love for a child by incorporating the spirit of death and producing a seminal ejaculate was one extreme figure of a woman with a phallus. The figure has appeared in other places in this book, including cyberspace, where a white woman from Seattle became the gender trickster Legba, often represented with a gargantuan dick; *Snow Crash*, where Y.T.'s "dentata" turned out to be her capacity to penetrate sexually; and Octavia Butler's entire oeuvre, where gender mixes as fluidly as race. *Paris Is Burning*, of course, is full of such figures, embodiments of womanliness with "little secret[s] down there."

The suggestion that the femme children represented in Livingston's film embody womanliness has been contested, notably by bell hooks in an infamous critique.[17] hooks read these drag forms as inherently misogynistic, and racist. The charge of misogyny echoed earlier arguments by Marilyn Frye[18] that femme drag ridicules women, reproducing the very oppressive forms which disempower them. These are the prosthetic forms that seem

to denaturalize "real" women's lives even as this "womanliness" is natural-ized—make-up, fake tits, spike heels, and a whole array of "feminine" behaviors, including sexual "passivity." hooks went on to argue that in *Paris Is Burning*, this misogyny takes a racist turn, as "the idea of womanness and femininity is totally personified by whiteness."[19] What's more, she argued, Livingston's implicit but unexposed role as a white female filmmaker placed her in an "imperial overseeing position" regarding black male would-be white women.

Judith Butler countered this reading with a reminder of the added sig-nificance of Livingston's lesbianism, and the complicatedness of her posi-tion behind the camera:

> The one instance where Livingston's body might be said to appear allegorically on camera is when Octavia St. Laurent is posing for the camera, as a moving model would for a photographer. We hear a voice tell her that she's terrific, and it is unclear whether it is a man shooting the film as a proxy for Livingston, or Livingston herself. What is suggested by this sudden intrusion of the camera into the film is something of the camera's desire, the desire that motivates the camera, in which a white lesbian phallically organized by the use of the camera (elevated to the status of disembodied gaze, holding out the promise of erotic recognition) eroticizes a black male-to-female transsexual—presumably preoperative—who "works" perceptually as a woman. . . . Livingston incites Octavia to become a woman for Livingston's own camera, and Livingston thereby assumes the power of "having the phallus," i.e., the ability to confer that femininity, to anoint Octavia as a model woman.[20]

To anoint Octavia would mean, literally, "to smear or rub with oil or an oily substance . . . as a sacred rite esp. for consecration."[21] How far could one push the figure of Livingston as the phallic priestess anointing a beloved child with the unguent of sexuality?

Surely, I've pushed it too far already, and yet Jean Rouch was also right when he wrote that the filmmaker participated in every ritual he filmed, becoming a part of the structure of divine representation. The balls filmed by Livingston follow many of the ritual structures of African diasporic reli-gion. But the way in which they *differ* from most Vodou, Santería, or Can-domblé ceremonies is the very way in which they demand that film enter

into the rite. As I wrote above, in the vast majority of African diasporic religious ceremonies, cameras (both still and video) are prohibited. This is sometimes explained in cosmological terms (according to the logic of possessional worship, divinity cannot be represented, but can only be made *present* in the living bodies of worshipers). But it is sometimes explained in historical terms (after a lengthy history of political repression, including violent attacks, African diasporic communities have learned to keep their cultural practices discreet). The prohibition of most filming is the reason you can be fairly sure that the "documentary" footage of Haitians in "voodoo trances" shown on television during the U.S. intervention was taken from tourist performances especially arranged for the cameras.

The Hauka filmed by Rouch did not organize their ceremonies for film documentation, and yet their ambivalent incorporation of European hegemony meant that Rouch and his camera were implicated before they even arrived on the scene. As Taussig argues, Rouch's own editorial juxtapositions follow the same ritual logic as the Hauka's sacrifice. The Hauka create a densely ambivalent irony in their imaging of the West. Obviously, so do the drag balls. Both race *and* gender are simultaneously ridiculed and worshiped, and the film, *Paris Is Burning*, participates fully in both aspects of the ritual.

Roland Barthes' *Mythologies* argued that the mythic figures of late twentieth century Western culture were taken from the screen. The "legends" of the balls explicitly mark their mythic genealogy through the media of print photography and film. As Octavia St. Laurent points to her collection of photographs of the supermodel Paulina, she recounts a litany of a goddess' multiple manifestations that rival the manifold forms taken by Ezili. There is no *apparent* ironic distance here, and yet the film creates such a distance by implying that Octavia can never fully embody an already prosthetic white "womanliness". The older drag queen of the film, however, Dorian Corey, fairly drips with irony as she recounts her own early desires to embody Marlene Dietrich, Betty Grable, and Marilyn Monroe, before understanding her "real" desire to embody Lena Horne. Corey's irony, still ambivalent, reflects on both the racial *and* sexual aspects of her personifications.

Because the "femme realness queens" explicitly worship film images, their greatest realization of their own divinity seems to take place in the act of their being filmed. This is part of hooks' discomfort with the film, as it structurally seems to put Livingston in the position of the one person who

can bestow on these children their deepest desire. hooks also argues—as many of the stars of the film argued after its unexpected commercial success—that while the children of the house had spoken of their desires not merely to escape poverty, but to acquire the wealth of "real" movie stars, it was Livingston, not most of them, who achieved a degree of professional and financial security from the film. But hooks imagines that Livingston's position behind the camera somehow removed her from representation in the film. To my mind, both she and *every* viewer becomes a part of the circle of divine presences and representations. Any woman watching the film who imagines that she, more than Octavia, embodies Paulina *must* have a moment of ironic distance from her own "realness."

Those who value the balls—and this film—for what they demonstrate about the performed "nature" of gender might balk at the idea of a comparison with possessional religious practices in which bodies incorporate divine principles. And yet divinity in the African diaspora is hardly essentialist. Because it can only be manifested in non-divine bodies, whose own apparent gender and race are often at odds with abstract descriptions of the gods, this divinity is necessarily real and yet "real."

MILITARY MEN

Womanliness is not the only "realness" category at the balls. One of the most interesting competitions documented in *Paris Is Burning* is that of military realness. A voiceover explains that the goal of the uniformed walkers is to appear as "natural" as possible. The screen image shown under this explanation is the most ceremonially stiff young man, marching with excruciating severity. If the Hauka mimed the French military in a frenzy of violent pomp, this military man worships through the perfection of subtlety.

The tremendous irony of this mimicry is that the social form itself, military man, is itself a radically denaturalized form of behavior, extremely performative. It is the masculinized version of a prostheticized womanly existence, equally machinated even as it is naturalized. What would it mean for a gay man to be in drag as a military man in the real military? It would mean to be following orders. Don't ask, don't tell. Not telling, though, is not merely necessary to avoid court-martial. Perhaps the most highly publicized violent attack on a gay man in recent history was the 1992 murder of a sailor named Allen Schindler. After telling his superior officer of his

homosexuality, requesting a discharge, and taking shore leave in Sasebo, Japan, Schindler was pummeled and stomped to death by Airman Apprentice Terry Helvey in a public bathroom while another shipmate looked on, joining in occasionally. A *New York Times* account described how Helvey

> kneed Schindler in the groin, struck him in the face and then, cradling his head in the crook of his arm, punched him repeatedly while lowering him to the floor. There, Helvey began stamping on him with the heel of his foot, striking blows from head to crotch that resulted, according to the pathologist who performed the autopsy, in abrasions, contusions and lacerations of the forehead, eyes, nose, lips, chin, neck, Adam's apple, trachea, lungs, liver—which was pulped "like a smushed tomato"—and penis. The pathologist compared the damage to that of a "high-speed auto accident or a low-speed aircraft accident" and said it was the most severe trauma he'd ever witnessed—even worse than a case he'd seen of a man trampled to death by a horse.[22]

The article from which this description was taken focuses on the experiences of Allen Schindler's mother, Dorothy, in the wake of his murder. Schindler had tried to tell her that he was gay, but she didn't believe him until after his murder, when she not only accepted her son's sexuality, but became a fast friend and ally of gay activists who protested Schindler's death. Jesse Green, author of the article, points out the irony in the fact that both Schindler and Helvey turned to the military after childhoods marked by the violence and neglect of the paternal figures in their lives:

> Perhaps it was once possible to think of the Navy as a substitute father for America's lost boys, but no longer. In this regard, the Navy failed Helvey as much as Schindler. In his unsworn testimony at the court-martial, Helvey said that all he had ever wanted was a family, and that the Navy, with all its "fights, typhoons and hurricane warnings," provided it. But what kind of family, Dorothy likes to ask, would reject a loving son merely for being what he is? And that's how the Navy failed Allen Schindler. He loved the Navy, and died of unrequited love; it shipped him back, an anonymous pulp, unrecognizable even to his mother, except for the insignia tattooed on his right arm—of the U.S.S. Midway.

In and out of the military, violence against gays has a long and ugly history, merely accelerated and exacerbated by the AIDS pandemic. In *Paris Is Burning*, Dorian Corey describes the stakes of realness on the street, outside of the balls:

> When they're undetectable, when they can walk out of that ballroom into the sunlight and into the subway and get home and still have all their clothes and no blood running off their bodies, those are the femme realness queens.

This narration is set over a screen image of Venus Xtravaganza, the most "real" of all the film's queens, who, in the course of the film, is killed for not being real enough.

Venus was strangled and left under a bed in a hotel room, discovered four days later, identified by her "mother" Angie Xtravaganza (GOOD MOTHER) at the morgue. Angie mourns the loss of her child, whom she never felt was cautious enough—particularly in sex work. But earlier in the film, Venus narrated her own understanding of the dangers of her life:

> I was with a guy and he was playing with my titties until he touched me—down there—he felt it and he seen it and he like totally flipped out. He said, "You fucking faggot—you're a freak, you're a victim of AIDS and you're trying to give me AIDS. What, are you crazy? You're a homo and I should kill you. . . ." But see, now I don't like to hustle anymore. I don't, and I'm afraid of what's going on, the AIDS, and I don't want to catch it.

Venus ends this story by saying her greatest fear is "catching AIDS," but as this story and the circumstances of her death show, her more immediate danger was homophobic violence. Interestingly, the gay-bashing john in her story also articulates his threat to kill Venus through AIDS, and in a strange circumlocution which could have been his, or could be Venus's in her repetition of the story. "You're a victim of AIDS," he says, as he bashes her. The astonishing brutality of attacking someone for being a "victim" is unbelievable, and yet all too familiar, as I have laid out in the preceding chapters. Those victimized by brutality due to a perception of their victimization by AIDS include not only gays, but Africans and Haitians as well.

Paris Is Burning is disturbingly oblique in its references not only to

violence, but also to AIDS. Venus's death is subsumed by a larger narrative of hegemonic economic and sexual exchange as mimed and ironized, sort of, in the balls. And while Venus's death makes it clear that she was taking certain risks that she earlier claimed to have foresworn, there is nothing to mark her own HIV status. In fact, no one in the film directly addresses the impact of HIV on the lives of the children of the houses. Dorian Corey, the brilliant narrator of much of the film, has a world-weary, philosophical air as she looks back at her life. She has learned, she says, not to hope for too much, just to enjoy life. "If you shoot an arrow and it goes real high, hooray for you." But she never claims that she learned mortal humility through a confrontation with HIV. She was diagnosed with AIDS shortly before the release of the film, and died in 1993.

OF CLOSET DOORS

At this point, it is hardly necessary to repeat the point that such discretions are not superstitious, but grounded in a history of violence. It is related to the significance of "realness" in the balls. As Peggy Phelan has written:

> Excessively marked as "other" outside the arena of the balls, the walkers employ the hyper-visibility of the runway to secure the power and freedom of invisibility outside the hall. . . . The walkers admire "whiteness" in part because it is unmarked and therefore escapes political surveillance.[23]

Political surveillance (and police surveillance, mimed by Livingston's camera fixed like a surveillance video in a Roy Rogers restaurant where some children gleefully rip off food) is a more abstract violence than the bloodying of unsuccessful femme realness queens just struggling to get home. But it is another part of a culture of discretion.

Butler cites Simon Watney's *Policing Desire* as a demonstration of the way in which AIDS has allowed for the positing of gays as "polluting persons" in Mary Douglas's sense of individuals whose own boundary-crossed bodies serve as a representation of the larger trespass of social boundaries. I would widen this description to argue that the HIV-positive body, increasingly construed not exclusively as a gay body but as a body of color,

serves as a marker for the anxiety of crossed sexual, racial, and cultural boundaries. Butler writes:

> The construction of stable bodily contours relies upon fixed sites of corporeal permeability and impermeability. Those sexual practices in both homosexual and heterosexual contexts that open surfaces and orifices to erotic signification or close down others effectively reinscribe the boundaries of the body along new cultural lines.[24]

But the significances of sexuality and permeability are already crossing cultural lines as African diasporic communities create their own bodily rites of permeability within and against North American hegemonic mythologies of gender and race.

No more would the mothers of the houses call the balls "voodoo rites" than they would pronounce the prevalence of HIV in their community. These are meaningful silences.

A brief interlude in *Paris Is Burning* shows two of Angie's children, Brooke and Carmen Xtravaganza, frolicking on the beach, laughing playfully for the camera. Brooke recounts the several plastic surgeries she has undergone in recent years, culminating with a sex change. Spinning around under the sunshine, she yells, "I can close the closet door—no more secrets!" (Carmen giggles to the camera that the only problem is "that voice," still pretty markedly husky.)

There are several kinds of closeted information in this film, from Venus's "little secret down there" (which appears to have slipped out and brought her down), to the African diasporic connections in the ball culture, to Dorian Corey's HIV status. But Corey had another, much more literal closeted secret in her life. After her death, a "mummified" body was discovered, wrapped in plastic, camouflaged in a garment bag, stuffed in the closet. It is estimated that Corey had that body in her possession for some twenty-five years.

Edward Conlon[25] has written of the set of circumstances, those that can be retraced, which led to the conjunction of two lives, that of Corey, née Frederick Legg, and Robert Worley, the body in the bag. The likeliest scenario that emerges is that in the late 1960s, Corey, working as a transvestite showgirl and living in Harlem, was harrassed, possibly robbed, by Worley, who had an addiction to take care of. She shot him in self-defense. A friend,

Jessie Torres, recounted her version of Corey's side of the story (a story Corey tried to tell on her deathbed, but which was read as pure delirium):

> He was known in the neighborhood as a junkie. If he knew you had
> a little bit of money, he would come around here, come around there
> with the attitude, "Fuck you, you-all are faggots." Fuck you bitch!
> He'd take women off too. Seeing that society frowns on junkies, they
> feel, you know, they could frown on us. I could imagine. I have been
> in situations like that—guys who say, "Go ahead, call the police, you
> faggot!"[26]

Conlon points out that this account may or may not be accurate. The more interesting thing, he says, is to think about the broader nexus of forces that brought Corey and Worley together:

> Corey and Worley were black men without much money, close in
> age, who moved to New York City from rural areas. As victims of
> AIDS and homicide, they embody two of the main statistical bases
> for abbreviated life expectancy in Harlem.[27]

The discoverers of Worley's body were two Halloween party-goers looking for a costume among Corey's belongings. They were looking for something specific: "[the] shoppers in her closet wanted a vampire costume and got a mummy instead."[28]

Perhaps the last thing Corey needs is to have me toss the word "voodoo" into the mix—enough material for a horror flick was already jammed into her closet. But the frightening thing about Dorian Corey's life wasn't voodoo, vampires, or mummies. It was her vulnerability to racism, poverty, harrassment, and surveillance—the same dangers to Robert Worley's life. If he'd lived as a junkie, he might have died of the same virus as Dorian Corey.

TEN

The Closed Body

I was sitting on the floor of Flávio's house one evening a few months ago, helping him cut up a big bowl of ochra. He was preparing a heaping sacrifice for Xangô, thunder king and principle of divine justice, as well as the ruler of Flávio's head. Besides the ochra, there was roast yam, a nice fat piece of tripe, and thick, pungent cigars and cane alcohol for Exú, the trickster who would communicate the gift. Flávio is a student of anthropology at the Federal University of Bahia in Brazil; his interest in Candomblé, however, is not merely academic. He is a big time *macumbeiro* —a master manipulator of fetishes.

Like the vast majority of Candomblé participants, Flávio's black. Like many male practitioners of African religion in Bahia who are deemed capable of taking the *fullest* part in the activities—i.e., undergoing spirit possession in the danced ceremonies—he's gay. And like most people in

the Candomblé community (graduate students or not), Flávio's poor. His house is a precarious two-room structure perched on a hill, and the owner of the house (not Flávio) recently constructed another, even more precarious structure right on top of it. Flávio is bookish, and unlike their U.S. counterparts, Brazilian intellectuals generally attach little cachet to the fine art of watching T.V. Flávio doesn't even have one. But in truth, that doesn't make much difference, because you can hear the T.V of the upstairs neighbors loud and clear, practically around the clock.

The night in question, while we were chopping away at our offerings, we could hear the telenovela blasting. Each season, the new telenovela is of intense national interest throughout Brazil. Generally, each new series launches the career of a new T.V. Globo[1] babe—a sexy white actress hand-selected by the major network (the same network, incidentally, which makes or breaks virtually every political candidacy in the country as well), who will later be invited to crown one of the Rio carnival floats, and subsequently get a well-paid spread in the Brazilian *Playboy*. The babe of the season was a bouncy blonde named (on the telenovela) "Babalú."[2] Her name already interested me. It could be read as one of the contractions of two "Christian" names so common in Brazil—as a shortened version of Bárbara Lúcia, or Bárbara Luisa. But it could also be read as the shortened version of a distinctly non-Christian name—Babaluaiyé, Obaluaiyé, or most commonly in Brazil, Omolú. This is the same Babaluaiyé with which my story began: the Yoruba god of epidemics, of contagious disease, so terrible and wonderful in his mortal power that his multiple praise names are each an acknowledgment of that power. Desi Arnez's infectious tune of the 1940s is the version of "Babalú" best remembered by U.S. audiences, who little suspected that they were swinging and finger-snapping to the praise name of an African god of epidemics.

The telenovela character of Babalú, however, was popular not for her mortal power, but for her bounce, and for her notoriously raunchy dialogue. We heard her shrill, telecast exasperated shriek from upstairs: Babalú was having another fight with her hot, hard-to-get boyfriend, Rai. "Aiiii," she wailed, as he apparently stormed out of her apartment, "*meu edí está pegando fogo!*" Boom boom boom, we heard the neighbors knocking on the ceiling. "Flávio—*o que é edí?*" What, they wanted to know, was the meaning of the word *edí*? Flávio leaned back in his most luxuriously professorial splendor, as he is wont to do, and intoned: "*Edí*: Yoruba substantive signifying the anus, that is to say, asshole. *Meu edí está pegando fogo*, my

asshole is catching fire." Flávio shook his head and smiled: "That Babalú is worse than a transvestite."

How is it that Yoruba, the West African language which dominates Candomblé, came to be associated with transvestism in Brazil? The transvestite and Candomblé communities may have some overlap, but it's certainly not a majority of transvestites who worship Yoruba divinities. The even weirder question is why T.V. Globo chose a bouncy blonde sex kitten to manifest, in the name of an African god of epidemics, the linguistic principle of Africanized free-play of gender—and anal sexuality. If there were the kind of vociferous religious right in Brazil that we have here, it's quite possible that they'd invoke the notion of epidemia themselves to talk, in a less playful way, about how cultural practices—be they linguistic or sexual—are contagious, dangerous—and they might conclude that such a telecast was propagating the spread. It would be crazy, but people have said crazier things than that. People have said you can get AIDS through voodoo.

I met Flávio while I was setting out to write this book, thinking through ways in which epidemia—specifically the AIDS epidemic—is being faced within the Candomblé community, and more broadly, in African diasporic communities. Worshiping Babaluaiyé, as I wrote above, doesn't mean one is spreading disease, nor pretending one can completely contain it. It means one is trying both to acknowledge its devastating capacity, and to understand its significance.

Despite the presence of a structure for intellectualizing epidemia in Candomblé's cosmology, in writing this chapter—and the rest of the book—I ultimately had to confront the impossibility, or at least acknowledge the danger, of publicizing AIDS within the religious community. That is to say, friends were often reluctant to talk about literal cases of HIV-related illness within Candomblé, even though they would make reference to the overarching principles of respect for the power of contagious disease, and the community's shared responsibility for members' well-being. In fact, it's precisely this sense of shared responsibility that leads to reticence. Even writing autobiographically posed problems, as writing about HIV can *never* be an individual's story—it always implicates others (in this respect, I have tried to enact what Maya Deren called "deliberate discretion"). Some friends were clearly dying to talk about their own painful experiences, and would, but always with a request for this information to remain off the record—not just anonymous, but really *unrecorded*. A

secret, someone said to me, is only a secret until you tell somebody. And this is the kind of information which, if it gets out, can affect people's lives in the worst way.

I have written above about the problems of enunciating HIV infection, both at the individual and community levels. U.S. AIDS activists taught the world about the tremendous value of acting up, of not merely enunciating, but of screaming a community's pain. Unfortunately, the black underclass in an underdeveloped country like Brazil stands little chance of making the kinds of gains made by the U.S. gay community through a strategy of acknowledging the prevalence of seropositivity.

U.S. activists and intellectuals, of course, need to understand their distance from the Candomblé community in this respect before they can enter into a meaningful dialogue with that community on AIDS education, treatment, and prevention. There are other things to be learned as well— such as the principle of Babaluaiyé. One of the profound and disturbing lessons of the global AIDS crisis has been that a structure for intellectualizing epidemia—for considering its social, spiritual, and cosmological significance—is desperately lacking in Western medical culture. Of course, allopathic medicine's tendency to view the process of healing as one of conflict and combat within the body can be seen as inherently alienating any unwell body from itself, and our culture's excessive faith in medical technology's ability to "triumph" over disease is painfully evident to all those whose illness is deemed "incurable." The emergence of a *communicable*, incurable, fatal disease at a historical juncture at which medical faith— through the many successes of antibiotic therapy—had so overshadowed the role of religious faith in our conception of health, had special consequences. AIDS researchers are beginning to utter, cautiously, the word "cure," as new combination therapies seem to be capable of eradicating HIV or at least stopping it in its tracks in certain individuals. But it is painfully clear that unless there is universal access to these therapies, the *pandemic* cannot be stopped. Communicability *forces* us to think about disease beyond the bounds of the individual body. Epidemiology in its limited sense may give us markers for thinking through ethical issues, but even an accurate account of the mechanism and course of contagion doesn't guarantee an ethically coherent response. And it does little to heal alienated bodies—and communities—into a cosmological understanding of illness and healing.

In Brazil, some AIDS education groups, generally originating in the

politicized gay community, have recognized the structures already in place in Candomblé's cosmology for intellectualizing—that is, thinking and teaching about—contagious disease. While it is true that politicized gays and lesbians in Brazil tend to be middle-class (and, because of the tautology of race and class there, white), the dialogue between the education groups and the religious community can't be simplified as a literate elite appropriating non-Western belief and ventriloquizing the elite political agenda back to an underclass community in its own terms. This is because Candomblé itself constitutes an intellectual community with its own political and pedagogical agendas. Many priests and priestesses—*mães* and *pais de santo*—characterize themselves as researchers and pedagogues, and express intense interest in dialogue with scholars from the Western intelligentsia. Candomblé is also one space within which the generalization of gay politicization as a white, middle-class phenomenon is often contradicted. Flávio is one eloquent voice which speaks to, and from within, both groups. Still, there are moments of disjuncture, when the communities seem to be speaking at odds. These are the moments at which AIDS activists' strategy of publicizing the seriousness of the epidemic bumps up against Candomblé's strategy of discretion. This is not just a strategy that emerged with the AIDS epidemic. Historically, Candomblé has always been forced to acknowledge the danger of divulging certain information. It just so happens that the topics that have required the greatest discretion are those most central to the publicization of AIDS: blood and sexuality.

PURE POTENTIALITY

Blood is fundamental to Candomblé worship. Blood allows for the vitality and dynamism of the belief system—vitality evidenced by the endurance of faith and praxis despite centuries of official repression. Blood is the vehicle for the transmission of the most basic element of spiritual energy: *axé*, pure potentiality, the power-to-make-things-happen.[3] In Candomblé's cosmology, *axé* is what makes life—human and otherwise—possible. In the words of the anthropologist Juana Elbein dos Santos:

> Like all force, *àṣe* [Yoruba orthography] is transmittable; it is conducted by material and symbolic means and it is cumulative. It is a force which can only be acquired by introjection or by contact. It can

be transmitted to objects or to human beings. . . . this force can not appear spontaneously: it must be transmitted.[4]

The spiritual energy both of the individual practitioner and of her or his house of worship is augmented by ritual obligations, in which objects, animate and inanimate, transmit their *axé*.

Àṣe is contained in a great variety of representative elements from the animal, vegetable, and mineral kingdoms, be they in the water (fresh and salt), on land, in the forest, in the "bush," or in the "urban" space. *Àṣe* is contained in the essential substances of all beings, animate or not, simple or complex, which compose the world. The elements, which are carriers of *àṣe*, can be grouped in three categories:

1. "red" "blood"
2. "white" "blood"
3. "black" "blood"[5]

Axé is a "blood"-borne, transmittable agent—but blood isn't just what courses through a living, pulsing body. "Red" "blood" is human and animal blood, but it's also palm oil (a viscous, orange oil used in Bahian cuisine both sacred and secular), honey ("flower blood"), copper, and bronze. "White" "blood" is semen, saliva, secretions, breath, snail plasma, sap, palm wine, shea butter, salt, chalk, and silver. "Black" "blood" includes animal ash, dark sap, indigo, coal, iron. In effect, all sacrifice is "blood" sacrifice.

What might be considered dangerous about the divulging of information about blood in Candomblé—particularly if "blood" isn't literal blood, but the abstract principle of the transmission of spiritual energy? The danger has factors that go beyond Brazil's literal or cultural borders, and North Americans are implicated. In the Candomblé, *axé* is not considered "good" or "evil" in itself; it is pure potential that can be utilized to various ends. But it is undeniably a good thing to *have axé*. One uses the term not only to imply the capability to effect divine change. Having *axé* is akin to what we call in the United States having soul. It means you feel deeply, swing low— and carry African culture. The figure of cultural memory as a communicable agent carried in the blood is inherent in the notion of *axé*. It's also the idea which takes a relatively benign form in white accounts of "infectious" black rhythm and dance styles.

Ishmael Reed, as I have argued, exploits precisely this figure in *Mumbo*

Jumbo. But Reed also hints at the danger of backlash against a vital culture. The repression of African religious (and at times, by extension, secular) culture in the United States has been argued on the grounds of a presumed uncontrollable sexuality inherent in danced worship. This, of course, is related to the necessity of sexual discretion in African diasporic communities. But these days U.S. repulsion is much more often expressed on the grounds of blood sacrifice.[6] Until very recently, Brazilians generally dealt in a much more direct way than most North Americans with the fact that the meat that they ate came from the slaughter of an animal. Even in big cities, live poultry was readily available, until the price of frozen prepared chickens fell below that of fresh. The fresh memory of home slaughter may in part explain the relative lack of anxiety surrounding the ritual killing of animals, which are often slaughtered, butchered, cooked, and consumed in virtually the same manner they so recently were in the home for "mere" human sustenance. Another possibility is that Catholicism's own blood symbology in the Eucharist makes other sacred blood seem less shocking. But Protestantism is spreading through Latin America at a dizzying pace, along with unease over blood literal or figural. And U.S. repulsion over and fascination with blood sacrifice gets globally distributed with each new cinematic distortion of "voodoo" practices. Hence the importance of blood discretion relating to animal sacrifice.

And now, because of AIDS, there's a new importance of blood discretion. Scarification in Candomblé, compared to that practiced in the African cultures from which it derives, is visually discreet.[7] Whereas in West Africa, marks are often made on the face, Brazilian scarification cuts are relatively small, often in the upper arm (site of vaccinations), sometimes in hidden places such as the scalp or tongue. But human blood is accruing new symbolic significance globally—and not as a sign for vitality and spiritual energy. It's a sign for the danger of mortal contagion. Of course, human blood is also literally a path of HIV transmission. But blood let in African diasporic ritual practices has incited more fear of contagion than appears to be founded by the epidemiological "facts." Despite scientists' early rush to implicate scarification as a mode of transmission, it has never been documented as having a significant impact on the spread of HIV.[8] In Africa, communities with a wider practice of scarification tend, in fact, to have lower rates of infection, because the more "traditional" societies also tend to be more isolated. And even in densely populated areas where scarification takes place, it doesn't seem to play a role in trans-

mission—although clearly anytime a bloody instrument is reused, transmission is a risk. Warnings about the risks of scarification are not wrong. But what gets sanitized in the publication of such warnings is not only the literal blades of scarification, but the notion of ritualized human bloodletting itself. The introduction of the recommendations of "AIDS experts" into ritual practice makes the practice *symbolically* safe.

LEGENDS

In 1991, the World Health Organization, Diakonia (Sweden), Terre des Hommes (Switzerland), and the Global AIDS Partnership Program funded the publication of a Brazilian AIDS education comic book entitled "Odô Yá!" The text was conceived by Nilson Feitosa, and the book is dedicated to him, *in memoriam*. It was produced by a non-profit organization called ARCA, Religious Support Against AIDS. The book begins with a call for all individuals to recognize their own responsibility in preventing the spread of HIV. It says that the text "was written based on the *itans* (legends) of the Candomblé of the Ketu nation and follows the counsel of priestesses and priests, of the sick, and of doctors."

"Odô Yá!" is composed of three sections. Each section first recounts an *itan*, illustrated by pictures of black figures of indeterminate gender dressed in the concealing, voluminous clothes of Candomblé worship. Their faces are similarly obscured by the beaded crowns donned by the *orixás* when they ride their worshippers' bodies. The *itans* recount the activities of the *orixás* themselves. After each one, there is a lengthy type-set explanation of the applicability of the story's significance in the context of the AIDS crisis.

"EVERYTHING BEGAN LIKE THIS . . ." is the first of these narratives. It tells the story of the creation of the world—a story in which one divinity, Obatalá, fails to meet his ritual obligations and so must forfeit the task of creation to another, Odudua. "JUST LIKE OBATALÁ," the explication warns,

WE TOO MUST FOLLOW CERTAIN PRECEPTS SO THAT OUR "JOURNEY" THROUGH LIFE WILL BE SUCCESSFUL. It is through the bodies of people that the *orixás* manifest themselves and transmit the *axé* necessary so that their children can go through life with HEALTH, PEACE AND HARMONY. Today, AIDS poses a risk

to our health. It is important that our body remain healthy and free of illness. CARE OF THE BODY INCLUDES THE CARE OF THE BODY OF FAMILY MEMBERS, FRIENDS, NEIGHBORS, AND FELLOW WORSHIPPERS.

AIDS is then compared to other health risks in Brazil which "don't depend strictly on individual hygiene," such as dengue, infantile paralysis, and yellow fever. This notion of the body's limits exceeding the literal limits of the individual body is consistent with the Candomblé's fundamental conception of health as a community's concern. And the requisite of communal health, according to the comic book, is "ample information campaigns," such as that intended by the book itself.

Two pages of basic information follow (What is AIDS? How is the AIDS virus transmitted?). And then comes the second *itan*—the one which, to unfamiliar ears, is surely the strangest. "THE EKODIDÉ OF OXALÁ" is the story that explains the wearing of a single red feather on the forehead of every new Candomblé initiate. A woman who was favored by Oxalá, *orixá* of purity, creativity and white cloth, drew the envy of other women, who placed a fetish on her chair by the god's side. The fetish caused her flesh to stick to the seat of the chair, so that when she rose, she tore the flesh from her backside. Because of his association with pure white cloth, Oxalá abhors the color red, and so the woman flees the scene in shame and horror. She is aided by Oxum, a female *orixá*, who transforms the blood to a single red parrot feather. On learning what has transpired, Oxalá allows each initiate, who must wear only white, this one bit of color which is tied to their foreheads.

The *itan* is followed by a discussion of the significance of blood in Candomblé ("blood is considered *axé*"), a catalogue of ritual situations in which blood contact can occur, and instructions for the sterilization of any instruments used in letting human blood. The instructions for sterilization are accompanied by a diagrammatic illustration—not in the lively style of the narrative illustrations. "OTHER SITUATIONS OF BLOOD CONTAMINATION"—transfusions or i.v. drug use—are explained. And then the typescript moves on to "CONTAMINATION BY SEXUAL RELATIONS":

The human body is so important that the orixás use it to come into our world. Sex is one of the manners by which human beings relate with one another, just as "giving saint" [undergoing spirit posses-

sion] is one of the manners by which human beings relate with the orixás. Just like men, the orixás also love to relate with one another sexually. Among the orixás, sex is not considered a sin. There is no precept which condemns its practice. It happens that many sicknesses are transmitted in sexual relations. AIDS is one of them. It is necessary to be careful. Prevention is fundamental. But one doesn't need to give up sex. A person only catches the AIDS virus in a sexual relation if he or she doesn't take the necessary precautions to avoid this. Many people don't like them, but the best solution is to use a condom [*camisinha* = literally, little shirt], impeding direct contact with sperm, with vaginal secretions or with blood. Oral sex is also a risk. If the mouth should be wounded, a tooth recently pulled, for example, the risk is great. The answer is a condom, even if this seems like a strange idea....

And, at the moment which the text marks as the strangest idea (stranger than a woman whose flesh sticks to her chair?), the reader encounters the most familiar of instructions, accompanied by the most impersonal and diagrammatic of illustrations:

—Place the condom on a hard penis.
—Squeeze the tip, as you unroll it, so that it doesn't fill with air.
—Remove from the penis while it's still firm, right after orgasm.
—NEVER use the same condom twice.

The final *itan* is the one invoked by the comic book's title, which is translated "Hail the mother of the river." It is the story of Obaluaiyé, who was born sickly and covered with pustulent sores. His mother abandoned him by the river, where Yemanjá, the *orixá* of the sea, discovered him. She raised Obaluaiyé as her own, nursing his wounds, and he grew to be the powerful master of his own disease.

With her attitude, YEMANJÁ gives us an example of dedication, showing that we shouldn't abandon sick people. There are already cases of people of saint [orixá worshippers] who have AIDS. Also, many people, on finding out that they carry the AIDS virus, have come to houses of orixá worship to seek aid.

The emphasis in the telling of the story of the god of epidemics is not on his own role, but on the role of Yemanjá, the female *orixá* who heals and nurtures him. This angle on the story downplays the notion of a divinity of epidemia. And yet the possibility of alternative forms of mothering has, as I wrote in the preceding chapter, specific resonances in the African diaspora. A man could embody Yemanjá—and men do. She is often figured in her fulsome maternity as having heavy breasts, overflowing with milk. If the mambo could produce seminal ejaculate, a man in Candomblé, if he is open enough to her, can embody Yemanjá's capacity to nurture, even if her milk is only figurative. It still sustains.

The comic book ends with the lesson of alternative relations of nurturance. But what about its overall structure—why does it begin with the *itan* of ritual blood? What is the reason for introducing the topic of sexuality as an afterthought to the topic of blood in Candomblé, if in Candomblé, like everywhere else, the probability of sexual transmission of HIV is infinitely greater than that of transmission from the blade of a knife? It would probably be an over-reading to suggest that the comic book was following the Candomblé precept that semen and vaginal secretions are "white" "blood," hence a subset of the blood discussion. More likely is this: literal blood sacrifice may not be an efficient transmitter of HIV, but it's long been tainted by white fear, which multiplies and mutates seemingly uncontrollably. That's why its disinfection is the top priority.

> Faça um Trabalho contra AIDS
> divulgando este folheto entre seus amigos!
> Feche seu corpo,
> abra seu coração:
> A camisinha é seu melhor amuleto!
> [Do a "Work" (of conjure) against AIDS
> by divulging this pamphlet among your friends!
> Close your body,
> open your heart:
> A rubber is your best amulet!]

This is the blurb on the back of a similar document, a pamphlet called "AIDS & Candomblé" which was published in 1988 under the auspices of BEMFAM (Civil Society for Family Well-Being), a health education orga-

nization in Rio de Janeiro. The pamphlet was written by the Grupo Gay da Bahia, one of the most successful gay political organizations in Brazil. The Grupo Gay da Bahia is headed by Luiz Mott, an activist and anthropologist who has written about both sexuality and African religion in Brazil.

"AIDS & Candomblé" is divided into four sections. 1. *What is AIDS?* briefly explains who is susceptible (everyone), how the virus is transmitted (via blood, semen, or vaginal secretions), and who is responsible for protecting us from contracting it (we all are). The section ends with an acknowledgment in Yoruba of the seriousness of the "terrible disease": "Xocotô beroló!"

2. *Candomblé and AIDS* addresses the specific situations in African Brazilian religious practice that might represent a risk of HIV transmission: ceremonies which involve making "small cuts in diverse parts of the body: the chest, arm, back, feet, forehead, or even the tongue of sons and daughters of saint ('Yaô')." There are various occasions for cutting in Candomblé, one being the "closing of the body"—a moment often compared by those in the religion to baptism. It is a ceremony which, ironically, opens the body in order to bring about a doubled healing: the individual body heals its own wound, but the individual is also healed into the larger body of the religious community. The raised scar—usually on the shoulder—marks the "closed" body as one which is doubly healed, and so protected. The Grupo Gay's pamphlet, like "Odô Yá!," doesn't discourage the cutting—it only encourages sterilization of all instruments prior to their use, and, again, it gives instructions for doing so. Animal blood, another important component of many ceremonies, "offers no risk of contamination. *Epa Babá!*" Praise the Lord!

3. *AIDS and Sex* addresses the risk of transmission through sexual fluids: "Sex is a delicious thing, and when realized by mutual consent, everything is valid and legitimate, following the example of the Orixás, Caboclos, Old Blacks, and Enchanted Beings [all divine or sub-divine entities from various African Brazilian religious traditions] themselves, whose sex lives are free, varied and without repression." Still, the pamphlet recommends, one should avoid contact of semen with the body, "be it in the vagina, mouth, anus, or if it gets into the eyes or any cut or wound." Any act of penetration should be with a condom. The emphasis is on the "greatest" risk constituted by anal sex, even though the pamphlet notes that AIDS does not affect gay men exclusively. Still, the section brings discussion back to Candomblé with candor: "It's a secret to no one that in the houses of

Afro-Brazilian cults, 'adés', 'monas', 'adofiros' and 'acucibetós' are numerous and very well accepted—*Arô Boboi! Ou Oriki Logun!*" Praise be to the divine principle of undecided gender and infinite sexual possibilities!

4. *Conclusion* urges the faithful to carry this information to their houses of worship. "You are also responsible for expelling this terrible epidemic from our midst. Have faith in the protection of Omolu, but don't ever forget to take these precautions. Information is still the only vaccine against AIDS, and prevention is the best medicine. *Atotô Obaluaê!*"

The rhetoric of AIDS education as a vaccine, of course, is perfectly familiar to North Americans. It seems to have functioned as a buffer against potential hostility toward a medical community that suggested the possibility of a literal vaccine practically at the outset of the pandemic, only to back off from the optimistic time-frames as the virus's complexity became apparent. Epidemiologists continue to rue the lack of a widely accessible *preventive* medication, which would clearly offer greater help than prohibitively expensive long-term treatments inaccessible to the vast majority of those infected. The "education vaccine" suggests that the responsibility is not just that of the State, nor of the medical establishment. But here, education is not just a vaccine, but also an "amulet." And the closing of the body—not with ritual scarification, but with a condom—becomes an act of divine significance. And yet, once again, even this "ritualized" sexuality is subsequent to the discussion of ritual blood.

THE PROBLEM OF OPENING ONE'S LEGS

The most surprising thing about the Grupo Gay da Bahia's pamphlet—and what makes it more surprising than the comic book, despite its relative lack of ethnographic detail—is its sexual candor. Let me specify that: the most surprising thing is its sexual candor *textualized*. It's quite true that Candomblé cosmology supplies ample room for celebrating diverse sexuality. The fundamental conception of sexual identity is inherently flexible in a belief system in which divine principles can manifest themselves in the bodies of worshipers of apparently discordant gender. Xangô, principle of kingly justice, phallic thunder, and macho sexuality can animate the flesh of a woman dancing. The *oriki*, praise poems of the *orixás*, do indeed speak playfully and enthusiastically of multifarious divine sexualities. And one is tempted to characterize the Candomblé community generally as admirably tolerant. But, at least in dialogue with

outsiders, the community is also discreet. People don't generally write this business down. In ceremonies, or most often immediately after, extremely bawdy songs are sung, but these are always songs of doubled meaning. Puns are made by mixing Yoruba and Portuguese in ways in which, through a kind of inverse coding, a non-Yoruba speaker could only make out obscenity, while speakers of Yoruba could construe a more innocent meaning.[9] This allows for an ostensible propriety, even as sexuality is celebrated.

As I discussed in the preceding chapter, discretion applies not only to members of Candomblé houses, but also to the ethnographers who take it upon themselves to inscribe Candomblé practice and belief. Until the work of contemporary scholars such as João Silvério Trevisan, Peter Fry, J. Lorand Matory, Jim Wafer, Hédimo Santana, and Luiz Mott himself,[10] as I have said, Candomblé ethnography was notably circumspect about the issue of sexuality. Of course homophobia hasn't disappeared. And while the ethnographic community now ostensibly takes a morally neutral position toward sexual culture and cultural sexuality, the rest of the world doesn't. That's why, in the Candomblé community, there is an emphasis on chariness. African Brazilian religious practice is no longer under official siege by the State. In fact, in Bahia in particular, its touristic appeal has led to state government subsidizing of major houses of worship. But Candomblé's resilience despite a history of repression can be attributed not only to *axé*, to the strength of belief and of cultural resistance, but also to a savvy understanding of the notion of discretion, not only regarding sexuality, but regarding all aspects of religious praxis.

The issue of discretion can be particularly difficult for people who straddle the ethnographic and religious communities—like Flávio. When I asked him about blood symbology in Candomblé, he enthusiastically pointed me toward an ethnography which had been researched in his own Candomblé house. It was full of excellent detail, and he consulted it often both in his academic studies and in his own ritual obligations. But even as he praised the work's accuracy, he indicated his dismay at the author's textualization of such sacred information. He cited the work in his own writing, used it in effect as a manual of correct religious praxis—but he would not have been inclined to textualize the information for the first time himself. "*É um problema no candomblé quando as pessoas vão abrindo as pernas assim. . . .*" It's a problem in Candomblé when people go around spreading their legs like that. Indiscretion regarding religious praxis is a

dangerous form of promiscuity. *Abrir as pernas* (to open one's legs) is a phrase Flávio uses all the time in reference to anybody, male or female, who divulges too much information about African aspects of Brazilian culture generally—but especially about Candomblé. Of course, he's funny and has a cutting sense of irony, and he's invoking that when he implies a metaphor of female sexuality to men, or, if you wish, of "bottom" sexuality to men who don't identify as gay. He also invokes metaphors of anal sexuality when talking about internal politics in the Candomblé community, even though that community is dominated by powerful women. He calls the jockeying for power through sexual relations ascent by the "*via anal*," even when the relations are between two women. It's an ironic recentering of gay male sexuality in a context which has had that sexuality effaced. Of course, lesbian sexuality has also been handled with reserve, for similar reasons.

When Flávio figures women in terms of gay male sexuality (needless to say, anal sexuality exists for women too, but the figure here is clearly meant to evoke sex between men), he isn't attempting to erase women—he's just playfully validating a mode of sexuality, his own sexuality—which doesn't usually get acknowledged out loud. All this is in the form of a private joke. That is, the figure doesn't enter into his academic writing on Candomblé. But I'm not divulging anything here that he'd want kept a secret. Figures like the *via anal* just serve to delimit a private discourse, a circle of friends who *get it*. Language does that—like the ritual closing of the body, it defines a body of understanding.

THE BLACK DICTIONARY OF THE QUEENS

All this brings me back to Babalú. If Flávio's queer figurations delimit his sense of intellectual and political community, his use of Yoruba language ties him both to his religious *and* sexual communities, which are not identical, although there is some overlap. "That Babalú is worse than a transvestite." To figure a woman in Candomblé through the terms of gay male sexuality is, in a sense, rhetorically to make her into a transvestite. Flávio certainly isn't the first person to make a rhetorical connection between Candomblé and transvestism. Yoruba is the language that closes the body of the transvestite community in Brazil. The sociologist Neuza de Oliveira has documented the use of Yoruba phrases among transvestites throughout Brazil,

as ciphered codes in their defense strategy against groups hostile to their public performances. Common terms are "*mona*" [young girl] to refer to one another; "*Okó*" to signifiy man, client, lover, or virile young man; "*Okondé*" to designate the prostitution zone, a particular region of the city; and "*Aliban*" to denote repression, the police, etc. They call this language the "Black Dictionary of the Queens."[11]

Oliveira notes that the links between the transvestite and Candomblé communities are not only linguistic:

> In general the transformation process of the transvestite and her insertion in the universe of prostitution are accompanied by an older and more experienced transvestite, or by a group which gives protection to the recent arrival, or initiate. . . . All this leads us to establish an analogy between the initiating transvestite and . . . the *mães-de-santo* [priestesses] of Candomblé. . . . The choosing of a feminine name constitutes a rite of incorporation. The term "to make one's transvestite" [*fazer o travesti*, to become a transvestite], commonly used in [Bahia], makes allusion to the expressions "to make one's head, to make saint," which are used in the Candomblé houses of Bahia, in reference to the principle initiation process in the Nagô-Yoruba liturgy. To make one's head is to announce the name of the orixá which the initiate incorporates. To make one's transvestite is to announce the feminine personage, giving her a name and an image which will be incorporated by the initiate.[12]

Brazilian transvestite culture makes frequent reference to the notion of spirit possession, which can become particularly complicated in theatrical contexts. Oliveira recounts the stage performance of a São Paulo man named Anastácio who holds that his transvestite personage, Marcela, "descends" and is incorporated in him, thus ascending the stage of the Tropical Night Club where she lip-syncs a tape of the extremely popular, widely perceived-to-be lesbian, gloriously melodramatic singer Maria Bethânia, whose own spirit "mounts" Marcela, who is already mounting Anastácio. This performance is further consecrated by the distribution around the stage of candles and sacred ground-drawings invoking the powerful female *orixá*, Iansã.

I've said above that Candomblé cosmology is admirably tolerant in

regard to diverse sexual expression, and I've indicated that the notion of cross-gender spirit possession allows for a certain flexibility of gender identification. And yet Candomblé is not a site of seemingly infinite re-identifications like the stage of the Tropical Night Club. In some ways, Candomblé stands out in the generally sexually permissive Brazilian society as a bastion of traditional gender roles. Women of each house, regardless of their sexual practice or politics, are expected always to wear skirts within the confines of the compound. Women never play the sacred drums. This is one of the men's roles. Men, as noted above, don't generally participate in possessional dance, and if they do, they are often identified not merely as gay, but specifically as "passive" gay men. So even in a context that seems to allow flexibility, gender and sexual roles are extremely rigidly defined. In his own house, Flávio sometimes ties a beautiful piece of African textile around his head in an elaborate turban. "Just see," he said to me with one eyebrow arched sky high, "what would happen in the Candomblé house if a man tried to tie his head tie with those stiff flaps hanging over the sides like the women do. Hmmm. . . ." Some of the strict gender coding is not immediately discernable to outsiders. It serves as another device for delimiting community. At the same time, this highly coded context allows for transgendered incorporations.

In the Bahian transvestite community, as well, there is an ironically strict notion of gender identity *at certain moments*. Don Kulick writes that among Bahian transvestite sex workers, the notion of penetrability is of utmost importance in establishing both personal and professional relationships. Kulick actually argues against the translation of the Brazilian term *travesti* as transvestite, since so many of the Brazilians' self configurations are at odds with, if one can imagine such a thing, *normative* North American transvestite self-figuring. But his examples of the ways in which the seeming rigidity of gender roles among Bahian transvestites *allow* for gender fluidity might indicate, rather, that *all* cases of gender demarcation belie ambiguity, just as all apparent gender flexibility belies an underlying systematization.

If in the Harlem drag balls, this systematization is laid out in rigid competitive categories, among the Bahians it is laid out in rules of penetrability. Kulick writes that, contrary to accounts of female prostitution which argue that sex workers strictly delimit their activities in sex for pay (and derive little or no sexual *pleasure* from these relations) but not their personal sexual relationships,[13] the *travestis* tend rather to limit their participation in

sex with their boyfriends, but not with clients (with whom they say they are *free* to take pleasure). At home, they are exclusively penetrated, rarely ejaculating themselves. But in the street, they can be either penetrated or penetrating—and in fact, the majority of their clients prefer them to take the "active" role.[14] Hence the importance of their ability to achieve and maintain erections, not only for their own erotic pleasure, but in order to make a living. This, Kulick explains, is one motive for a *travesti's* discontinuation of hormone treatments, which can cause impotence.

Kulick writes that some Bahian transvestites begin such treatments as early as the age of eight, in an effort to achieve a physical form—female—which will make their bodies more marketable. They also use industrial silicone of the type used to make automobile dashboards:

> In the form in which travestis buy it, silicone is like a clear, thick oil. Its viscosity makes it difficult to inject into human bodies, and the travestis who work as *bombadeiras* (literally: pumpers) use needles the thickness of pencil points, and all their strength, to force the silicone into the bodies of the *travestis* they have been payed to "pump" (*bombar*).... The amount of silicone that individual travestis choose to inject ranges from a few glasses (travestis measure silicone in liters and water glasses [*copos*], six of which make up a liter) to up to eighteen liters.[15]

And yet despite the extremes to which the Bahian transvestites will go *literally* to incorporate womanliness, Kulick found that "the overwhelming majority of *travestis* do not self-identify as women and have no desire to have an operation to become a woman even though they spend their lives dramatically modifying their bodies to make them look more feminine."[16] Penetrated, they already occupy the position of "not-men." Penetrating, they access their manhood.[17]

Gendered clothing, restricted language, and *situationally* rigid sex roles define both Candomblé and transvestite communities. So does scarification. Luiz Mott, of the Grupo Gay da Bahia, and Arolda Assunção have documented the prevalence of "self-mutilation" in the Bahian transvestite community. They ascribe the slitting of wrists, arms, necks, and genitals to a complex nexus of factors: "the various scars of diverse epochs criss-cross each other, making the arms of these poor creatures true puzzles, whose solution contains the most disparate parts: eroticism, violence, black-mail,

despair and pain."[18] Oliveira's informants offer the most practical of explanations. Simone says she cuts herself "when I've been in jail for three, four days with nothing to do; then, the cuts, the blood, they send you to the First Aid clinic. Me, I've thrown blood right in the face of the police. Three squad cars came to pick me up, and I said I wasn't going. I cut my arm and threw blood in their faces."[19]

In Bahia, transvestism (and again by economic tautology transvestite prostitution) is in the vast majority an underclass phenomenon. The Grupo Gay da Bahia has done community outreach work with transvestites, offering condoms and HIV-testing, as well as an invitation to join in the gay activist movement. While the condoms are welcome, medical *services* would be even more so. Needless to say, hormone and silicone use both present serious health threats. There have been no statistical studies of specific rates of HIV infection for the Bahian transvestite community, although AIDS education is of course one of the main goals of the Grupo Gay. Still, it is worth noting that the Grupo Gay's political strategy of volubility may have put them at odds with potential allies.[20]

Kulick describes the typical life trajectory of a *travesti*: "The vast majority of them come from very poor backgrounds and remain poor throughout their lives, living a hand to mouth existence and dying before the age of fifty from violence, drug abuse, health problems caused or exacerbated by the silicone they inject into their bodies, or increasingly, AIDS."[21] It is interesting that in this list violence—Kulick elsewhere specifies the threat of *police* violence—precedes the pathologies of dangerous penetrations both hypodermic and sexual. Oliveira's research was performed prior to the AIDS epidemic. But today it would be hard not to read a transvestite's counter-threat to police violence—the threat of blood contact—as a manipulation of assumptions about her relationship to AIDS.

Blonde Babalú, all glowing in your bronzed and unmarked skin—where are you? You seem impossibly distant from the piss-smelling *okondé* where a desperate *mona* slashes at her own arm with a razor to ward off the violent *aliban*. On the pristine screen, you are the spitting image of *gringa* playmate ideality, the sign of the globalization—of the T.V. Globo-ization—of all these ostensibly closed communities, and your own only apparently closed, uninfected body. Your indiscretions, however sanitized, bare the complexities of the cultural traces that criss-cross Brazil, and the rest of the world. Like Anastácio, mounted by Marcela, mounted by Bethânia, mounted by

Iansã, you are yourself the bouncing blonde body, mounted by a poor mixed-race transvestite, mounted by a young African girl, mounted by your own golden Globo ideal. Each one of you swoons to take it up the *edí*!

A strange image to pray to, I know. But if we want to figure anything out about what really closes bodies, what really connects bodies, infects them, animates them, protects them—then blonde Babalú may demand our attention.

NOTES

PREFACE

1. Daniel Baxter, assistant medical director of an AIDS residential treatment
center in the South Bronx, responded to this article in an Op-Ed piece four
days later: "In my clinic, which cares for a number of substance-abusers, I
have seen many residents ask for the new treatments, and their compliance
with pill-taking regimens has often impressed me. . . . AIDS has brought to
our attention these marginalized people whom we usually try to ignore in
their cardboard boxes on the sidewalks. From the standpoint of both self-
interest and humanity, we ignore these fellow sojourners at our peril."
("Casting Off the 'Unreliable' AIDS Patient," *New York Times,* March 6, 1997,
Op-Ed page.) I understand Baxter's strategy in invoking both fear (self-
interest) and shame (humanity), while I suspect that he would agree with
the premise of this book that it is the notion of "self-interest" and "human-
ity" as separate categories that is at the heart of the problem.

INTRODUCTION

1. Amado's romanticism is nearly always marked in erotic terms. Cultural syn-
cretism is figured through cross-racial sexual pleasure, which itself kills racial
hatred. In *Tent of Miracles* there is a scene in which a savvy mixed-race lover
conquers an African spirit of rage, a *iaba,* by giving her a cosmic orgasm. At
the moment she peaks, he inserts a fetish of male power in her anus, and sud-
denly, "the *iaba* was a *iaba* no longer, but black Dorotéia. The arts of Xangô
had planted in her bosom the most tender, submissive, loving heart. Black
Dorotéia forever, with her fiery cunt, her insolent butt, and the heart of a tur-
tle dove." Jorge Amado, *Tent of Miracles,* trans. Barbara Shelby (New York:
Avon, 1971), 154. The specific image of a fetish of African masculinity which
penetrates the anus and controls black rage will become increasingly signifi-
cant in the final chapters of this book. Needless to say, for all the currency of
such erotic narratives of racial contact in Brazil, racism does continue to play
itself out, as in the rest of the diaspora, in violent terms.

2. For a more extended description of Bahian carnival institutions and their
racial and sexual politics, see Christopher Dunn, "Afro-Bahian Carnival: A
Stage For Protest," *Afro-Hispanic Review* 11, nos. 1–3 (1992), and Larry N.
Crook, "Black Consciousness, *samba reggae,* and the Re-Africanization of

Bahian Carnival Music in Brazil," *The World of Music* 35:2 (1993), 90–108, as well as my *Samba: Resistance In Motion* (Bloomington: Indiana University Press, 1995), ch. 4.

3. Lee's decision to shoot footage of the black underclass in the *favelas* of Rio for the same video provoked outrage in Brazilian political and journalistic circles. Lee was decried as a "racist filmmaker," and the credibility of Jackson's concern for the plight of children was questioned. See Alfredo Ribeiro, "O Ridículo Sururu Pré-Carnavalesco," *Veja* 29:7 (14 February 1996), 34–39. This controversy followed on the heels of internal and external tension over Olodum's perceived exploitation (political, aesthetic, and commercial) by Paul Simon.

4. On this transformation, and on the relationship between grass roots activism, race politics, and marketing, see Marcelo Dantas, *Olodum: De Bloco Afro a Holding Cultural* (Salvador: Edições Olodum, 1994).

5. These include community-based schools where adults and children receive instruction in African musical, choreographic, and theatrical traditions, as well as shelter and employment possibilities. See Crook, "Black Consciousness," 90–108.

6. See CEAP, *The Killing of Children and Adolescents in Brazil*, trans. Vera Mello Joscelyne (Rio de Janeiro: Centre for the Mobilization of Marginalized Populations, 1991), and Ben Pengalese, *Final Justice: Police and Death Squad Homicides of Adolescents in Brazil* (New York: Human Rights Watch, 1994).

7. James Brooke, "After Prison Riot, Brazilians Hear of Police Atrocities," *New York Times*, October 5, 1992, A3.

8. The literalness of epidemiological figures—and in particular estimates—is a question which resurfaces periodically throughout this book. While there is no doubt that statistics can be and have been manipulated, self-consciously and unself-consciously, by researchers blinded by cultural and sometimes racist assumptions, they are, at times, the only way of indicating the gravity of a health situation within a given community. When I invoke such figures myself in this book, I mean for them always to be bracketed by an understanding of their tenuous position *between* the literal and the figural.

9. While a poll following the massacre showed a slight majority of São Paulo residents to question the police action, many felt the killing was justified. "Indeed, in the uproar surrounding the prison massacre, São Paulo's new military police commander described the police operation as 'perfect.'" James Brooke, "Brazil's Police Enforce a Law: Death," *New York Times*, November 4, 1992.

10. Caetano Veloso, lyrics (my translation), "Haiti," *Tropicália 2: Caetano e Gil* (Elektra Nonesuch 79339–2, 1994).

11. On the syncretic rhythms of samba-reggae, see Browning, *Samba*, 132–33.

12. Paul Gilroy, *The Black Atlantic: Modernity and Double Consciousness* (Cambridge: Harvard University Press, 1993), 103–8. In addition, Gilroy's earlier *There Ain't No Black In the Union Jack: The Cultural Politics of Race and Nation* (London: Hutchinson, 1987) was a powerful, seminal demonstration of the relationship between economic exploitation and cultural exchange. See also Tricia Rose, *Black Noise: Rap Music and Black Culture in Contemporary America* (Hanover, NH: Wesleyan University Press, 1994).

13. Gilroy, *Black Atlantic,* 110.

14. Dick Hebdige, *Subculture: The Meaning of Style* (New York: Routledge, 1979), 38.

15. Susan McClary, "Same As It Ever Was: Youth Culture and Music," in Andrew Ross and Tricia Rose, eds., *Microphone Fiends: Youth Music and Culture* (New York: Routledge, 1994), 37. My thanks to Chris McGahan for calling this passage to my attention.

16. Arjun Appadurai, "Disjuncture and Difference in the Global Cultural Economy," *Public Culture* 2:2 (Spring 1990), 1–24 (13).

17. See Paul Farmer, *AIDS and Accusation: Haiti and the Geography of Blame* (Berkeley and Los Angeles: University of California Press, 1992), 141–50.

18. On the political efficacy of ACT-UP, see Steven Epstein, *Impure Science: AIDS, Activism, and the Politics of Knowledge* (Berkeley and Los Angeles: University of California Press, 1997).

19. Some of the most influential of these analyses are contained in Douglas Crimp, ed., *AIDS: Cultural Analysis/Cultural Activism* (Cambridge: MIT Press, 1988) and Simon Watney, *Policing Desire: Pornography, AIDS, and the Media* (London: Comedia, 1987).

20. Even as I say this, I must acknowledge that this notion of two distinct communities affected by a first and second wave of infection is specious. What's more, even the appearance of difference shouldn't preclude dialogue. Kobena Mercer has argued that "black people as much as anyone else have much to learn from coalition-building initiatives such as ACT UP. . . . [T]he shameful silence around AIDS in black political discourse must be transformed, and . . . our understanding of mourning in black psychic life must be deepened, by listening to texts such as Douglas Crimp, 'Mourning and Militancy,' *October* 51 (Winter 1989), as closely as we do to the melancholy evoked in 'Will They Reminisce Over You?' by Pete Rock and CL Smooth, from *Mecca and the Soul Brother,* Def Jam Records, 1991." Mercer, *Welcome To the Jungle* (New York: Routledge, 1994), 312.

21. See Charles Geshekter, "Outbreak? AIDS, Africa, and the Medicalization of Poverty," *Transition* 67 (Fall 1995), 4–14.

22. Farmer, *AIDS and Accusation,* 141–50, and Farmer, *The Uses of Haiti* (Monroe, ME: Common Courage Press, 1994).

🌿

23. Emily Martin, *Flexible Bodies: Tracking Immunity in American Culture—From the Days of Polio to the Age of AIDS* (Boston: Beacon Press, 1994).

24. Treichler, "AIDS, Gender, and Biomedical Discourse: Current Contests for Meaning" in *AIDS: The Burdens of History*, eds. Elizabeth Fee and Daniel M. Fox (Berkeley and Los Angeles: University of California Press, 1988), 207; cited in Paul Farmer, Margaret Connors and Janie Simmons, eds., *Women, Poverty and AIDS: Sex, Drugs, and Structural Violence* (Monroe, ME: Common Courage Press, 1997), 27.

25. The phrase "explanatory model" was introduced to medical anthropology by Arthur Kleinman, who also most fully articulated the ethical implications of deep and serious listening in a medical anthropological context. See Kleinman, *Patients and Healers in the Context of Culture* (Berkeley and Los Angeles: University of California Press, 1980).

26. I discuss the question of ethnographic discretion in greater detail at the end of chapter 5, below. Maya Deren's own "deliberate discretion" in her work on Haiti always moved me, but it wasn't until I completed this book that I fully came to understand its implications. It was also Deren who taught me that sometimes what is at the heart of the matter is most appropriately written in an endnote.

27. Browning, *Samba*, 169.

28. On February 14, 1990, a misinformed, extremely assertive counselor from the New York State Department of Health told me that my HIV test result was "definitely" a false negative. He deduced this from the positive test result of my lover, and the extent of my likely exposure over the six years of our intermittent relationship, which had included a pregnancy. In the ensuing months, the experience of trying to secure adequate health care for him (he was an uninsured artist and a legal alien) taught me a great deal about race, class, and ethnicity in the medical system. But that practical lesson was part of a much larger realization. During the period of my uncertainty as to my own HIV status, it became clear to me that if I died of "complications from AIDS," then HIV would merely have been the vector of other forms of virulence: homophobia, racism, xenophobia, and class oppression—despite the fact that I was an overeducated white woman in a heterosexual relationship. The devastation of this realization and the inability of Western medicine to accommodate the fullness of its human implications were what led me to engage in a deeper way with the cosmology of Candomblé, African religious practice in Brazil, which had previously interested me as a dancer and scholar, for aesthetic, historical and political reasons. Now I turned to it in order to find some logic to my personal pain. There are two reasons to state this quietly, in an endnote. One is the patent inappropriateness of my claiming too large a place in a narrative which ultimately so far exceeds my story. The

other is that my lover, while he lived, chose to remain silent regarding his HIV status, and I have tried to honor his discretion. His motives were complicated—some of them will become apparent in the course of this book. For political, cultural and personal reasons, utter silence is not possible for me. But I have been compelled to respect it, and try to understand it.

CHAPTER I

1. In the last two years, infection rates have shot up in poor Asia. This isn't surprising if you acknowledge what Paul Farmer has long argued: in AIDS epidemiology, poverty is the most significant risk factor.

2. Reported cases through December 1996 (CDC figures). I use here the term "hispanic," not "Latino," because it is the category designated by these statistical sources.

3. New York State Department of Health Figures for New York City through 1st quarter, 1997.

4. Ishmael Reed, *Mumbo Jumbo* (New York: Macmillan, 1972), 6.

5. On the metaphor of the "talking book," see Henry Louis Gates, Jr., *The Signifying Monkey* (New York: Oxford University Press, 1988), 127–69.

6. The first AIDS diagnosis was made in 1981; The Pasteur Institute in Paris isolated the virus today known as HIV-1 in 1983.

7. Reed, *Mumbo Jumbo*, 202.

8. Gates, *Signifying Monkey*, 229.

9. Reed, *Mumbo Jumbo*, 6.

10. I say simplified, because the novel makes it impossible to separate cultural elements into clean ethnic categories. The most brilliant analysis of the book is James Snead's "European pedigrees/African contagions: nationality, narrative, and communality in Tutuola, Achebe, and Reed," in Homi Bhabha, ed., *Nation and Narration* (New York: Routledge, 1990), 231–49. Snead writes: "It is not so much that Reed finds himself 'having to expropriate the tools of Western culture' as that he is revising a prior co-optation of black culture, using a narrative principle that will undermine the very assumptions that brought that prior appropriation about" (247). Snead died, tragically, as his essay was going to press. Homi Bhabha notes in his acknowledgments: "Amongst those of us who have shared in making this book, Jamie Snead has a special place that must now remain empty. At short notice, and in adverse circumstances, he agreed to write his essay. He sent it to me, shortly before he died of a long illness that he had kept private"(ix). The essay, however, discreetly speaks to Snead's own illness. His decision to remain discreet is a part of my own preoccupation with silence in this book.

11. For an account of the false leads regarding and current speculations on the

inaugural period of the epidemic, see The Panos Institute, *AIDS and the Third World* (Philadelphia: New Society, 1989), 70–74.

12. Reed, *Mumbo Jumbo*, 7.

13. For a sensitive portrait of one Haitian mambo's readerly skills, see Karen McCarthy Brown, *Mama Lola: A Vodou Priestess in Brooklyn* (Berkeley and Los Angeles: University of California Press, 1991).

14. For an introduction to the relations between the African and New World belief systems mentioned here, see Robert Ferris Thompson, *Flash of the Spirit* (New York: Vintage, 1983). On Yoruba beliefs in Nigeria, see William Bascom, *The Yoruba of Southwestern Nigeria* (New York: Holt, Rinehart and Winston, 1969). On Vodou, see Maya Deren, *Divine Horsemen* (New York: Thames and Hudson, 1953); Melville Herskovits, *Life in a Haitian Valley* (Garden City: Anchor Books, 1971); and Alfred Metraux, *Voodoo in Haiti* (New York: Oxford University Press, 1959). On Santería, see Lydia Cabrera, *El Monte* (Havana: Ediciones C.R., 1954). On Candomblé, see Pierre Verger, *Notes sur le culture des orisa et vodun* (Dakar: IFAN, 1957) and Roger Bastide, *Le Candomblé de Bahia* (Paris: Mouton, 1958). And on Hoodoo, see Zora Neale Hurston, *Mules and Men* (New York: Harper & Row, 1970).

15. Reed, *Mumbo Jumbo*, 4–5.

16. This admittedly awkward term leaves out much of the complexity of the development of African religions in the diaspora. Some of the syncretism complicating these religions actually took place through precolonial cultural exchanges on the African continent, while some took place through the creative communications of diverse African populations displaced and regrouped by the slave trade. I cover some of these exchanges more specifically in subsequent chapters.

17. At the beginning of the epidemic in this country, four "risk groups" were asserted—the so-called "4 H's": Homosexuals, Heroin-users, Hemophiliacs, and Haitians. The little mnemonic device of the 4 H's had devastating implications for those categorized by them.

18. See Bascom, *Yoruba*, 91–92 and Thompson, *Flash*, 61–68.

19. Bascom, *Yoruba*, 91.

20. See Susan Sontag, *AIDS and Its Metaphors* (New York: Farrar, Straus & Giroux, 1989).

21. Reed, *Mumbo Jumbo*, 213–14.

22. The most eloquent and precise account of spirit possession which I have encountered is in Deren, *Divine Horsemen*, 247–62, and in her long and fascinating note [8], 322–24.

23. On Vodou rites and the revolution, see Deren, *Divine Horsemen*, 61–63. For a fuller account of the political history of Haiti, see C. L. R. James, *The Black*

Jacobins (New York: Vintage, 1963). I discuss Haitian history's relation to religion below in chapter 5.

24. Among scholars of Vodou, there is disagreement regarding the origins of the two branches of *lwa*. While many argue that one emerged as a response to colonial violences, others argue that the African ethnic origins are different—*Rada* (the cool side) coming out of the Dahomean line, and *Petwo* (the hot side) out of the Kongo line. See chapter 5, below.

25. Wade Davis, *The Serpent and the Rainbow* (New York: Warner Books, 1985), 159.

26. Of course, even access and education are not sufficient to prevent risk. The internalization of one's own dehumanization, whether on account of one's race, class, sex or sexuality, can be as risky as simple lack of protection. So can the unquestioning belief that one falls outside of risk categories. These are not mutually exclusive. Consider Y.T., a figure I discuss below in chapter 7.

27. This acknowledgment can lead to further exploitation, as suggested by the film *Ashakara* which I discuss in chapter 4 of this book.

28. See Claude Lévi-Strauss, *The Savage Mind* (London: Weidenfeld & Nicolson, 1966).

29. Reed, *Mumbo Jumbo*, 90.

30. Ibid., 91.

31. This is precisely the argument of Mary Douglas in *Purity and Danger: An Analysis of the Concept of Pollution and Taboo* (Boston: Routledge, 1966).

32. October 24, 1986, 2199.

33. See Daniel B. Hardy, "Cultural Practices Contributing to the Transmission of HIV in Africa," *Reviews of Infectious Diseases* 9(6) (November-December 1987): 1109–19; and Peter Piot et al., "AIDS: An International Perspective," *Science* 239 (5 February 1988): 573–79.

34. I mean that such practices don't constitute a significant epidemiological factor. The possibility of viral transmission in scarification ceremonies exists, and awareness of the possibility is growing. For a consideration of AIDS education within a religious community, see chapter 10 of this book.

35. The Panos Institute, *AIDS and the Third World*, 66.

36. Reed, *Mumbo Jumbo*, 83.

37. Alex Shoumatoff, *African Madness* (New York: Vintage, 1990), xi.

38. Ibid., 200.

39. Ibid., 188. My emphasis.

40. Harlon Dalton, "AIDS in Blackface," in Stephen Graubard, ed., *Living with AIDS* (Cambridge, MA: MIT, 1990), 244. On race prejudice and the specific scapegoating of Haitians in the pandemic, see René Sabatier, *Blaming Others:*

Prejudice, Race and Worldwide AIDS (Washington: Panos, 1988), as well as Paul Farmer, *AIDS and Accusation.*

41. Dalton, "AIDS in Blackface," 243.
42. See in particular the poetry of Assotto Saint, Essex Hemphill and Roy Gonsalves.
43. "Non-literary" studies of and by women of color with AIDS comprise one section of ACT UP/NY Women & AIDS Book Group, *Women, AIDS and Activism* (Boston: South End Press, 1990).
44. Reed, *Mumbo Jumbo,* 98.
45. On the bodily text of African diasporic dance, see Browning, *Samba,* 36–50.
46. Dalton, "AIDS in Blackface," 237. My emphasis.
47. Reed, *Mumbo Jumbo,* 218.

CHAPTER 2

1. See Ariel Dorfman and Armand Mattelart, *How to Read Donald Duck: Imperialist Ideology in the Disney Comic* (New York: International General, 1975): "Power to Donald Duck means the promotion of underdevelopment. The daily agony of Third World peoples is served up as a spectacle for permanent enjoyment in the utopia of bourgeois liberty" (98).
2. Campaign for Labor Rights Newsletter (www.compugraph.com/clr/news1.html#NLC) March 24, 1997 (14:49:24).
3. Lipsitz, *Dangerous Crossroads: Popular Music, Postmodernism and the Poetics of Place* (New York: Verso, 1994), 7.
4. For an extended consideration of Esu as the sign of African diasporic communication, see Gates, *Signifying Monkey.*
5. Lipsitz, *Dangerous,* 10.
6. Ibid., 12.
7. See Appadurai, "Disjuncture."
8. "[T]he new political art (if it is possible at all) will have to hold to the truth of postmodernism, that is to say, to its fundamental object—the world space of multinational capital—at the same time at which it achieves a breakthrough to some as yet unimaginable new mode of representing this last, in which we may again begin to grasp our positioning as individual and collective subjects and regain a capacity to act and struggle which is at present neutralized by our spatial as well as our social confusion. The political form of postmodernism, if there ever is any, will have as its vocation the invention and projection of a global cognitive mapping, on a social as well as a spatial scale." Jameson, *Postmodernism, or The Cultural Logic of Late Capitalism* (Durham, NC: Duke University Press, 1991), 54.

9. Marshall McLuhan, *The Global Village: Transformations in World Life and Media in the 21st Century* (New York: Oxford University Press, 1989).

10. *Social Text* 31/32 (1992), 202–16.

11. Ibid., 202.

12. From Angélique Kidjo, *Ayé*, (Mango, 539934, 1994).

13. Colin Turnbull, *Music of the Rainforest Pygmies of the North-East Congo*, (Lyrichord, LLCT7517).

14. Reebee Garofalo, "Whose World Is It, Anyway?," *World of Music* 35(2), 1993, 19.

15. Ibid., 22.

16. Deborah Pacini-Hernandez, "A View from the South," *World of Music* 35(2), 1993, 50–51.

17. See Gerhard Kubik, "Neo-Traditional Popular Music in East Africa since 1945," *Popular Music* 1 (1981), 83–104. Kubik argues that East Africans "picked up" the rhumba during the Second World War. In the 1960s and 1970s, he cites Zairian pop artists' influence in East Africa. John Collins and Paul Richards, ("Popular Music in West Africa," in Simon Frith, ed., *World Music, Politics and Social Change* [Manchester: Manchester University Press, 1989], 12–46) give earlier examples of U.S. jazz influence.

18. "On Redefining the 'Local,'" *World of Music* 35(2) 1993, 39.

19. Ibid., 40.

20. Baudrillard, *La transparence du mal* (Paris: éditions Galilée, 1990), 13, cited in Veit Erlmann, "The Politics and Aesthetics of Transnational Musics," *World of Music* 35(2), 1993, 8.

21. Erlmann, "Politics and Aesthetics," 7.

22. Ibid., 8.

23. John Collins and Paul Richards, "Popular Music in West Africa," in Simon Frith, ed., *World Music, Politics and Social Change* (Manchester: Manchester University Press, 1989), 21.

24. Garofalo, "Whose World," 23.

25. See the introduction of this book.

26. See Neil Lazarus, "'Unsystematic Fingers at the Conditions of the Times': 'Afropop' and the Paradoxes of Imperialism" in Jonathan White, ed., *Recasting the World: Writing After Colonialism* (Baltimore: Johns Hopkins University Press, 1993), 137–60.

27. For a detailed history of WOMAD, see Peter Jowers, "Beating New Tracks: WOMAD and the British World Music Movement," in Simon Miller, ed., *The Last Post: Music After Modernism* (Manchester: Manchester University Press, 1993), 52–87.

28. Gabriel attempted a U.S. version of the festival, but concluded that this

country is not the easiest place to "sell" world culture—again, giving lie to Disney's, and multiculturalism's, optimisms.

29. Appadurai, "Disjuncture," 4. An early reader of the manuscript of this book wondered in the margin whether it didn't *itself* constitute a kind of "synchronic warehouse of cultural scenarios." I hope, however, that some differentiation can be made between cultural productions—and cultural analyses—which subsume different places and moments into a Western context, and those which, precisely, indicate the political implications of such maneuvers.

30. Peter Gabriel, *Xplora 1: Peter Gabriel's Secret World*, (Voyager, 1994).

31. Werner Graebner, liner notes, *Luo Roots*, (Globestyle Recordings CD/ORB 061, 1990), cited in Cynthia Schmidt, "The Guitar in Africa: Issues and Research," *World of Music* 36(2) 1994, 4–5.

32. Whether this kind of innovation in materials used constitutes "progressive indigenization," ironic "neo-traditionalism" or simply ingenious use of available resources is an open question. In fact, it is likely the latter, and yet the resonances of these other significances matter. I discuss the notion of neo-traditionalism and irony in the following chapter.

33. I will return to a consideration of the significance of the Rodney King video in chapter 6 of this book.

34. See Jon Pareles, "Art Music, Experience Unbound," *New York Times* July 13, 1994 (C1, 10).

35. "Live Television" (Y. N'Dour, H. Faye and J. P. Rykiel) and "Things Unspoken" (Y. N'Dour, H. Faye and J. P. Rykiel) from Youssou N'Dour, *Eyes Open* (Virgin Musique 1992 Editions).

36. Music videos emerged simultaneously with the other global cultural phenomena I describe here, and it's interesting to note the anxieties they produced in the West at the time, as evidenced by the title of an early critique in *New Musical Express*: "Video Virus." The metaphor retains its resonances today. In the May 1996 defense of his dissertation, "Playing at the Crossroads: Social Space as Metaphor in Ebira Masked Performances," (Performance Studies, New York University) Onukaba Adinoyi-Ojo presented an MTV-style video self-produced by a "traditional" performer in central Nigeria. "As you can see," said Ojo, who is himself Ebira, "we are not immune to MTV."

37. See Reebee Garofalo, "Understanding Mega-Events: If We Are the World, Then How Do We Change It?" in Garofalo, ed., *Rockin' the Boat: Mass Music, Mass Movements* (Boston: South End Press, 1992), 28.

38. Ibid.

39. Greil Marcus, "Rock for Ethiopia." Panel presentation at the Third International Conference on Popular Music Studies. Montreal, Canada. July 1985, 17. Cited in Garofalo, "Understanding Mega-Events," 29.

40. See Garofalo, "Understanding Mega-Events," and Neal Ullestad, "Diverse Rock Rebellions Subvert Mass Media Hegemony," in Garofalo, ed., *Rockin' the Boat*, 37–54.

41. "The Same" (Y. N'Dour and H. Faye), in N'Dour, *Eyes Open.*

CHAPTER 3

1. From Wideman, *Fever: Twelve Stories* (New York: Henry Holt and Co., 1989), 130.

2. Ibid., 135.

3. Ibid., 132–33.

4. A similar epidemic conflation of historical moments occurs in the Caribbean novelist Caryl Phillips' *The Nature of Blood* (New York: Knopf, 1997), which recalls the Black Death of the mid-fourteenth century. The plague (now most often attributed to an Asian origin—an epidemiological narrative with its own significances) was supposed by Europeans at the time to be spread by Jews. Thousands of Jews were slaughtered in Germany in an uncanny foreshadowing of the Holocaust, precisely the connection Phillips makes, among others. In an earlier novel based in the slavery-period Caribbean, *Cambridge* (New York: Knopf, 1992), Phillips included a subtle subtext of the exchange of syphilis between Europeans and captive Africans.

5. In connection with the historical deflection of AIDS onto other epidemics, it's interesting to note the controversy provoked by historian Philip Curtin's recent *Why People Move: Migration in African History* (Waco, TX: Markham Press, 1995). Curtin states that he, too, is interested in reexamining diasporic flows more multidirectionally, in resistance to a narrative of trans-Atlantic migration which attributes all active change and cultural development to Europeans. Yet he seems blind himself to the historical context of the attribution he makes to Africans in the diaspora: he suggests that a number of significant epidemics, including syphilis, the more "deadly" strain of malaria, and yellow fever, originated in Africa. While he casts this argument in moral opprobrium of Europeans' role in the slave trade, he fails to comment on the significance of his own hypothesis in the context of the history of blame and displaced fear which I have outlined here.

6. The recent proliferation of representations of both real and fictional epidemics includes the film "Outbreak!", as well as the bestsellers *The Hot Zone* by Richard Preston (New York: Anchor, 1994) and *The Coming Plague* by Laurie Garrett (New York: Penguin, 1995).

7. See J. Jones, *Bad Blood: The Tuskegee Syphilis Experiment* (New York: Free Press, 1981), cited in Dalton, "AIDS in Blackface," in Stephen Graubard, ed., *Living With AIDS* (Cambridge: MIT, 1990), 237–59.

8. See Lynda Richardson, "Experiment Leaves Legacy of Distrust of New AIDS Drugs," *New York Times*, April 21, 1997, A1, B4, and the preface to this book.

9. See Treichler, "AIDS and HIV Infection in the Third World: A First World Chronicle," in Barbara Kruger and Phil Mariani, eds., *Remaking History* (Seattle: Bay Press, 1989), 43. See also The Panos Institute, *AIDS in the Third World*, 74-75 and Paul Farmer, *AIDS and Accusation*, 229–35.

10. See Linda Hutcheon, "The Post Always Rings Twice: The Postmodern and the Postcolonial," *Textual Practice* (Fall 1994), 205–38.

11. On both the historical manipulations of museum culture and recent efforts to subvert them, see Ivan Karp and Steven D. Lavine, eds., *Exhibiting Cultures: The Poetics and Politics of Museum Display* (Washington, D.C.: Smithsonian Institute, 1991) and Ivan Karp and Steven D. Lavine, eds., *Museums and Communities: The Politics of Public Culture* (Washington, D.C.: Smithsonian Institute, 1992).

12. For a powerful example of the former reading, see Chinua Achebe, "An Image of Africa: Racism in Conrad's *Heart of Darkness*," in *Hopes and Impediments* (New York: Anchor, 1989), 1–20.

13. Hutcheon, *Textual Practice*, 210.

14. Ibid., 211–12.

15. Ibid., 219.

16. Appiah, "The Postcolonial and the Postmodern," in *In My Father's House* (New York: Oxford University Press, 1992), 137–57.

17. Ibid., 148.

18. Ibid., 144.

19. Kasfir, "Taste and Distaste: The Canon of New African Art," in *Transition* 57 (1992), 63.

20. Ibid., 64.

21. "African Art and Authenticity: A Text with a Shadow," in *African Arts* 25:2 (April 1992), 43.

22. See Nancy Scheper-Hughes, *Death Without Weeping: The Violence of Everyday Life in Brazil* (Berkeley and Los Angeles: University of California Press, 1992).

23. Donna Haraway, *Modest Witness@Second Millennium: Female Man© Meets OncoMouse™* (New York: Routledge, 1997), 208.

24. Interview with Mercadé, cited in Bogumil Jewsiewicki, "Cheri Samba and the Postcolonial Reinvention of Modernity," *Callaloo* 16,4 (Fall, 1993), 789.

25. Jewsiewicki, "Cheri Samba," 772–95 (780).

26. See André Magnin, "Aka Soa, Udro-Nkpo, Srele . . . Art in Black Africa." *Africa Now* (Groningen: Groningen Museum, 1991), 15–24 (21). Cited in Jewsiewicki, "Cheri Samba," 780.

27. In Susan Vogel's estimation, "Cheri Samba usually means exactly what he

says—and no more." Vogel, "Art of the Here and Now," in *Africa Explores: 20th Century African Art* (New York: The Center for African Art, 1991), 114–129 (124). Bogumil Jewsiewicki gives Samba a more subtle reading, but still states: "Cheri Samba . . . is primarily a moralist and teacher who will try to instruct not only members of his own society but anyone he considers in need of a lesson." He goes on, however, to note that the most moralistic canvases also serve as an occasion for depicting eroticism and nudity. Moralizing justifies such depictions, says Jewsiewicki, not only to the censorious authorities and public, but to himself: citing Samba's religious up-bringing, he says he "represses his obvious taste for painting nudes." Jewsiewicki, "Painting in Zaire: From the Invention of the West to the Representation of Social Self," in Vogel, *Africa Explores*, 130–51 (134–35).

28. Interview with B. Mercadé, cited in Jewsiewicki, "Cheri Samba," 789.
29. Recounted in Jewsiewicki, "Cheri Samba," 787.
30. A postcard. Ironically, I myself own a postcard print of "Le renoncement à la prostitution." A popular postcard set printed by a German press, *Cheri Samba: 30 Postcards* (Köln: Benedikt Taschen, 1994) is probably the form in which his work circulates most "freely."
31. See Henry Drewel, "Mermaids, Mirrors, and Snake Charmers," *African Arts* 21 (2): 38–45.
32. See Susan Vogel, "Urban Art: Art of the Here and Now," in Vogel, ed., *Africa Explores*, 114–29 (116).
33. See Patton, *Last Served? Gendering the HIV Pandemic* (Bristol, PA: Taylor & Francis, 1994), 52.
34. On the similarities between linguistic and artistic hybrid languages, see Paula Ben-Amos, "Pidgin Languages and Tourist Arts," *Studies in the Anthropology of Visual Communication* 4.2: 128–39, cited in Kasfir, "African Arts and Authenticity."

CHAPTER 4

1. Wyatt MacGaffey, *Religion and Society in Central Africa: The BaKongo of Lower Zaire* (Chicago: University of Chicago Press, 1986), 138–39.
2. Cited in Wamugunda Geteria, *Nice People* (Nairobi: African Artefacts, 1992), vi.
3. Ibid., 185.
4. Ibid., 29.
5. Ibid., 29.
6. Ibid., 24.
7. Ibid., 170–71.
8. Ibid., 47.

9. See Geshekter, "Outbreak?"

10. For Rouch's own account of this position, see Rouch, "Our Totemic Ancestors and Crazed Masters," *Senri Ethnological Studies* 24 (1988), 225–37.

11. Jean Rouch, John Marshall and John W. Adams, "Jean Rouch Talks About His Films to John Marshall and John W. Adams," *American Anthropologist* 80:4 (December 1978), 1007.

12. Homi Bhabha, *The Location of Culture* (London: Routledge, 1994).

13. See Paul Stoller, "Horrific Comedy: Cultural Resistance and the Hauka Movement in Niger," *Ethos* 12:2 (1984), 165–88, cited in Michael Taussig, *Mimesis and Alterity: A Particular History of the Senses* (New York: Routledge, 1993), 241.

14. Rouch, "Jean Rouch Talks About His Films," 1010.

15. Rouch, "On the Vicissitudes of the Self: The Possessed Dancer, the Magician, the Sorcerer, the Filmmaker, and the Ethnographer," *Studies in the Anthropology of Visual Communication* 5:1 (Fall 1978), 2.

16. Taussig, *Mimesis*, 242.

CHAPTER 5

1. Maya Deren, *Divine Horsemen*, 113–14.

2. See Farmer, *AIDS and Accusation*, and *The Uses of Haiti*.

3. Farmer, *AIDS and Accusation*, 8.

4. Farmer, *The Uses of Haiti*, 49–50.

5. C. L. R. James, *The Black Jacobins* (New York: Vintage, 1963), 87.

6. Brown, *Mama Lola*, (Berkeley: University of California Press, 1991), 95, n. 2.

7. Joan Dayan, "The Crisis of the Gods: Haiti After Duvalier," *Yale Review* 77:3 (June 1988), 329.

8. For an overview of this history, see André Droogers, "Syncretism: the problem of definition" in J. Gort, H. Vroom, R. Fernhout and A. Wessels, eds., *Dialogue and Syncretism: An Interdisciplinary Approach*.

9. Albert J. Raboteau, *Slave Religion: The "Invisible Institution" in the Antebellum South* (New York: Oxford University Press, 1978), 22–23.

10. See Herskovits, *The Myth of the Negro Past* (Boston: Beacon Press, 1958).

11. See Hurston, *Tell My Horse: Voodoo and Life in Haiti and Jamaica* (New York: Harper & Row, 1990). See also Robert Farris Thompson, *Flash of the Spirit*, and Luc de Heusch, " Kongo in Haiti: A New Approach to Religious Syncretism," *Man* 24:2 (June 1989), 290–303.

12. Deren, *Divine Horsemen*, 62.

13. Brown, *Mama Lola*, 100.

14. The cultural and political strategy of absorbing that which is other into the familial pantheon corresponds to other African diasporic cultural and polit-

ical patterns which I discuss elsewhere in this book. See, for example, the discussion of Octavia Butler in chapter 7 below. Obviously, this is a strategy in contrast with U.S. policy on Haitian immigration, among other things.

15. Brown, *Mama Lola*, 109.

16. "Haiti and Its Regeneration by the United States," *National Geographic* 38 (1920), 505; cited in Farmer, *The Uses of Haiti*, 229.

17. Kate Ramsey, "That Old Black Magic: Seeing Haiti Through the Wall of Voodoo," *The Village Voice* Sept. 27, 1994, 29.

18. Dr. William R. Greenfield, *JAMA* 24 October 1986, 2199.

19. Wade Davis, *The Serpent*, xi.

20. The priest presiding over Davis' first ceremony, and an important figure throughout his book, is the well known *houngan* and intellectual Max Beauvoir. "Since 1986, Beauvoir has been one of the central organizers of the political mobilization in defense of Vodou that responded to the dechoukaj attacks on temples, houngans and mambos; and in a way his work with Davis was perhaps a previous (ultimately failed . . .) attempt to challenge representations of Vodou. He has played an active role in creating a kind of public persona for Vodou. . . . He is a complex figure who is part of a larger move among houngans and mambos . . . who have chosen to try and develop counter-representations of Vodou in order to defend the religion. With this goal, Beauvoir and others have . . . accepted the use of film in ceremonies in the . . . hope that they might be able to present the religion in a different light." (Laurent Dubois, personal communication, July 20, 1997) Surely, the possibility of positive film depictions of Vodou exists—I will discuss one attempt later in this chapter. The distressing sense, however, that the positive images promoted by Beauvoir and others might ultimately be exploited is compounded by what happens to Beauvoir's own image in Craven's film: he yanks his own head off.

21. Her willingness, however, to work with Brown on her sympathetic ethnography demonstrates her own desire—in this case much more felicitously achieved than Beauvoir's—to create positive public images of Vodou.

22. The efficacy of Haitian Americans' public protest is important to note in the context of this book's repeated invocation of a politics of discretion (see Introduction, as well as the last pages of this chapter). Despite this community's apparent lack of political sway, the righteousness—and volume—of its message was potent. I never want to argue *against* a voluble response to discrimination based on assumed *or* actual HIV infection. Rather, as I have written above, I want for us to attend—very carefully—to the silences *as well as the cries of protest.*

23. Brown, *Mama Lola*, 10.

24. Deren, *Divine Horsemen*, 5.

25. Ibid., 7.

26. Of course, the phrase "white darkness" means something else as well: as a white woman incorporating a principle of African divinity, Deren, like Mami Wata, demonstrates that religious syncretism and racial history are inextricably intertwined.

27. Deren, *Divine Horsemen*, 26.

28. In *Samba: Resistance in Motion*, I argued that this same suspension propels secular dance in African Brazil: "*it is the suspension or silencing of a beat which provokes movement.*" (15) My argument there was that dance often articulates a political consciousness which has been silenced.

29. In the context of this book's larger argument for recomplicating the political premise that Silence=Death, the invocation of the *closet* will surely resonate with issues of sexual politics in this country. I hope it will be clear that I am by no means arguing for the closeting of sexuality—nor of diasporic culture. Still, the story of Deren's cans of film resonates in deep ways with another story of closets I discuss below. See the conclusion of chapter 9 of this book.

CHAPTER 6

1. While some commentators on the events pursuant to the Rodney King verdict reject the term "riots" in favor of "uprising," noting the political significance intended by many of the participants, I use the term here precisely to argue that even when such mass action is *not* politically articulated by its agents, it continues to have political meanings.

2. David O. Sears, "Urban Rioting in Los Angeles: A Comparison of 1965 with 1992," in Mark Baldassare, ed., *The Los Angeles Riots: Lessons for the Urban Future* (Boulder, CO: Westview Press, 1994), 237–54 (240). The original Watts analysis was written up in David O. Sears and John B. McConahy, *The Politics of Violence: The New Urban Blacks and the Watts Riot* (Boston: Houghton-Mifflin, 1973).

3. Sears notes that in spite of this "unreadability," or perhaps because of it, the riots provoked a proliferation of interpretations, many contradictory, as exemplified by the essays collected in Robert Gooding-Williams, ed., *Reading Rodney King: Reading Urban Uprising*, (New York: Routledge, 1993).

4. Ibid., 253.

5. Haki R. Madhubuti, "Introduction: Same Song, Different Rhythm," in Madhubuti, ed., *Why L.A. Happened: Implications of the '92 Los Angeles Rebellion* (Chicago: Third World Press, 1993), xiii.

6. "Bloods/Crips Proposal for L.A.'s Face-Lift," in Haki R. Madhubuti, ed., *Why L.A. Happened*, 274–82 (281).

7. Mike Davis, *City of Quartz* (New York: Verso, 1990), 276.

8. Ibid., 316, 270.
9. David Palumbo-Liu, "Los Angeles, Asians, and Perverse Ventriloquisms: On the Functions of Asian America in the Recent American Imaginary," *Public Culture* 6 (1994) 365–81 (368).
10. Ibid., 378–79.
11. Laurie Hawkinson, "Mapping L.A." in Mick McConnell, ed., *LAX: The Los Angeles Experiment* (New York: Lumen Books, 1994), 25–38.
12. See Charles Jencks, *Heteropolis: Los Angeles, the Riots, and the Strange Beauty of Hetero-Architecture* (London: Academy Editions, 1993).
13. Michel Foucault, *Discipline and Punish*, trans. Alan Sheridan (New York: Vintage, 1979), 198.
14. See Fredric Jameson, *Postmodernism, or the Cultural Logic of Late Capitalism* (Durham: Duke University Press, 1991), 12–13 and *passim*.
15. Davis, *City of Quartz*, 223.
16. Foucault, *The History of Sexuality: Volume I, An Introduction*, trans. Robert Hurley (New York: Vintage, 1990), 147.
17. Ibid., 149.
18. Jencks, *Heteropolis*, 87–88.
19. Ibid., 93.
20. Michael Sorkin, "Local Code," in McConnell, ed., *LAX*, 85–99.
21. Richard Schechner, "Anna Deavere Smith: Acting as Incorporation," *TDR* 37:4 (1993), 63–64 (63).
22. Ibid., 64.
23. "Anna Deavere Smith: The Word Becomes You," interview with Carol Martin, *TDR* 37:4 (1993), 45–62 (51).
24. Anna Deavere Smith, *Twilight: Los Angeles, 1992* (New York: Anchor Books, 1994), 254.
25. Ibid., xxv–xxvi.
26. Ibid., 222–23.
27. See William Sun and Faye Fei, "Masks or Faces Re-Visited: A Study of Four Theatrical Works Concerning Cultural Identity," *TDR* 38:4 (1994), 120–32.
28. Ibid., 233.

CHAPTER 7

1. Donna Haraway, "A Manifesto for Cyborgs: Science, Technology, and Socialist Feminism in the 1980s," *Socialist Review* 80 (March-April 1985), 65–107 (66).
2. Of course Smith's technique is apparently organic, even though it depends upon the relatively "primitive" technology of audiotape recording. The more important element is her own embodied *repetition* of language. Still, the

comparison to the highly mechanized process of simstim seems apt—think of Koffi Kouakou's manual simulation of mechanical reproduction in his sculpture.

3. William Gibson, *Count Zero* (New York: Ace, 1987), 24.

4. Ibid., 29.

5. Ibid., 18.

6. Gibson's fictional Haitians maintain the organic element of their religion by filling their floor of the projects with hydroponic vegetation under gro-bulbs. Likewise, Karen McCarthy Brown records that "One *manbo* in Bedford-Stuyvesant, who lives on the thirty-seventh floor of a low-income housing project, carts a garbage pail filled to the top with earth up to her apartment, and all libations are poured there." Brown, *Mama Lola*, 377.

7. Gibson, *Count Zero*, 58.

8. Ibid., 77.

9. Ibid., 84.

10. Ibid., 114.

11. Julian Dibbell, "A Rape in Cyberspace; Or How an Evil Clown, a Haitian Trickster Spirit, Two Wizards, and a Cast of Dozens Turned a Database into a Society," in Mark Dery, ed., *Flame Wars: The Discourse of Cyberculture* (Durham: Duke University Press, 1994), 237–62 (239).

12. Ibid., 242.

13. Ibid. 242.

14. Ibid., 243–44.

15. Ibid., 259.

16. Haraway, "A Manifesto," 67.

17. See the brochure for "ImagiNation," one such on-line service. From the name of this service, one can already see how the internet messes with other forms of identity, including national. But that's another story.

18. Allison Fraiberg, "Of AIDS, Cyborgs, and Other Indiscretions: Resurfacing the Body in the Postmodern," *Postmodern Culture* 1:3 (May 1991), 10.

19. Neal Stephenson, *Snow Crash* (New York: Bantam, 1992), 36.

20. Ibid., 37.

21. Ibid., 14–15.

22. Ibid., 16.

23. Ibid., 57.

24. The bibliography here is extensive, but for specific reference to the figuring of women in relation to AIDS and the immune system, see Paula Treichler, "Beyond *Cosmo*: AIDS, Identity and Inscriptions of Gender," *Camera Obscura* 28 (Jan. 1992), 21–76.

25. Kenneth P. Weiss, quoted in Joel Kurtzman, "Curing a Computer Virus," *New York Times* Nov. 13, 1988, f-1, cited in Raymond Gozzi, Jr., "The Computer

'Virus' as Metaphor," *ETC: A Review of General Semantics* 47:2 (Summer 1990), 177–80 (178).

26. On the epidemiological categorization of "prostitutes," see chapter 3 above.

27. This strain of *Snow Crash* of course links it intimately to *Mumbo Jumbo*, in which the oral transmission of African culture allows for its (wonderfully) uncontrollable spread.

28. Rife's Pearly Gates chain is undoubtedly modeled after the famously "moral" Wal-Mart empire—precisely the place where Charles Kernaghan bought his Haitian-made Pocahontas t-shirt.

29. Stephenson, *Snow Crash*, 381.

30. Ibid., 258.

31. This is not to imply that pregnancy cannot be a specter to a man as well. A male friend recently recounted to me a nightmare, in which a pregnant friend of ours was cheerfully stabbing an already bloodied syringe into the arm of her boyfriend. My friend tried to intervene, and she laughingly said, "Don't worry, it doesn't hurt at all. See?" With this, she turned to my friend and began to jab him in the top of the head. The figural connection between pregnancy and infection may have preceded AIDS, but now it has certainly come, as it were, to a head.

32. Emily Martin has characterized the "common picture" of reproductive function in scientific literature as: "egg as damsel in distress . . . sperm as heroic warrior to the rescue." Martin, "The Egg and Sperm: How Science Has Constructed a Romance Based on Stereotypical Male-Female Roles," *Signs* 16, 3 (1991), 485–501 (491).

33. In another configuration, semen can carry something utterly different from individual identity—think of the mambo possessed by Gede with which I began the Haitian chapter of this book.

34. See Paula Treichler, "Beyond *Cosmo*," 27. Treichler notes that the account of the vagina "shot through with cracks and lesions, punctures and sores" is just the flip side of an equally dangerous depiction—"rugged . . . impervious to sordid pathogens." It's the old virgin/whore story located in a single vagina.

35. See Emily Martin, *Flexible Bodies*, 55–59. Martin also notes the race and class coding of the term "housekeepers of the immune system."

36. Stephenson, *Snow Crash*, 383.

37. Here, again, I slip myself into my own omniscient narrative, like a needle under the skin. As the long-time partner of an HIV-positive person, I, Y.T., found myself struggling with the epidemiologists' identification of me as both negative and "Whitey." We were a "nonconcordant" couple, and there wasn't an epidemiological questionnaire that we filled out that didn't resolidify our other (racial and ethnic) differences.

38. Sometimes, of course, things get *out* of hand. Sexual violence (as well as other forms of manipulation, including economic) exists, which is why, unfortunately, we can't get rid of the rhetoric of hand-to-hand combat.

39. Octavia Butler, *Clay's Ark* (New York: Warner Books, 1984), 212.

40. While, as I noted above, HIV rates have begun to climb precipitously in poor Asia, we are also increasingly encountering powerful, often hopeful signs of African-Asian hybridization (Hiro Protagonist is another case in point). It remains to be seen, however, whether the sea change in the AIDS pandemic will be reflected in virulent, racist depictions of Asianness. Certainly, historical precedent exists for Asian contagion figures: consider the Hong Kong flu pandemic of 1968, and the Korean Hantaan virus outbreak among U.S. marines from 1951–55. But surely the most devastating pandemic attributed to Asia was (an interesting figural reversal of the "African" Yellow Fever) the Black Death, which European historians surmise originated in Mongolia around 1346.

41. Octavia Butler, *Bloodchild and Other Stories* (New York: Seven Stories, 1996), 30.

42. Ibid., 30.

43. Octavia Butler, *Adulthood Rites* (New York: Warner Books, 1988), 6.

44. Octavia Butler, *Imago* (New York: Warner Books, 1989), 30–31.

45. For an overview of the political co-factors impacting women of color in the global pandemic, see Paul Farmer, Margaret Connors and Janie Simmons, eds., *Women, Poverty, and AIDS.*

CHAPTER 8

1. See Mike Cooley, *Architect or Bee? The Human Price of Technology* (London: Chatto & Windus, 1987). One of Cooley's hopes is that if more women enter into the technological sphere, not merely the manual labor force, they might affect the ethical aspects of the manufacturing revolution. But as Juanita Marquez knows, it isn't always so simple for a feminist sensibility to infiltrate the culture of technology.

2. See Fiorenza Belussi, "Benetton Italy: Beyond Fordism and Flexible Specialisation: The Evolution of the Network Firm Model," in Swasti Mitter, ed., *Computer-Aided Manufacturing and Women's Employment: The Clothing Industry in Four EC Countries* (London: Springer-Verlag, 1992).

3. Donna I. Haraway, *Simians, Cyborgs, and Women: The Reinvention of Nature* (New York: Routledge, 1991), 166.

4. Ibid., p. 166.

5. Swasti Mitter, "Women Organising in Casualised Work," in Mitter and Sheila Rowbotham, eds., *Dignity and Daily Bread* (1994), 24.

6. Henry A. Giroux, "Consuming Social Change: The 'United Colors of Benetton,'" *Cultural Critique* (Winter 1993–94): 5–32 (10). See also Carol Squires, "Violence at Benetton," *Artforum* 30 (1992): 18–19; and Les Back and Vibeke Quaade, "Dream Utopias, Nightmare Realities: Imaging Race and Culture Within the World of Benetton Advertising," *Third Text* 22 (1993), 65–80.

7. *Colors* no. 7: *AIDS* (1994), 30.

8. The Benetton Group, "A Brief History of Benetton," 1994 (no page numbers).

9. McKenzie Wark, "Still Life Today: The Benetton Campaign," *Photofile* 36 (August 1992), 33–36 (33).

10. Cited in Douglas Crimp, *AIDS: Cultural Analysis/Cultural Activism*, 8.

11. Wark, "Still Life," 36.

12. *Colors, AIDS*, 46.

13. Ibid., 5.

14. Donna Haraway discusses this image in *ModestWitness @ Second Millenium*, 259–60.

15. The image was produced by the photographer Hiro, though not our friend Hiro Protagonist . . . See Ibid., 261.

16. *Colors, AIDS*, 121.

17. Ibid., 137.

18. Quoted in the Benetton promotional materials.

19. Ibid.

20. Haraway, "A Cyborg Manifesto," 80.

21. Donna Haraway, "The Biopolitics of Postmodern Bodies: Constitutions of Self in Immune System Discourse," in *Simians, Cyborgs, and Women*, 203–30 (204).

22. Ibid., 223.

23. Emily Martin, *Flexible Bodies*, 245.

24. Ibid., 247.

25. John Marcellino, cited in Martin, *Flexible Bodies*, 233–34.

26. See Étienne Balibar, "Is There a 'Neo-Racism'?" in Balibar and I. Wallerstein, eds., *Race, Nation, Class: Ambiguous Identities* (London: Verso, 1991), 17–28.

27. Bruce Kleiner, cited in Martin, *Flexible Bodies*, 242–43.

28. Allan Chase, cited in Martin, *Flexible Bodies*, 126.

CHAPTER 9

1. Brown, *Mama Lola*, 220.

2. See in particular bell hooks, "Is Paris Burning?" in *Black Looks: Race and Representation* (Boston: South End Press, 1992), 145–56; Judith Butler, "Gender Is Burning: Questions of Appropriation and Subversion," in *Bodies*

That Matter: On the Discursive Limits of "Sex" (New York: Routledge, 1993), 121–40; and Peggy Phelan, "The Golden Apple: Jennie Livingston's *Paris Is Burning*" in *Unmarked: The Politics of Performance* (New York: Routledge, 1993), 93–111.

3. The bibliography on African diasporic carnival is enormous—as is the more general theoretical bibliography on carnivalization as a counter-hegemonic practice. See Mikhail Bakhtin, *Rabelais and His World* (Cambridge: MIT Press, 1968); Roberto Da Matta, *Carnivals, Rogues & Heroes: An Interpretation of the Brazilian Dilemma*, trans. John Drury (Notre Dame: University of Notre Dame Press, 1991); George Lipsitz, "Mardi Gras Indians: Carnival and Counter-Narrative in Black New Orleans," *Cultural Critique* 10 (Fall 1988), 99–121; and my own "The Daughters of Gandhi: Africanness, Indianness and Brazilianness in the Bahian Carnival," in *Women & Performance* 15 (January 1995).

4. Jim Wafer, *The Taste of Blood: Spirit Possession in Brazilian Candomblé* (Philadelphia: University of Pennsylvania Press, 1991), 3–4.

5. See Browning, *Samba*, 51–58.

6. Ruth Landes, *The City of Women* (Albuquerque: University of New Mexico Press, 1994).

7. "Mounting" is also the metaphor used in Santería and Vodou (the reference in Maya Deren's title, *Divine Horsemen*). And while I have said that the association between male homosexuality and spirit possession cannot be generally applied to the diaspora, Lorand Matory has argued that the metaphor of mounting exists, and carries sexual implications, in Yorubaland as well. See Matory, "Homens montados: Homossexualidade e simbolismo da possessão nas religiões afro-brasileiras," in J. J. Reis, ed., *Escravidão e invenção da liberdade: Estudoe sobre o Negro no Brasil* (São Paulo: Brasiliense, 1988), 215–31.

8. See Sally Cole, "Ruth Landes and the Early Ethnography of Race and Gender," in *Women Writing Culture*, eds. Ruth Behar and Deborah Gordon (Berkeley and Los Angeles: University of California Press, 1995), 166–85. See also Ruth Landes' own account of this episode and its consequences in "A Woman Anthropologist in Brazil," in *Women in the Field: Anthropological Experiences*, ed. Peggy Golde (Berkeley and Los Angeles: University of California Press, 1986), 119–39.

9. See Edson Carneiro, "Uma 'Falseta' de Artur Ramos," in *Ladinos e Crioulos: Estudos sobre o Negro no Brasil*, ed. Carneiro (Rio de Janeiro: Civilização Brasileira, 1964), 223–27.

10. See Luiz Mott, "The Gay Movement and Human Rights in Brazil," in Stephen O. Murray, ed., *Latin American Male Homosexualities*, (Albuquerque: University of New Mexico Press, 1995), 221–30.

11. See Richard Parker, "Changing Brazilian Constructions of Homosexuality," in Murray, ed., *Latin American Male*, 241–55.

12. This is precisely the point of Murray's edited volume, which attempts, at times more successfully than others, to catalogue some of these differences. Of help is the devotion of an entire section of this volume to the case of Brazil, which offers particular challenges to translation between activist communities.

13. Don Kulick, "The Gender of Brazilian Transgendered Prostitutes," *American Anthropologist* 99:3 (1997), 1–13 (1–2).

14. Butler, *Bodies That Matter*, 136–37.

15. Ibid., 134.

16. Mary Douglas, 128.

17. bell hooks, *Black Looks*, 145–56.

18. Frye, *The Politics of Reality: Essays in Feminist Theory* (Trumansburg, NY: The Crossing Press, 1983).

19. hooks, *Black Looks*, 147

20. Butler, *Bodies That Matter*, 134–35.

21. Webster's New Collegiate Dictionary.

22. Jesse Green, "What the Navy Taught Allen Schindler's Mother," *New York Times* Sunday, Sept. 12, 1993, sec. 6, 58.

23. Phelan, *Unmarked*, 93, 95.

24. Butler, *Gender Trouble* (New York: Routledge, 1990), 133.

25. See Edward Conlon, "The Drag Queen and the Mummy," *Transition* 65 (Spring 1995), 4–24.

26. Ibid., 23.

27. Ibid., 24.

28. Ibid., 24.

CHAPTER 10

1. T.V. Globo is one of the more interesting cases in the globalization of the television industry. While based in relatively underdeveloped Brazil, it owns affiliates in Europe. The Globo network started out under the supervision of Time-Life, but after establishing its independence, became a major international exporter of Brazilian programs, particularly telenovelas, which are dubbed and broadcast throughout Europe and the rest of Latin America. See Michèle and Armand Mattelart, *The Carnival of Images: Brazilian Television Fiction* (New York: Bergin & Garvey, 1990).

2. The actress who played Babalú was Letícia Spiller. Spiller had already come into the public spotlight a few years before when she was the apparent sec-

ond target of a kidnapping attempt on Xuxa, the children's television star. Spiller got her start as a *paquita*—one of the dozens of Xuxa look-alikes who bounce and wiggle in the background as Xuxa herself performs a surprisingly, to North American eyes, explicit seduction act for kiddies. Xuxa on her own provides ample material for a study of the configuration of race and sex in Brazil. See Amelia Simpson, *Xuxa: The Mega-Marketing of Gender, Race, and Modernity* (Temple, 1993). Xuxa first came to fame as the Aryan-looking soft-core porn-star girlfriend of the famous black soccer player, Pelé. After a number of failed celebrity romances, Xuxa now tells the press she will conceive, if necessary, alone. So much for the supposed "Madonna/whore" division in Latin America. While a number of commentators have noted the irony of Xuxa's *paquitas*—a jiggling front of Aryan beauty playing to a multi-racial crowd of kids—Xuxa has recently developed an enthusiasm for hip-hop, and is now joined on her show by dark-skinned male dancers (as well as the old Xuxa clones). As for Spiller, she married her novela boyfriend in what, as Don Kulick reminded me, was yet another demonstration of the strange way Brazilian telenovelas have of leaking out into "real life."

3. On *àşe*, see Pierre Verger, "The Yoruba High God," *Odu* 2:2 (1966), 19–40 (35); and Juana Elbein Dos Santos, *Os Nàgô e a Morte* (Rio de Janeiro: Editora Vozes, 1975), *passim*.

4. Dos Santos, *Os Nàgô,* 39.

5. Ibid., 41.

6. Evidence of this cultural anxiety is the fact that arguments for the specific state-legislated banning of blood sacrifice have reached the Supreme Court in recent years. The court, however, has thus far declined the State's authority to intervene in religious practice which does not technically violate already existing health codes.

7. On scarification among the Yoruba, see Henry John Drewal, "Yorùbá Body Artists and Their Deity Ògún," in Sandra T. Barnes, ed., *Africa's Ogun: Old World and New* (Bloomington: Indiana University Press, 1989), 235–60.

8. See Daniel B. Hardy, "Cultural Practices Contributing to the Transmission of HIV in Africa," *Reviews of Infectious* Diseases 9:6 (November-December, 1987), 1109–19; and Peter Piot et al., "AIDS: An International Perspective," *Science* 5 February 1988, 573–79.

9. Such punning is called *sotaque,* which means accent. See Maria Teixeira, *O Rodar das rodas: Dos homens e dos orixás* (Rio de Janeiro: Instituto Nacional do Folclore, 1985). See also my *Samba,* 26–28.

10. See Trevisan, *Perverts in Paradise* (London: Gay Men's Press, 1986); Fry, "Male Homosexuality and Spirit Possession in Brazil," in *The Many Faces of*

Homosexuality: Anthropological Approaches to Homosexual Behavior, Evelyn Blackwood, ed. (New York: Harrington Park Press); Matory, "Homens," Wafer, *Taste of Blood*, and Mott, "The Gay Movement."

11. Neuza de Oliveira, *Damas de Paus: O Jogo Aberto dos Travestis no Espelho da Mulher* (Salvador: Centro Editorial e Dedático da UFBA, 1994), 118.

12. Ibid., 113.

13. See Sophie Day, "Prostitute Women and the Ideology of Work in London," in *Culture and AIDS*, Douglas A. Feldman, ed. (New York: Praeger, 1990), cited in Kulick, "The Gender of Brazilian Transgendered Prostitutes."

14. Kulick, "Gender."

15. Kulick, "Penetrating Gender: Brazilian Transgendered Prostitutes and Their Relevance for an Understanding of Sexuality and Gender in Latin America," paper delivered at NYU, 1996, 6.

16. Ibid., 8.

17. In writing of the *travestis*, Kulick rejects the increasingly popular anthropological category of a "third gender". Travestis, he argues, in a way emblematize national views of sexuality (men and not-men)—and simultaneously become something of a national symbol, within Brazil and abroad. In the global sex market, Brazilian *travestis* are world famous. Perhaps this has something to do with Octavia Butler's siting of a particular episode in *Imago*: the ooloi Jodahs's first male lover is a Brazilian named João from a human resister village called São Paulo. Jodahs grows breasts to attract João, who responds, despite himself. He tells Jodahs, accusingly, "I know what you do—your kind. You take men as though they were women. Your kind and your Human whores are the cause of all our trouble! You treat all mankind as your woman!"(Butler, *Imago*, 77). This caricature of Brazilian machismo, however, is ultimately both confirmed in his manhood by his love of hybridity, and "confused" about his own identity. The European and North American stereotypes of Brazilian sexuality combine rigid machismo with carnivalized free play. These circulate globally along with real-life Brazilian sex workers and T.V. Globo images—all, certainly, inflecting each other.

18. Luiz Mott and Aroldo Assunção, "Gilete na carne: Etnografia das automutilações dos travestis da Bahia," *Temas IMESC, Soc. Dir. Saúde* 4:1 (1987), 41–56 (41).

19. Oliveira, *Damas de Pans*, 148–49.

20. When Mott read an early draft of this essay, outside of the larger argument of this book regarding strategic discretion, he immediately wrote in the margin, "SILENCE=DEATH." Mott has been a major Brazilian promoter of the policy of acting up. Some members of the transvestitite community have explicitly argued that Mott's orthodox version of gay political identity does-

n't correspond to their own self-understandings (Kulick, personal communication, July 20, 1997). This is not, however, to deny that Mott's volubility has made an important impact.

21. Kulick, "The Gender of Brazilian Transgendered Prostitutes," 3.

INDEX

significance in Candomblé, 177–85

tainted, 133, 146

blood sacrifice, 82, 88, 92, 102, 179

Bloodchild and Other Stories, 212n41, n42

Bloods and Crips, 13–14, 107–108, 115, 117

"boat people," 91, 149, 157

Bodies That Matter, 213n2, 215n14–n15, n20

bodily fluids, 54, 67, 88, 127, 133–35

bòkò, 26

bossa nova, 49

Boukman, 92, 93

Boukman Eksperyans, 35–36

brand name, 15, 150, 152, 153

branding (*see also* scarification), 150

Brazil, 1–4, 15–16, 21, 60, 160–62, 173–92, 193n1

breastfeeding, 60, 159

breast implants (*see also* prostheses and silicone), 130, 159

breast milk, 54, 60, 133, 138, 183

Brechtian distancing, 119

Bronson, Charles, 110

Brooke, James, 194n7, 194n9

Brown, James, 38

Brown, Karen McCarthy, 96–97, 100–101, 163, 198n13, 206n6, n13, 207n15, n23, 210n6, 213n1

Browning, Barbara, 194n2, n11, 196n27, 200n45, 214n3, n5, 216n9

Buckley, William F., 150

Burroughs, William, 150

Butler, Judith, 163, 165, 170–71, 213n2, 215n14, n15, n20, n24

Butler, Octavia, 14, 137–40, 160, 164, 207n14, 212n39, n41–n44, 217n17

Byrne, David, 41, 47

CDs, 12, 37, 40, 47

CD-ROMs, 12, 42–45

CIA, 53, 91, 93

CIM (computer-integrated manufacturing), 143

CNN, 45–46, 99

Cabrera, Lydia, 198n14

Cambridge, 203n4

Candomblé, 15, 21, 160–62, 173–92, 196n28

Candomblé de Bahia, 198n14

Cannizzo, Jeanne, 56

Carneiro, Edson, 162, 214n9

carnival, 1, 160, 193n2

Carnival of Images: Brazilian Television Fiction, 215n1

Carnivals, Rogues & Heroes, 214n3

cars, 112

cartography, 8, 36, 43, 154

catalyst, 77

categories
 of identity, 10–12, 14, 121, 127, 128, 150–51, 160, 162
 of risk, 10–11, 22, 47, 121, 151, 198n17, 199n26

Cédras, Brigadier General Raoul, 91, 98

Center for African Art: *see* Museum for African Art

Centers for Disease Control (CDC), 17, 153, 197n2

Centre Pompidou, 55

cha-cha-cha, 49

Chandler, Otis, 118–19

Charles, Ray, 47

Chase, Allan, 213n28

Cherry, Neneh, 38

Chinese music, 49

ciaccona, 6

cinéma vérité, 82

City of Quartz, 108, 208n7, 209n8, n15

City of Women, 162, 214n6

city planning, 112

civility, 14, 114–15, 127, 129

classism, 25
 HIV a vector of, 196n28

Clay's Ark, 138–39, 212n39